ARTISTS AT WORK

Inside the Studios of Today's Most Celebrated Artists

First published in the United States of America in 1999 by
Rizzoli International Publications, Inc.
300 Park Avenue South, New York, NY 10010

© Assouline, 1999
26-28, rue Danielle-Casanova
Paris 75002 France

ISBN: 0-8478-2237-0
LC 99-74708

Color separation: Gravor (Switzerland)
Printed in Italy by G. Canale & C. S.p.A. - Borgaro T.se - TURIN

ARTISTS AT WORK

Inside the Studios of Today's Most Celebrated Artists

David Seidner

Project coordinator: Diana Edkins

RIZZOLI
NEW YORK

My dear friend Lisa Fonssagrives-Penn's words to me have never stopped reverberating: "Don't try so hard—I never wanted to make a career, I just fell into one." This book had a very loose master plan with no deadline, but here it is, eight years and twenty artists' studios later. And, lo and behold, it is an interesting document of a brilliant group of artists. They are the salt of my earth, and the public I always wanted to gain approval from. I worship artists. And since every artist wants to be loved, fortunately they responded with open arms. It was as easy as that. Of course, it didn't hurt to have the backing of important magazines and the support of major museums. It has been a blessing. So often I've woken up in the morning and thanked the heavens for allowing me to earn a handsome living doing what I love to do. An irrefutable blessing. There were so many people along the way that made this project possible. First, my mother, who told me when I was five years old that my paint doodles were as good as those by Jackson Pollock. My close friend Lenny Steinberg opened my eyes to the modern idiom, which I didn't even know existed before I turned seventeen. Nicolas Wilder, a friend and art dealer in Los Angeles taught me another great lesson. After I had said snidely about a multipanel Ellsworth Kelly painting, "I could do that," Nick replied, "But you didn't." And then he went on to explain the beauty of a flower or a Zen rock garden: it's beautiful because it is. In the late 1970s, Herbert Read's *Philosophy of Modern Art* was my bible, and the watershed event for me was the Joseph Beuys retrospective at the Guggenheim. I never felt like I fit in, anywhere. Then, when I was eighteen, Samia Saouma, my friend and first art dealer, said to me, "You're not weird, you're deep." A lightning bolt. When I arrived in New York in the 1970s, I felt accepted by a brilliant group of artists whose

spirit of camaraderie I likened to my fantasies of what bohemia was like in Montparnasse in the 1920s. We used to sit around and discuss the thinking behind the work more than the work itself—that was the important aspect of the conceptual Zeitgeist. I loved it. Humility, thy name is not David. I suppose I was born with a false sense of entitlement—and isn't youth a wonder when you think that you are the equal of anyone? It allowed me to throw myself into the world and have a wonderful book twenty years later. The work included here was done over an eight-year period, green-lighted by my dear friend and supporter Colombe Pringle, at the time editor-in-chief of French *Vogue*. She gave me free rein and loved the material. Her contribution to this project cannot be overestimated. Another great motivator was my good friend Betsy Sussler, the editor of *BOMB Magazine*, with whom I've collaborated since 1981, doing interviews, taking photographs, and writing essays on other artists' work. Together, we were wonderful and it allowed me to develop cherished friendships with golden minds. These artists are all ones whose work I really admire. My adoration is heartfelt, and I hope it is reflected in the quality of the images. Some of the work has never been published before, as, alas, magazine editors do come and go. And, of course, things always change. Several of these essays were done for my friend Wendy Goodman at *Harper's Bazaar*, some for Marianne McEvoy, also a dear friend, at *Elle Decor*, and one, Roni Horn's, for American *Vogue*. The most recent is the one on Francesco Clemente, prepared for *Vanity Fair* and scheduled to coincide with his upcoming retrospective at the Guggenheim this fall. There were no conscious omissions. This work just happened, out of a deep love and appreciation. Hopefully, that feeling will resonate through the following pages.

Ross Bleckner

Ross Bleckner lives and works in the six-story building in lower Manhattan that, for a brief period in the early 1980s, housed the legendary Mudd Club. It has now become the corporate hub for Bleckner Enterprises Ltd. The studio is a double-height space composed of the second and third floors. Here are produced a huge number of paintings of all shapes and sizes, works on paper, books, meetings, and charity events (Bleckner being the president of the Community Research Initiative on AIDS). Ross has remained true to his Long Island Jewish roots, and there is no pretense or affectation about him. He is loud, funny, honest, deep, intelligent, and very supportive and generous. Ross would make a great diplomat. He's comfortable with all types of people: easygoing, he remains himself. He's restless, always wanting more, thinking about what to do next, not resting on his laurels. He's great at doing nothing, but he also knows how to churn out work on deadline. His treatment of the people in his orbit has won him their unswerving loyalty, and he has created around himself the semblance of a happy family life. His flurry of activity in the art and social worlds is a foil for a complex and fascinating mind. He has an incredibly light touch with some very serious subjects, which need to be treated in such a light manner in order to promote awareness. Hardly a review or article is published about him and his work without mention of the AIDS epidemic, death, grief, loss. Yet, the surfaces of his paintings shimmer, the lines vibrate, and the entire body of work seems crafted by the elements. Bleckner's studio is like an alchemist's lair. I've seen him burn paint with blowtorches, rearrange it with air, pour it with water, and make it gritty as earth.

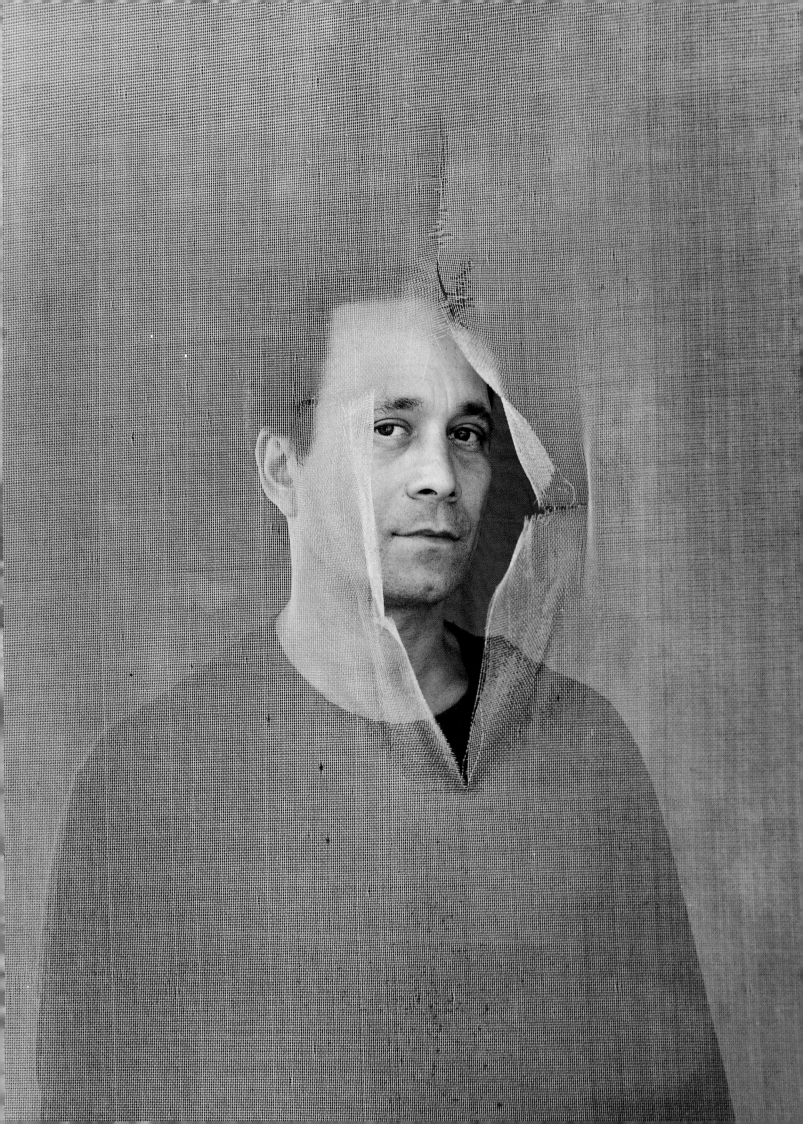

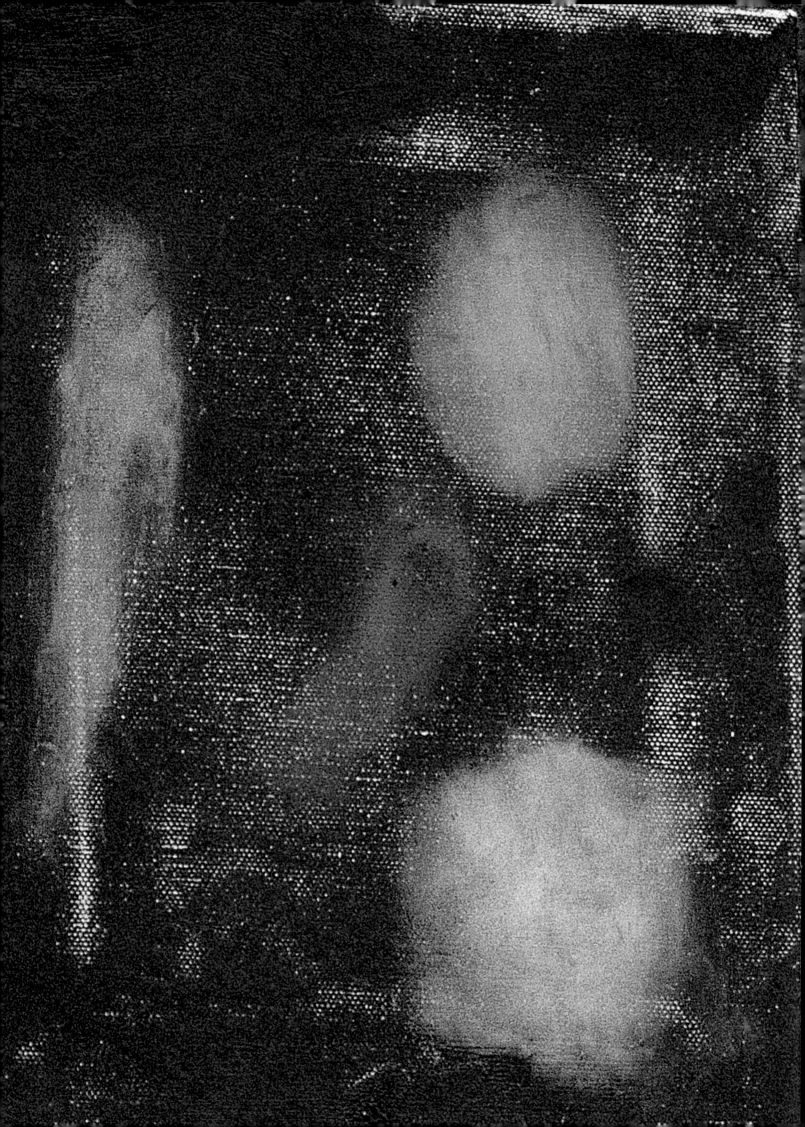

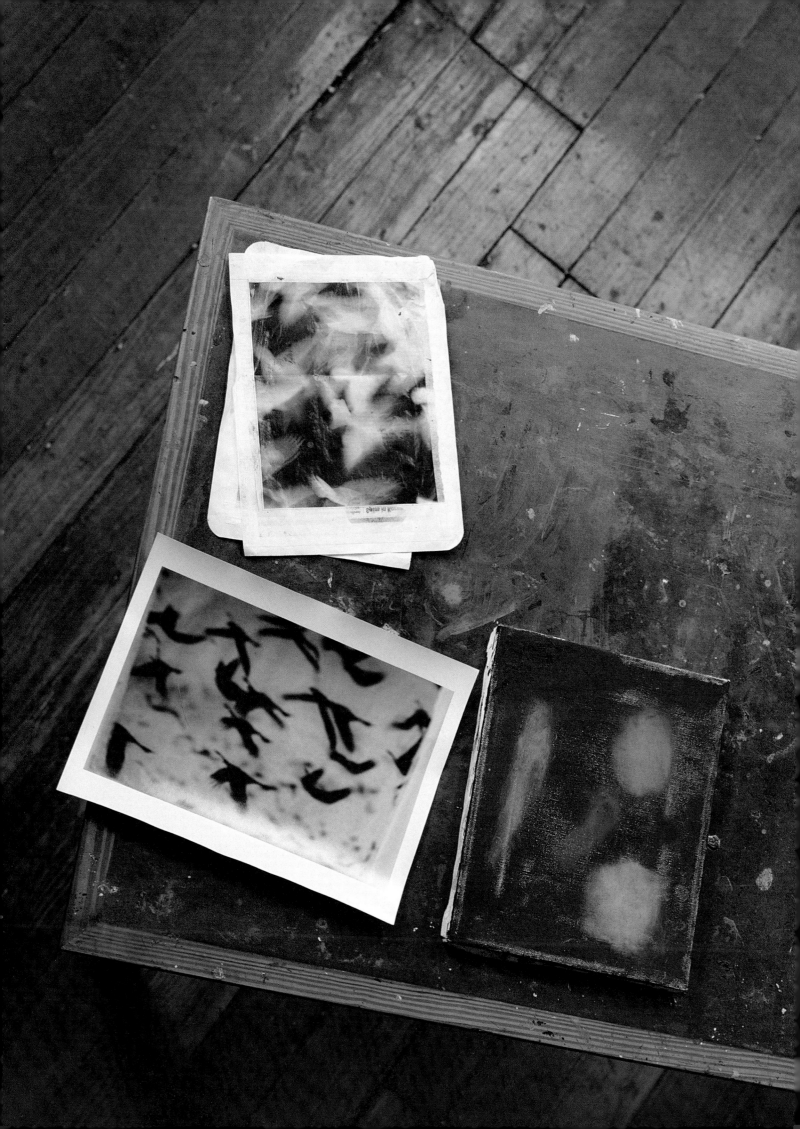

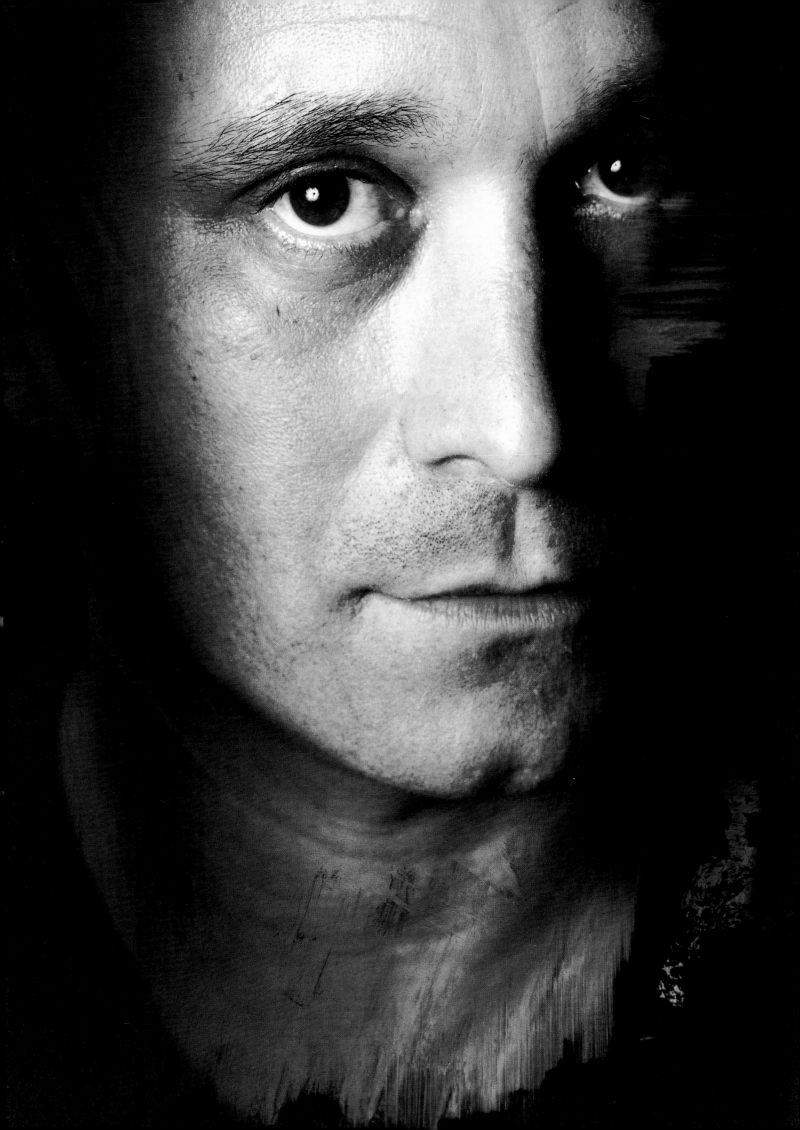

There is usually a profusion of canvases piled against the walls of this cavernous space, with its twenty-five-foot ceilings—paintings of birds, flowers, and molecules, things that evoke life. He now shares the space with his pet dachshunds, but at the time of the first shoot (there were others subsequently), his studio mascot was his dear old friend Renny, his constant companion of fifteen years. Bleckner divides his time between the city and the country, where he inhabits Truman Capote's old beach house. (The portrait of Ross behind the porch screen was done for *Harper's Bazaar* before the house was renovated.) In the stairwell of his city studio is a Jenny Holzer plaque which reads: PROTECT ME FROM WHAT I WANT. One day Ross and I took a trip together from Paris to Amsterdam to see the Malevich retrospective at the Stedelijk. When we got into the taxi at the Amsterdam airport, I said to the driver, "Do you know what else is going on in the museums in the city?" And the driver was familiar with every exhibition in every museum. I started to laugh and said to Ross, "Can you imagine the answer if you asked a cab driver in New York?" My favorite story is about his mother, Ruth, at the Guggenheim retrospective, introducing me to Sam Lefrak as we were standing outside the Lefrak Gallery of the museum. She stood on the edge of the parapet, looking out over the museum's wonderful rotunda, lifted her hands from the wall in a gesture of supplication, and said, "Look how gorgeous the paintings make the building look!".

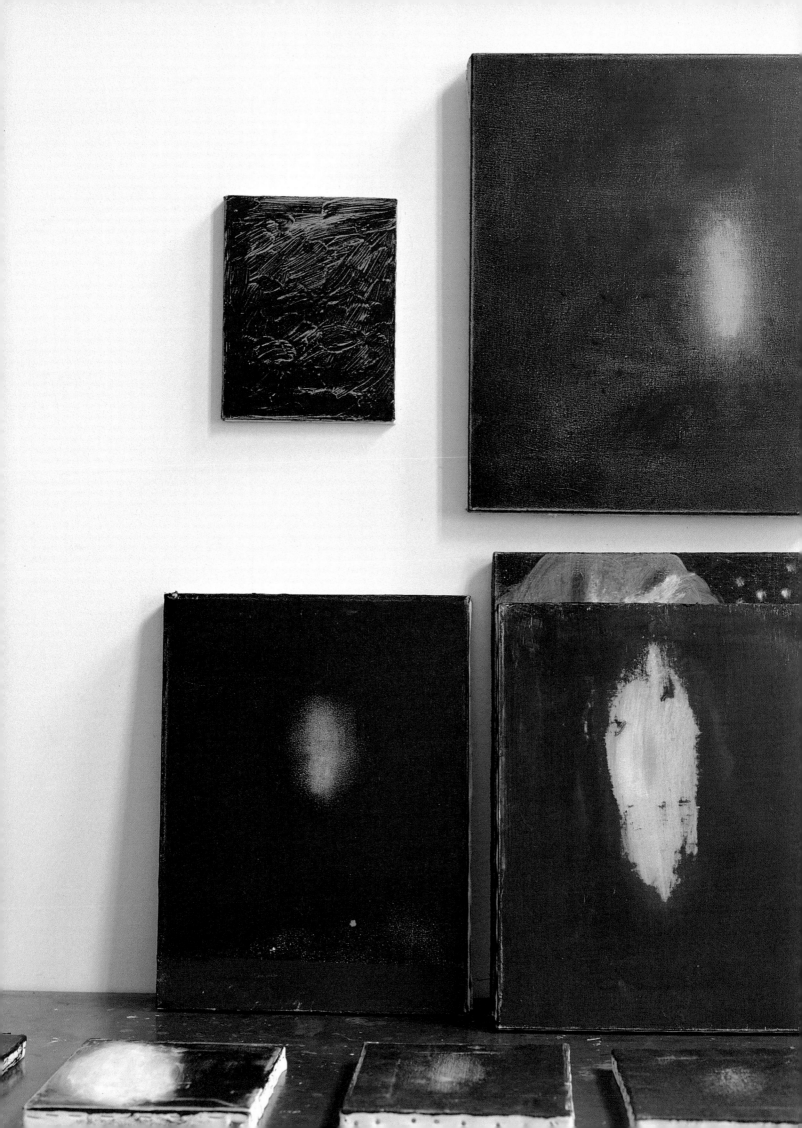

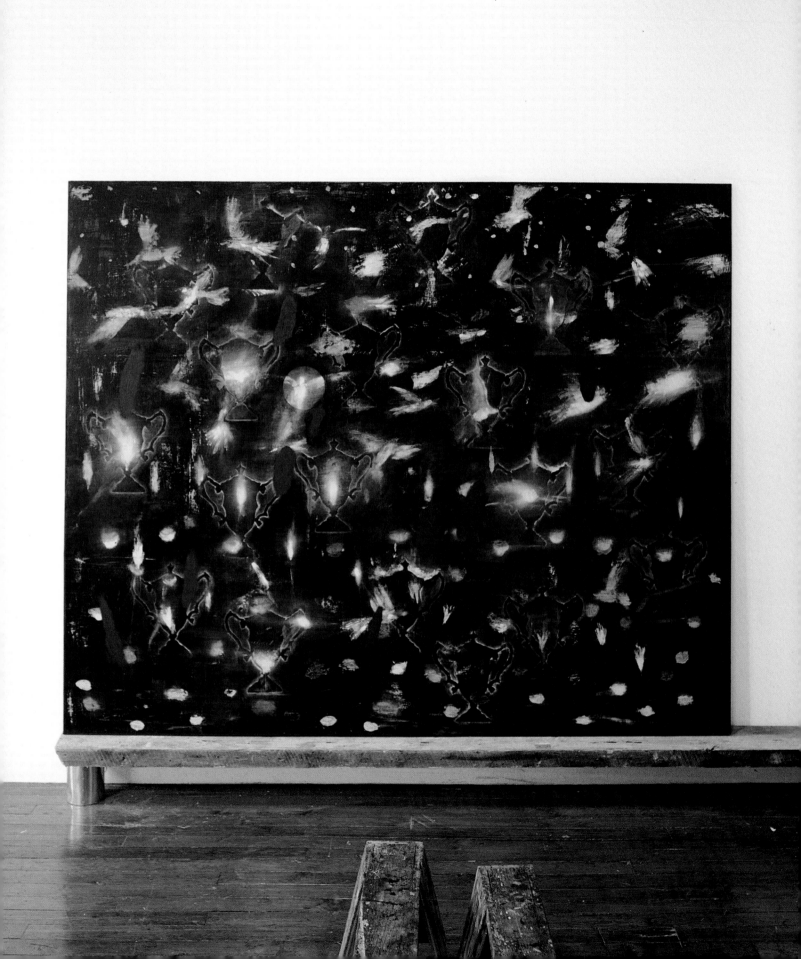

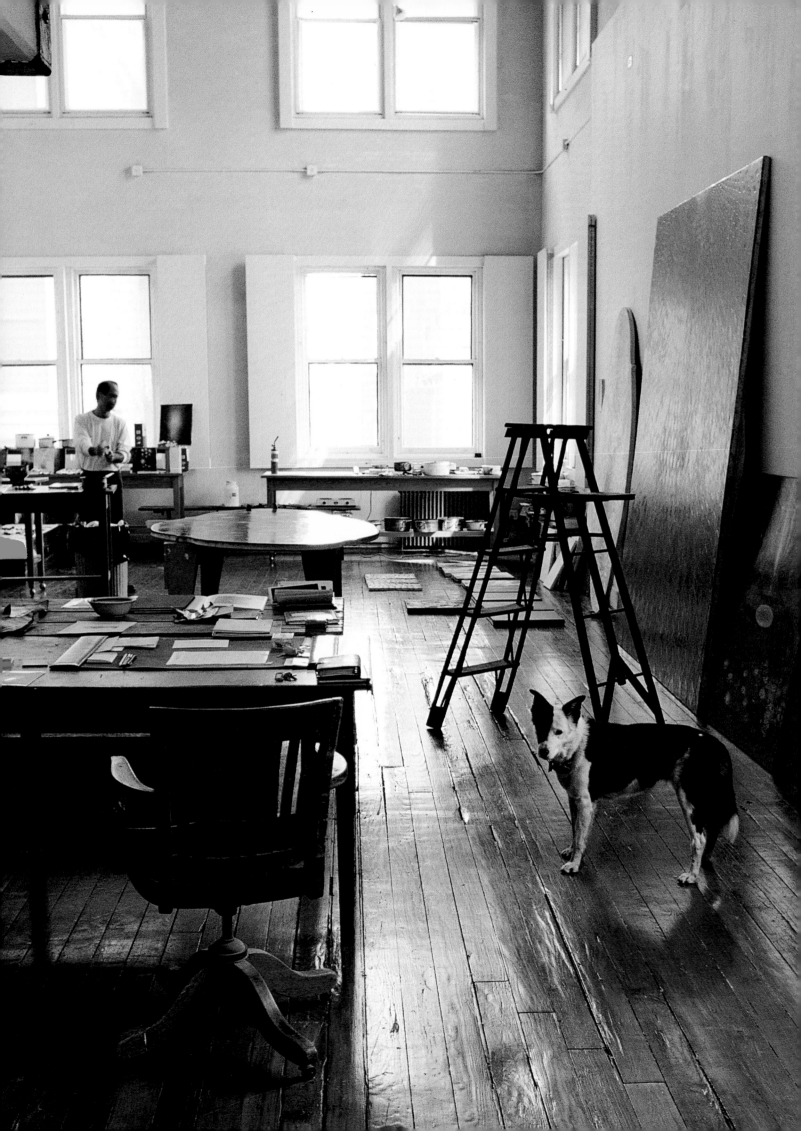

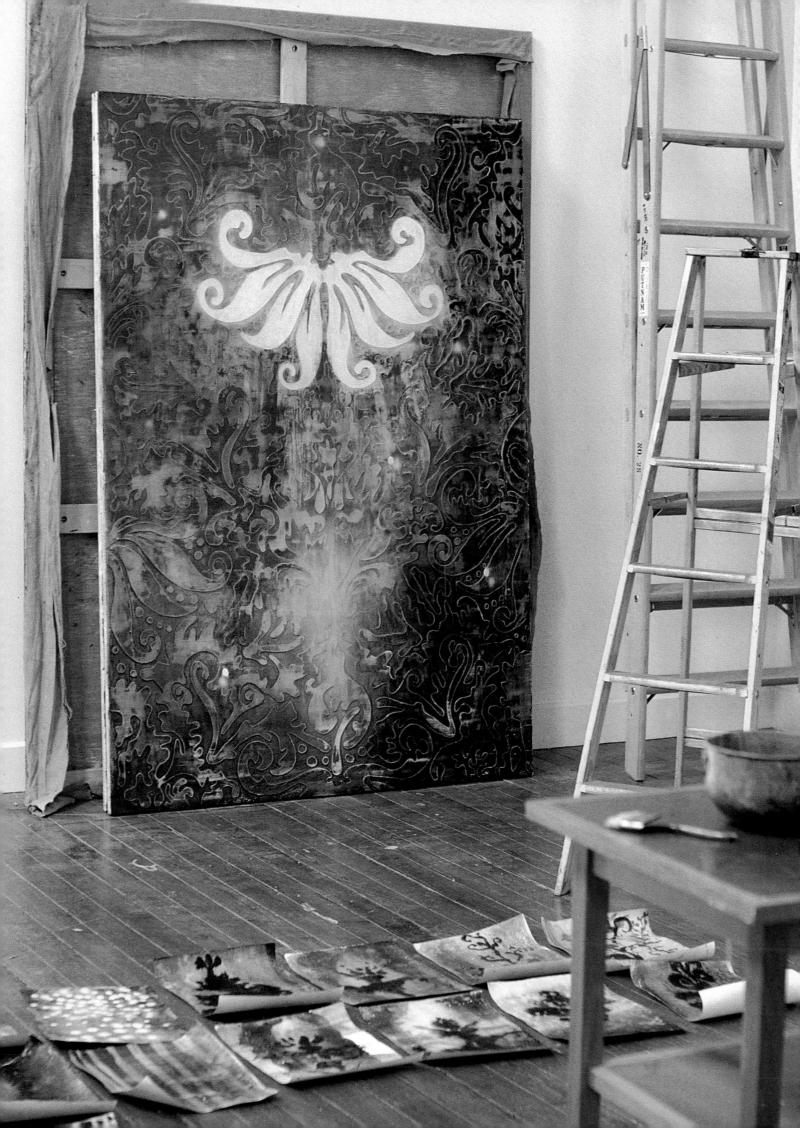

Christian Boltanski

Christian Boltanski's studio was in a converted factory complex called Malakoff, just outside Paris. He and his wife, artist Annette Messager, had studios at opposite ends of a simple loft. The impression in Christian's space was of someone just moving in, or out. There were boxes and old photographs piled up all over the place. Some of the rusted biscuit tins he used in his "Monument" series were poking out of the garbage just outside of the front door. I joked with Christian that one should always check an artist's refuse. He explained that he was about to close down the studio because most of his work was now involved with site-specific installations. In the living room, there was a taxidermy cat quiety reposed on a chair. Christian lovingly called it "Annette's cat." There were photographs of Frida Kahlo's interiors, lined with ex-votos. The studio debris in Christian's space spilled over into his library, up on a mezzanine. It was covered floor to ceiling with photographs of photographs. Boltanski posed with a pipe, looking like the portait of an artist from the 1920s. He often put his hand over his mouth—the artist who spoke no evil. Christian was born in Paris on Liberation Day in 1944 (his middle name is "Liberté"), and his first exhibition was on the day of the student riots in May 1968. He said he had reinvented his childhood so many times that he no longer knew truth from fiction. And then he said that also was not true. He disarmed his critics by calling himself a crook and a liar, like the television evangelists in America. He called himself a cadaver merchant and an alchemist, and he said the artist and the Jew were similar in that they were both chosen people.

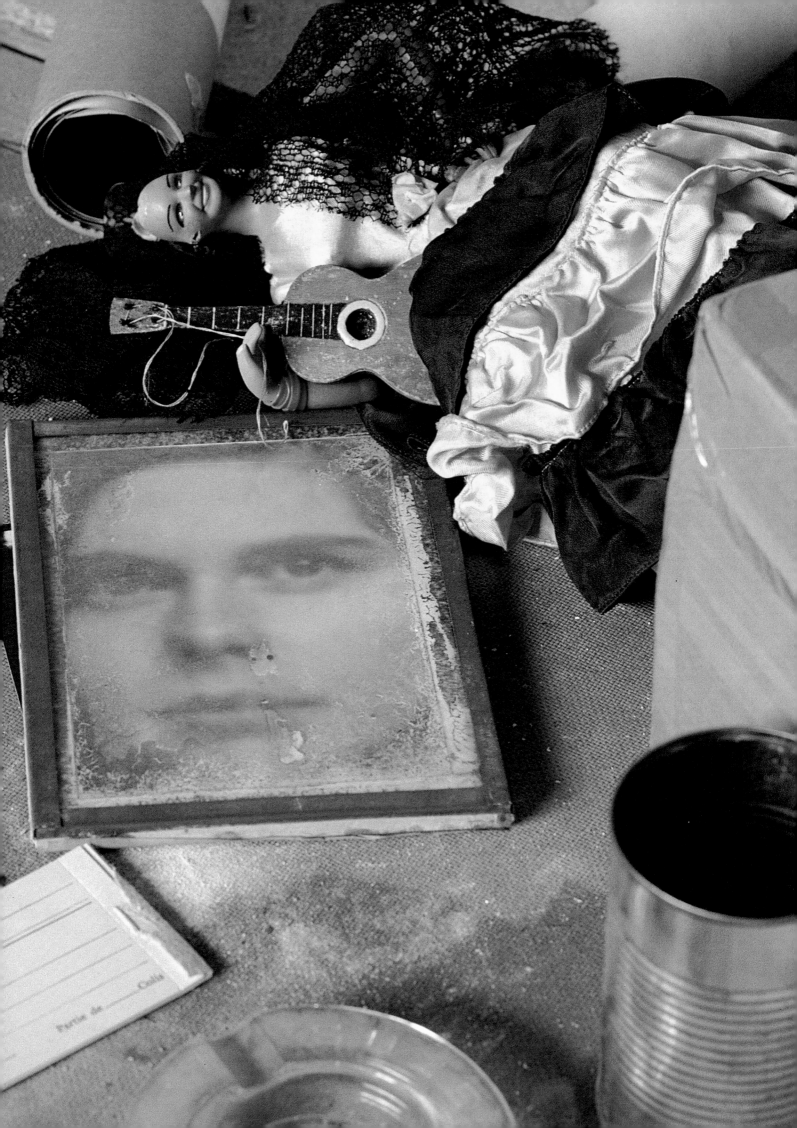

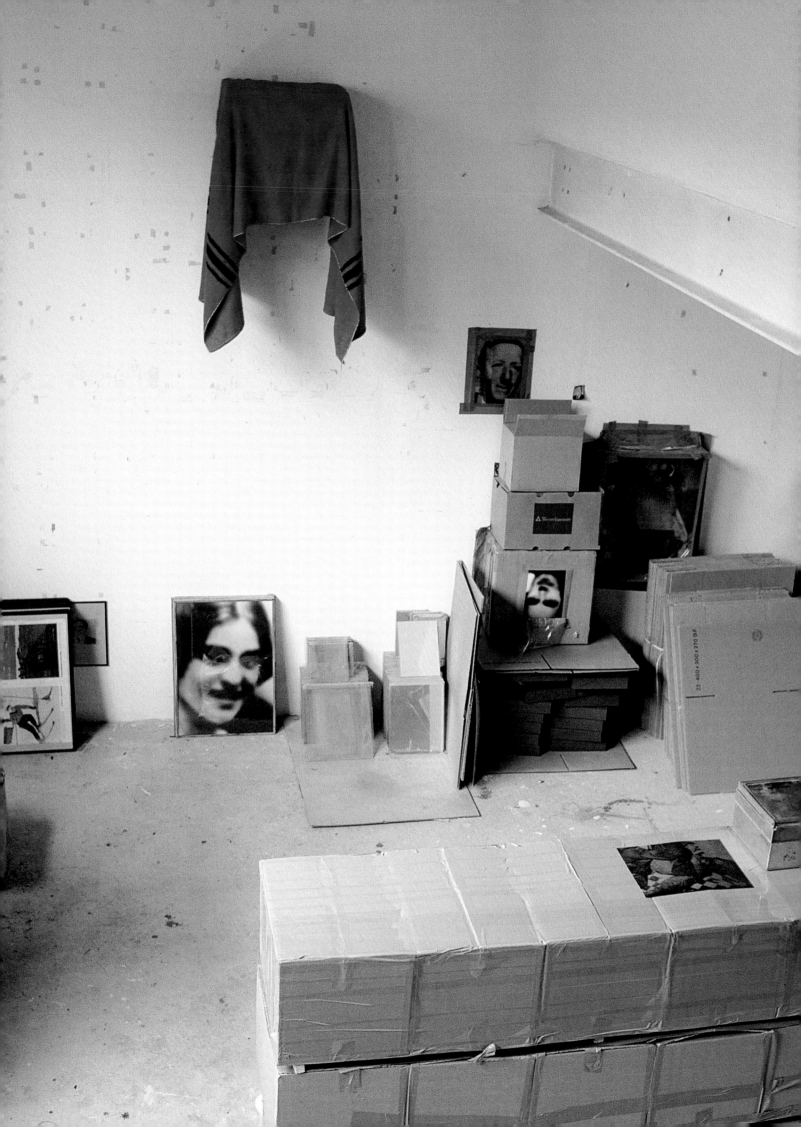

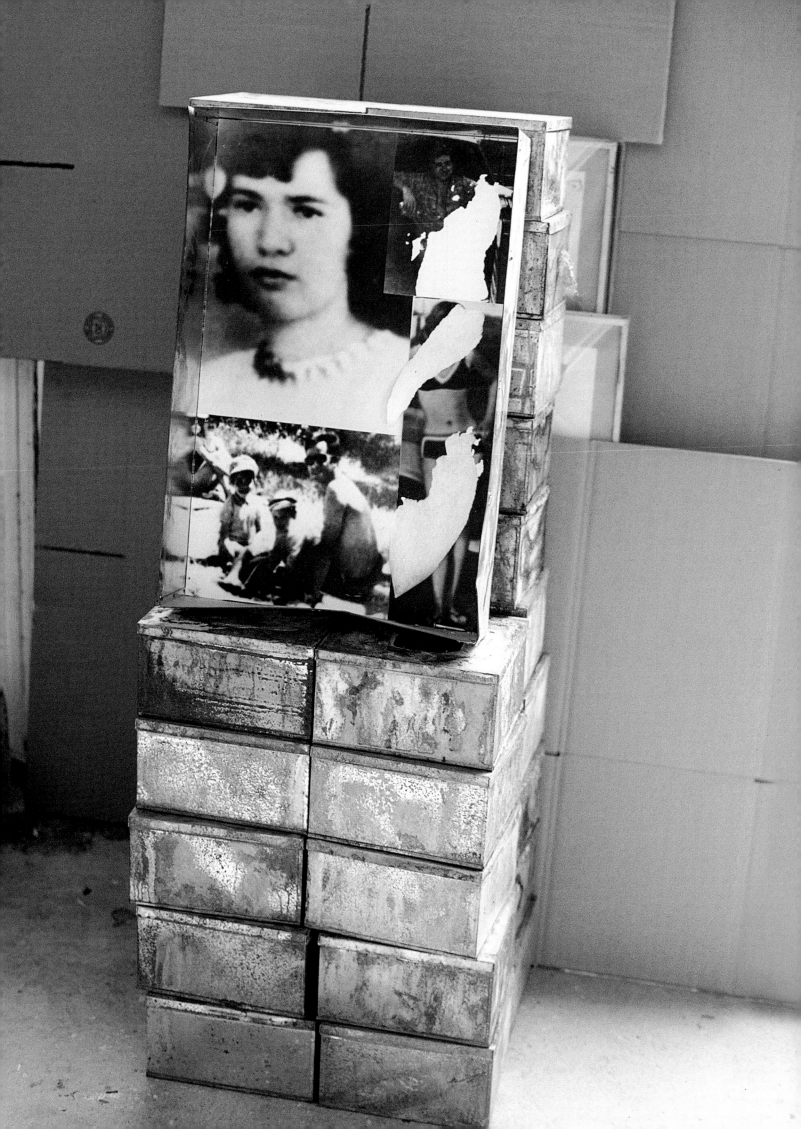

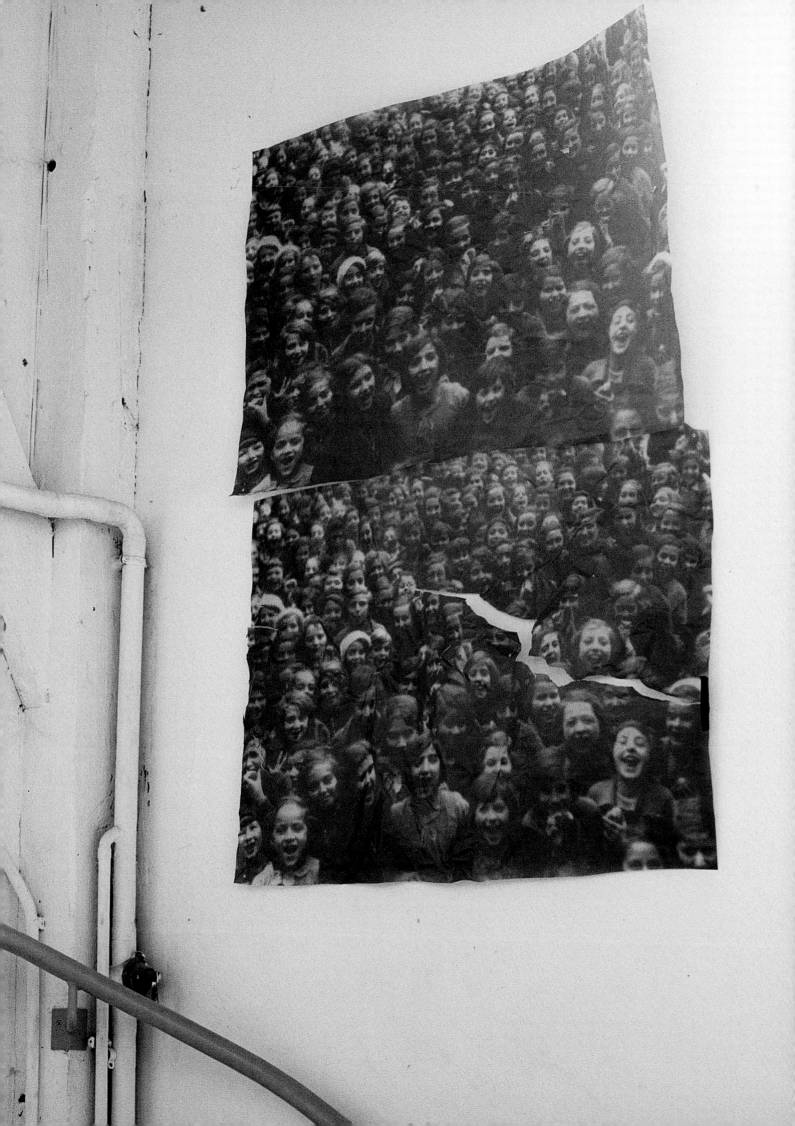

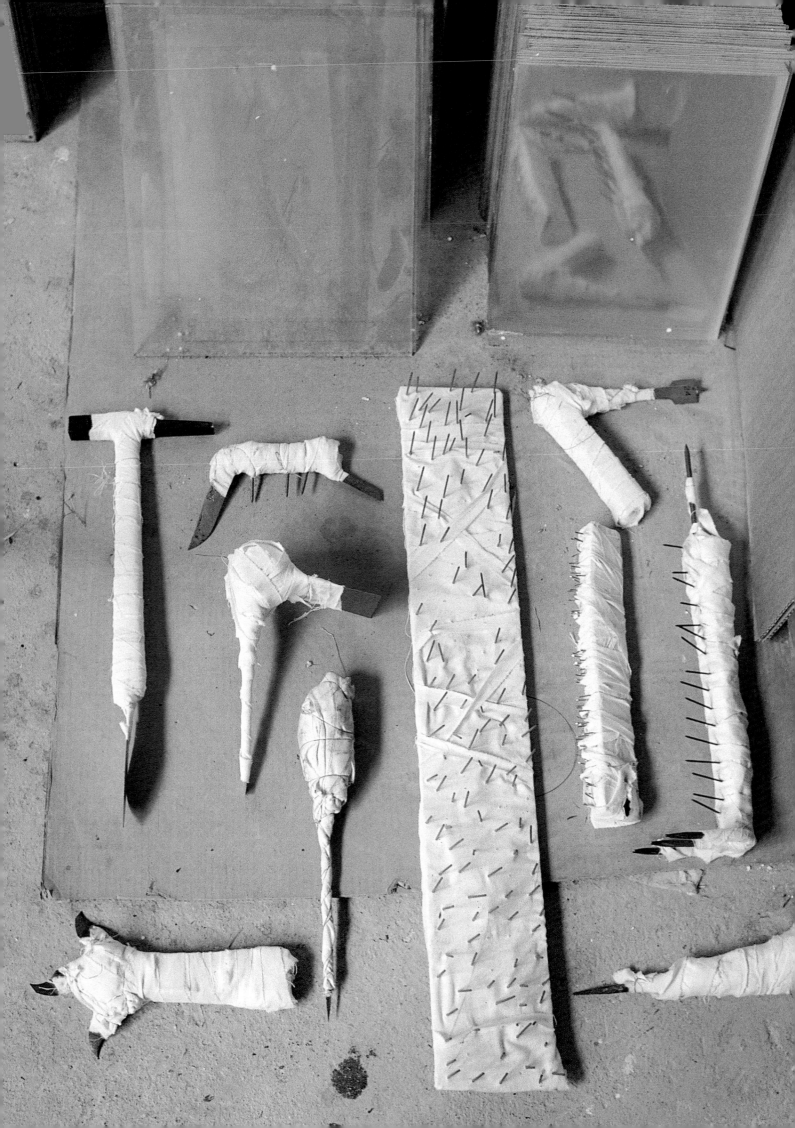

SANS SOUCI

Christian the prankster, bigger then life, made a lot of fun of himself. Perhaps that was the only way to deliver such a powerful, tragic message. He reminded me a lot of a Buddhist monk with his shaved head and continual laughter, his round posture and perpetually happy attitude, deflecting questions with other questions. He had a great gift for making you feel like you were his only confidant as he talked a blue streak. He said that there are really only three subjects in art—love, war, and death. He was full of these kinds of pearls of wisdom that one was tempted to quote endlessly. There are so many times in my life that connected me with Christian and Annette that I wouldn't quite know where to start—from his early exhibitions at the Centre Pompidou, to the projected shadows in Parisian galleries, to Annette's stuffed animals and installations in Paris and New York. There were friends in common, neighbors, family members—the web was vast and far-reaching. He's a wonderful man, incredibly colorful, and a very powerful artist.

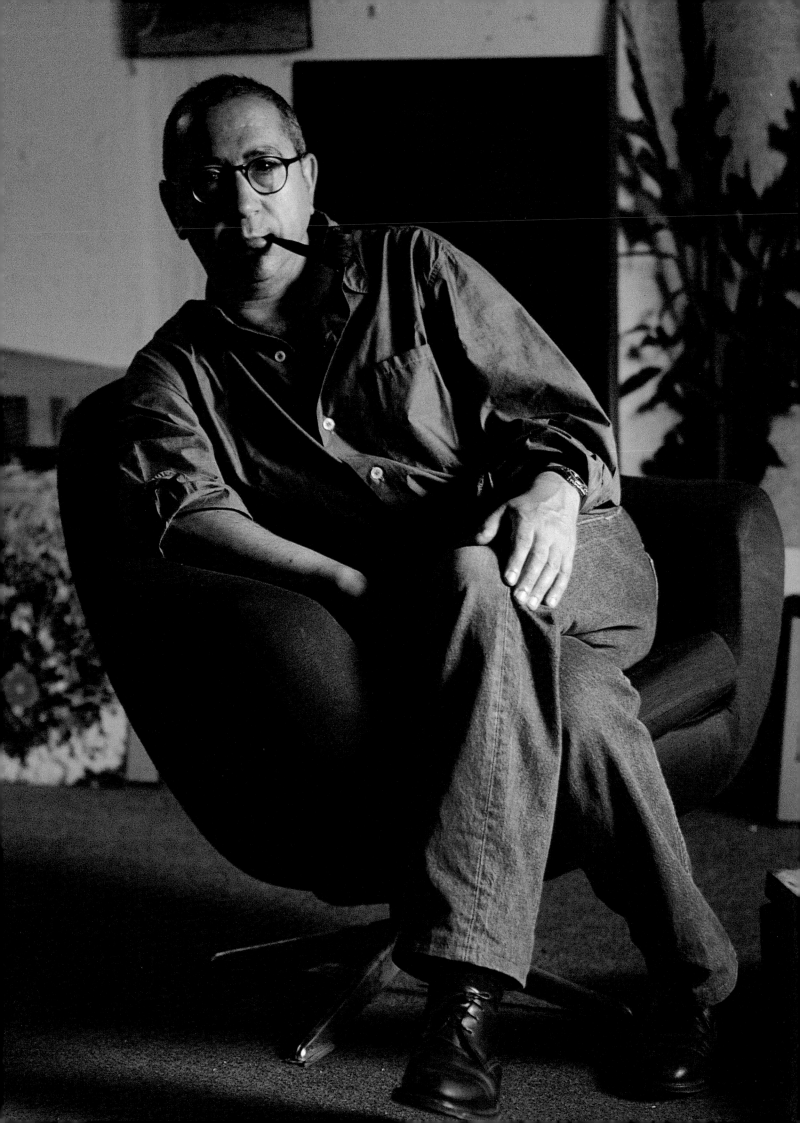

Louise Bourgeois

With all its contents, the studio that Louise Bourgeois occupies in Brooklyn is like a giant version of one of her installations. I entered a nondescript masonry building and was met by a bright white fluorescent-lit hallway—like an isolation chamber from the artist's space. Once inside, I encountered the old foreman's office from the loft's last life. There, Louise now keeps her own office and watches over what goes on in the antechamber through a window. She hides in that cubicle until she's ready to receive her visitors. A room off the main studio was bursting with decades of work. Rarely has the autobiographical manifestation of plastic form taken such a tangible human presence. There was a profusion of limbs, phallic tendrils, pistons, lumps, cylinders, and erections, in wood, plaster, marble, bronze, and latex—a dizzying maze of psychosexuality. When she emerged from her womblike office, Bourgeois was tentative, coquettish, impossible. She did not strike me as a Surrealist. Rather, she has her own reality, a stacatto stream of consciousness that goes in myriad directions at once. She seemed to speak in nonsequitors, so I stopped trying to anticipate any kind of logical conversation and simply deferred to her wishes. She was a bully until I seduced her by complimenting her work, talking about past museum shows and installations. Then, she became a docile little girl, smiling, almost blushing. I had been warned beforehand that she would want to take the film from the sitting, develop it, edit, and decide what would be the final print. So, to make sure I left with a portrait, I instructed my assistant to put a mason jar full of water in the trash bag in which we would put the Polaroid negative.

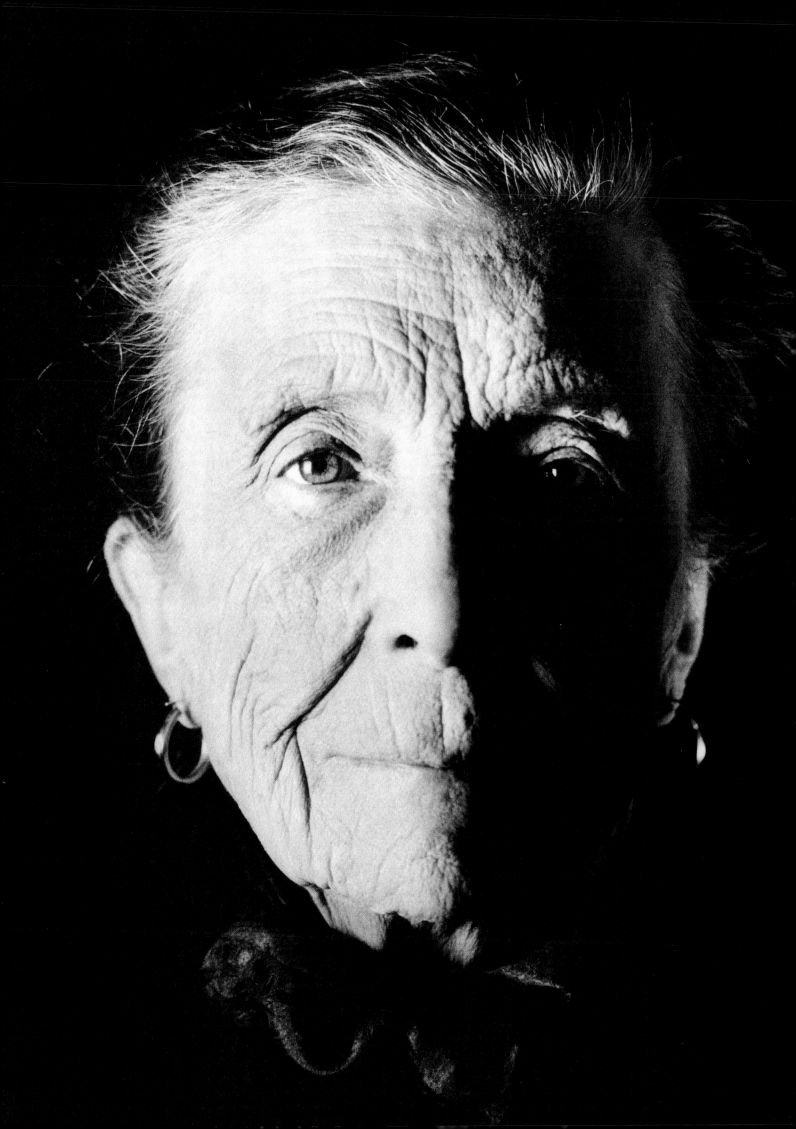

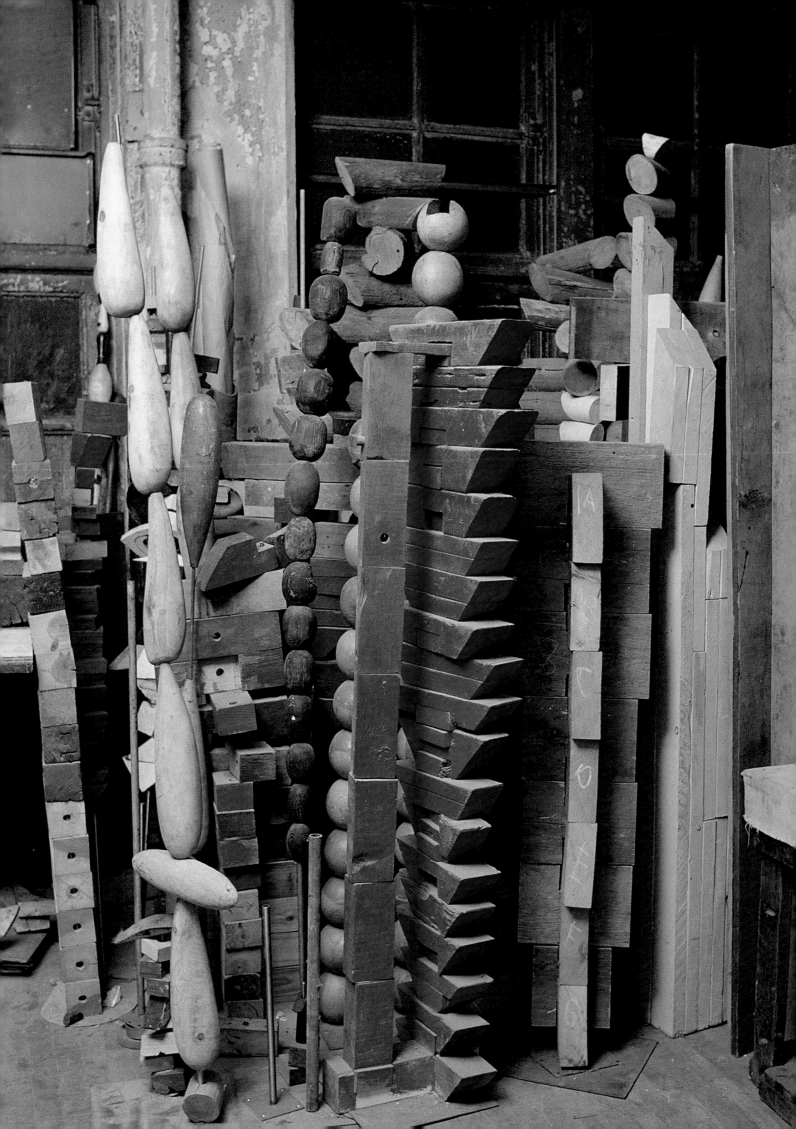

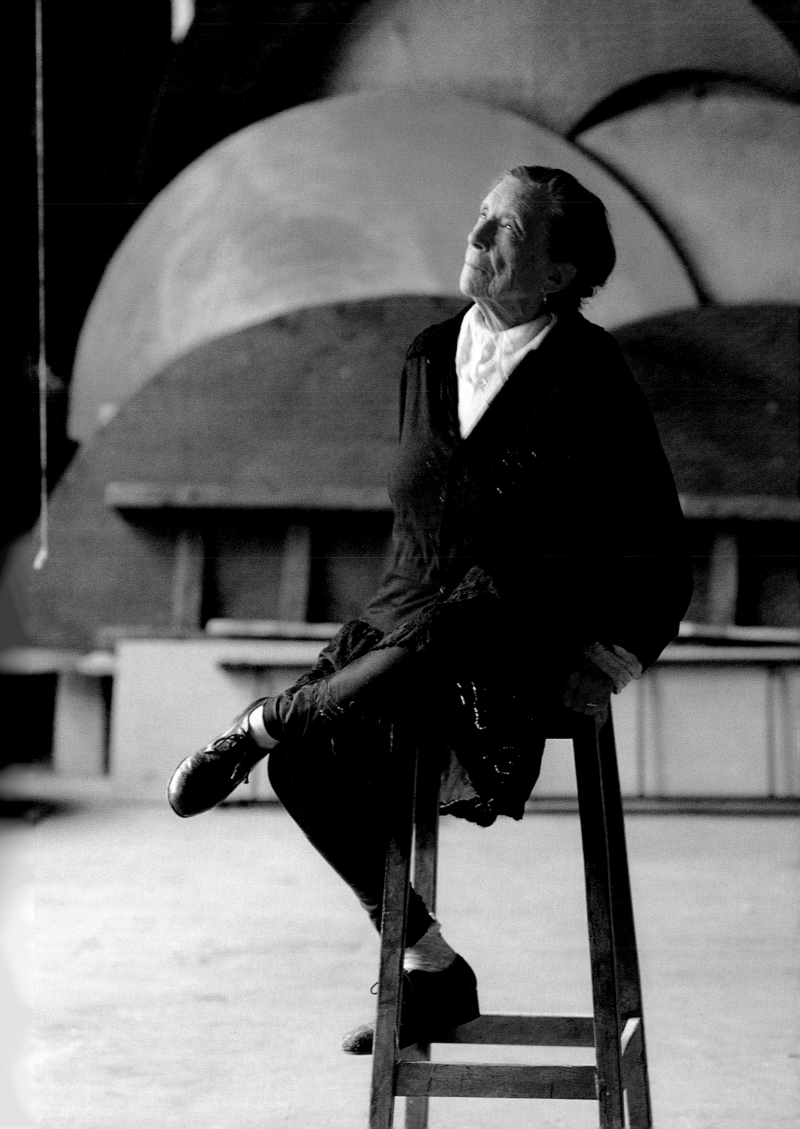

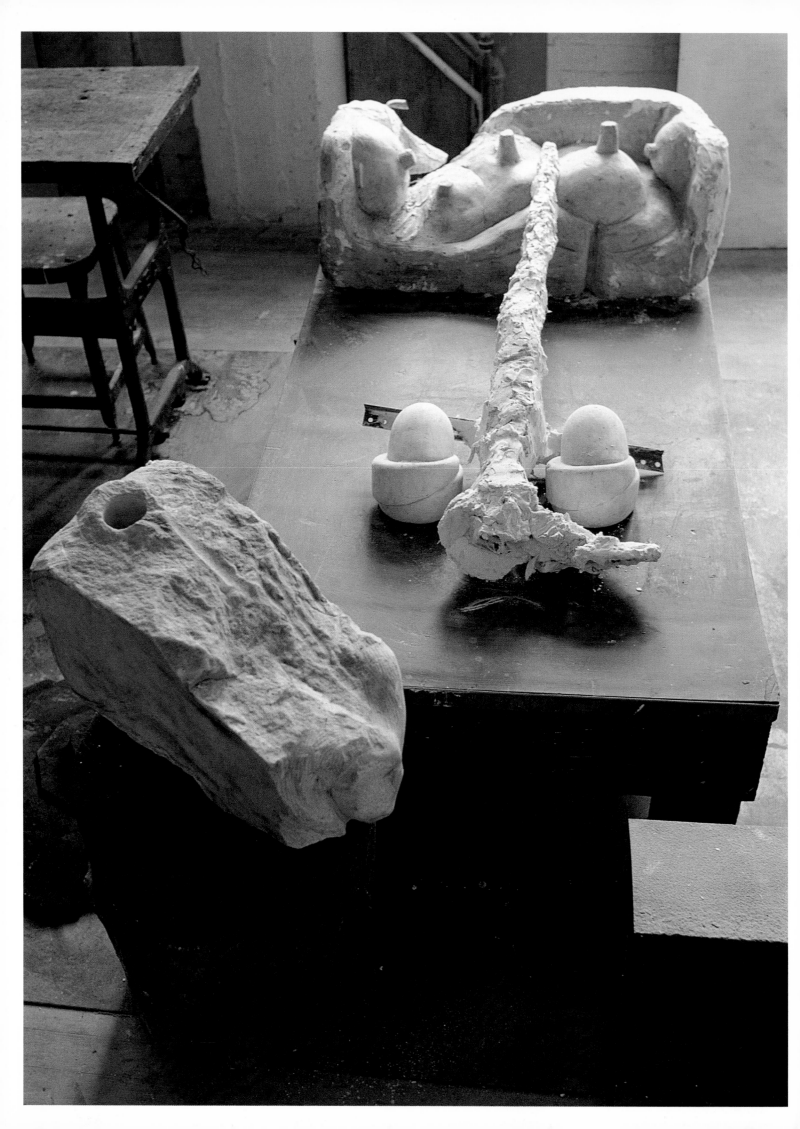

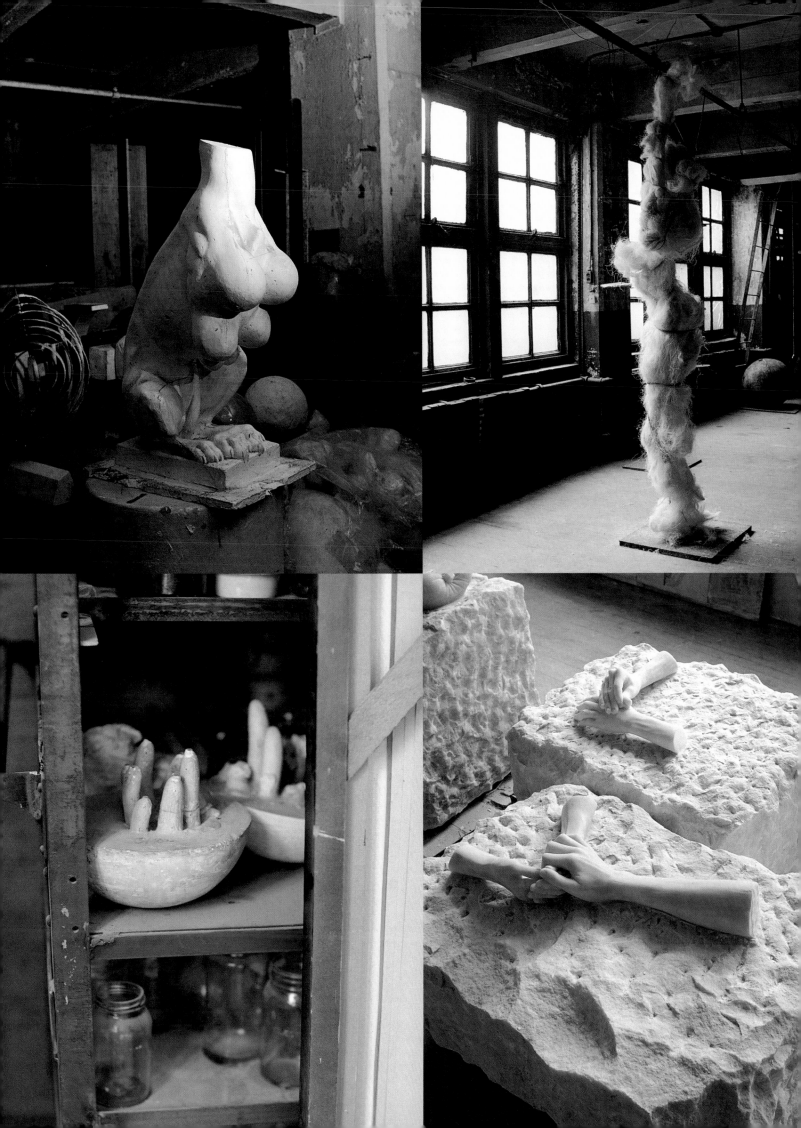

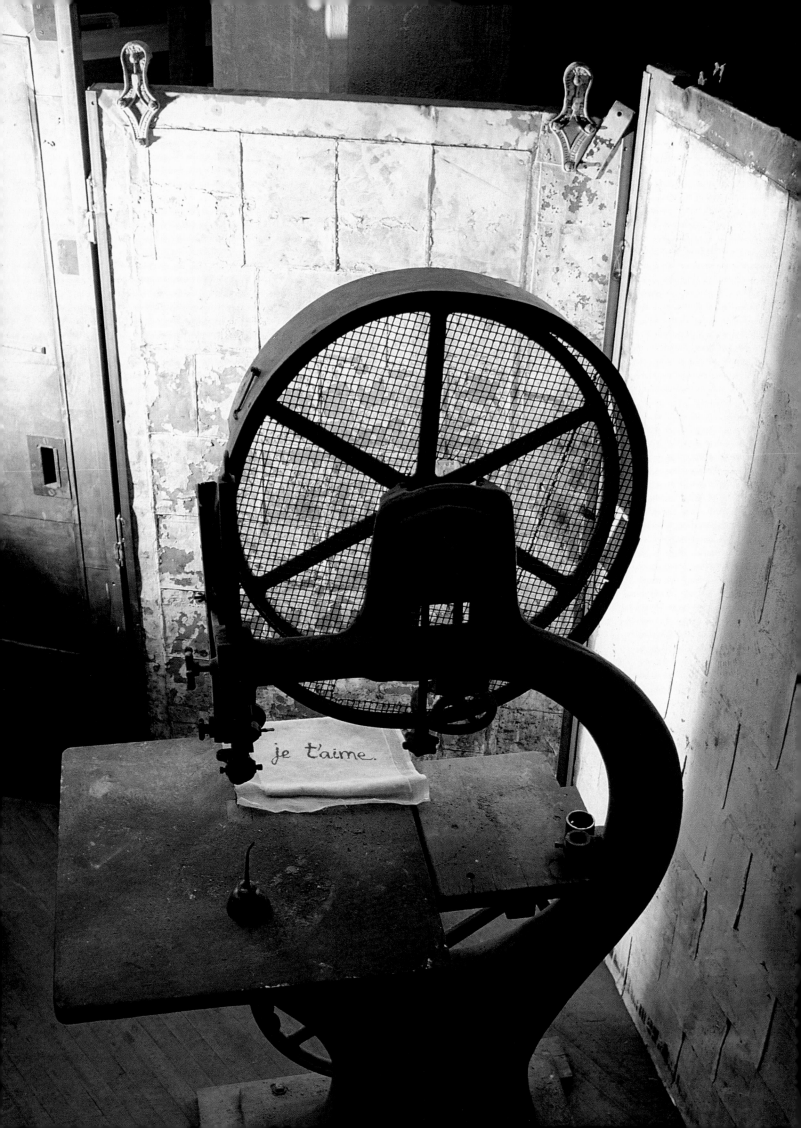

She saw the Polaroid and loved it, and began rearranging her collar, hair, and scarf. I only mention this because the woman seemed to have a total absence of vanity, but in true French fashion, was very concerned with the way she looked. I had been trying to photograph Louise for three years. When I originally called about doing her portrait for *Beaux Arts* magazine, I sent over a copy of a book of fragmented fashion photographs. She said, "The way you cut up women is phenomenally cruel and I will never subject myself to that!" And she hung up on me. Finally, through her alter-ego, my friend Jerry Gorovoy, who rediscovered Louise in the early 1980s and has become the lion at her gate, I was coached and prepared, and I passed the initiation rite smoothly. For the interview, I submitted all the questions beforehand. Certain words, like "totem" were taboo. The strawlike column in the photograph she actually made for this sitting. At eighty-two years of age, she pulled out all that packing material and wrapped twine around it to create a column. Her energy was daunting. I loved spending time with her in Brooklyn, and in her modest townhouse in West Chelsea where she seemed to have been forever. In the studio, she told me that her favorite place was the empty fluorescent-lit space in the hallway. To see her crouching in that bright white corner, tiny, dressed in black, is a memory I'll hold onto forever. In the townhouse, she took me down into the basement where the floor underfoot was paved with smooth round stones, like a rocky promontory. She said this was her favorite part of the house. Given to philosophizing and proclamations, she told me that her favorite bedtime reading was *Le Concept de l'Angoisse* by Søren Kierkegaard. Her answers to questions at first seemed convoluted, but on closer inspection, revealed a razor sharp clarity. The answers turned and came back around on themselves, so that the answer and the question both became Bourgeois' own doing. That seemed to me a fitting metaphor.

John Cage

The large loft on West 18th Street that John Cage shared with Merce Cunningham was a simple, sunny, skylit living-working studio. It was divided into a sleeping area, a working space with a desk right off the kitchen (which was the center of John's universe since he and Merce were strict macrobiotics), and an area for playing chess that was literally overgrown with plants. There was a long row of south-facing windows and a large central skylight. There was a cat in the loft that he and Merce named "Rimpoche Taxicab." They amused themselves by putting a cardboard box over Rimpoche the cat and watching it move through the loft inside of the box, becoming "Rimpoche Taxicab." Everything was fun with John Cage—he was extremely serious without ever taking himself seriously. In his twilight years, John was preserving his early work and making new work, drawings of smoke and river-rocks and new compositions; receiving friends and pilgrims; and always cooking. This was probably John's last portrait. The chess board is one that he played at with Duchamp; the tool box photographed with all the little screws and nuts and bolts was from his first prepared piano piece of 1938. It was a magical day for me: the guru and his disciple. I said to him: "You know John, reading your book *Silence* at eighteen had a profound effect on me. And your encouragement over the years has meant more to me than you can imagine." Without hesitation, he answered in his even, high-pitched voice, "Yes, many people tell me that." And we both laughed. John laughed a lot. He was goodness and generosity personified.

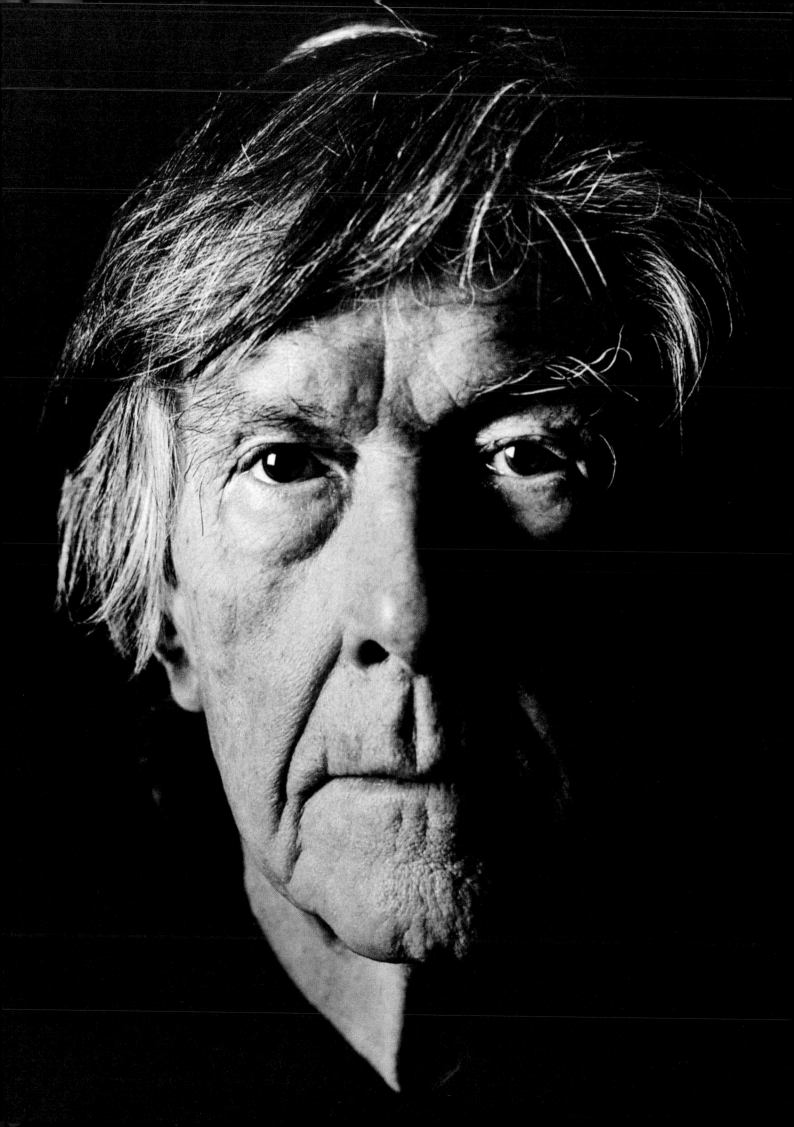

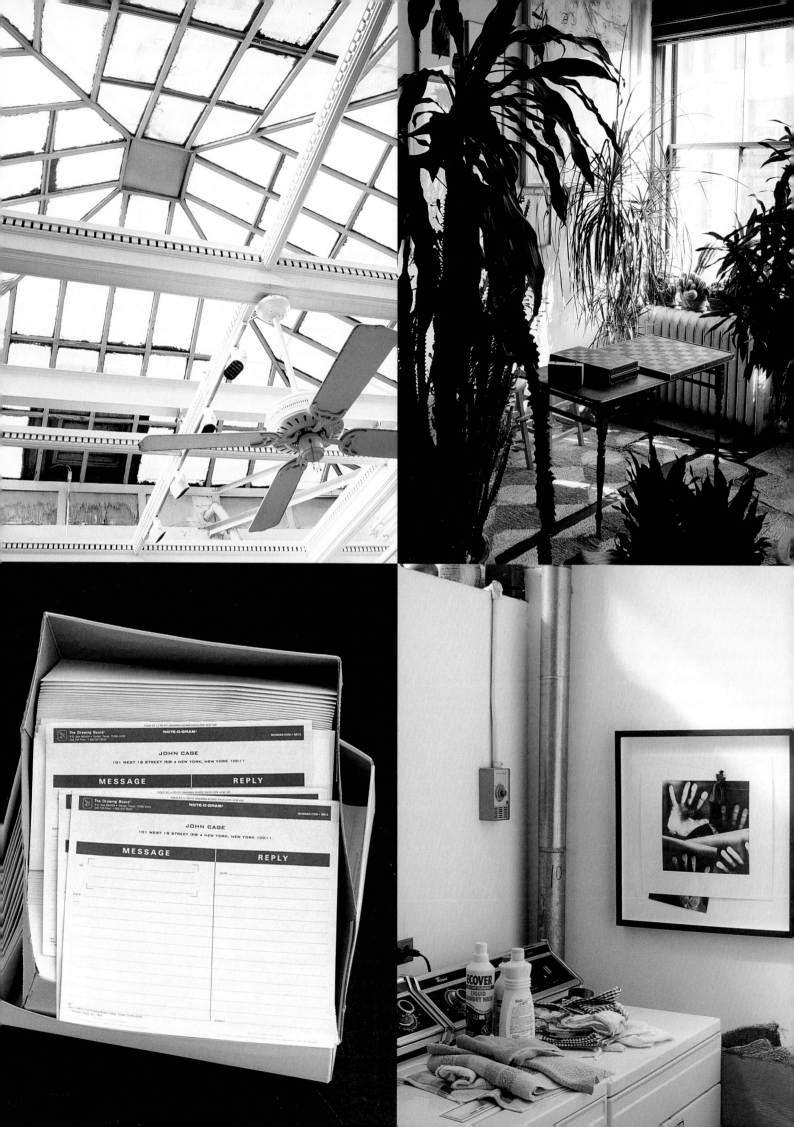

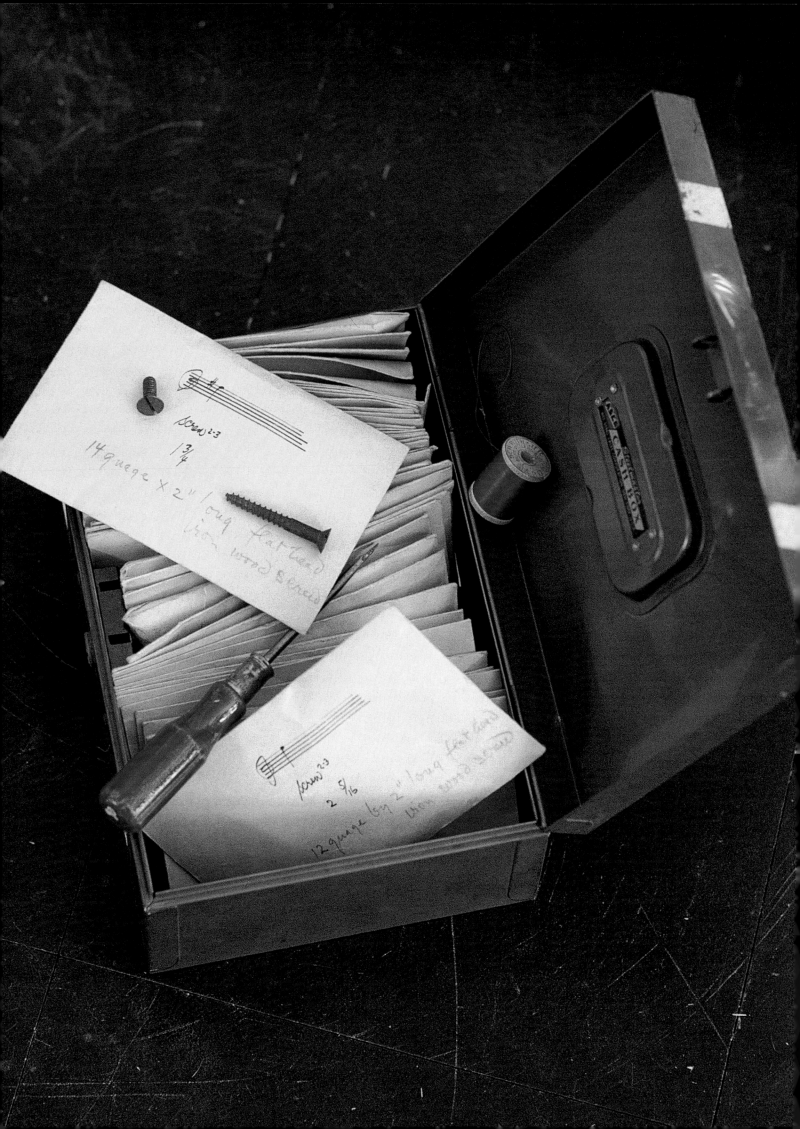

He wasted nothing. Everything was grist for his extraordinary mill and he was appreciative of everything. He took nothing for granted. He talked about how fortunate he and Merce were to have the space, how much he appreciated any kind of recognition. He was gentle, serious, hard-working, brilliant. He was also endlessly quotable: "Avant-garde is a consumptional necessity as we've used up all the rest," and "Anything can be art, all you have to do is change your mind."

31

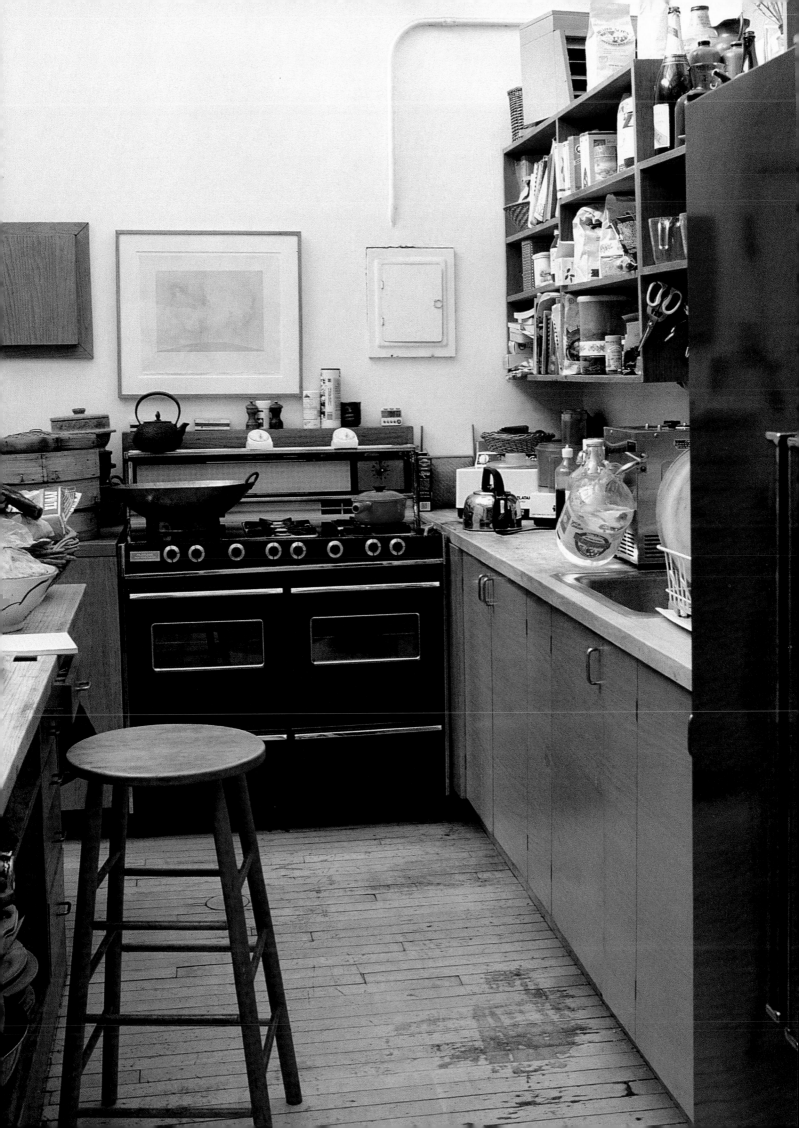

Chuck Close

Chuck Close's studio in lower Manhattan is a storefront. Like the man, it is an inspiration. The first impression is of bright whiteness. A large, opaque plate-glass window illuminates the front office space, which opens onto a larger all-white studio with the painting area at the back of the room under a skylight. I had always been a big fan of his work, and was very flattered when he said he liked my portraits. To see Chuck working with the braces fashioned to hold his brushes is a lesson in humility. The ground floor painting area is designed so that the canvas can be lowered incrementally into the basement and turned to every angle so that Chuck can always work from wheelchair height. Next to the portrait in progress was an eight-by-ten-inch color Polaroid, divided into a grid. From this, Chuck was painting the squiggle and lozenge shapes that comprised the likeness of his subject. Chuck is always extremely accessible, open, encouraging, and generous. His involvement with other artists and the artworld is total and complete. Chuck in his wheelchair is a familiar sight in galleries and museums around town. His accident in no way lowered the bar for the high standard of work that he has continued to produce. Never one to complain, he does more with half a body than five people put together. He remains true to my own parable for existence: adversity can be a great motivator. Never give up hope. Remain productive. He has used this portrait on several occasions, for catalogues and award ceremonies. I once said to him: "Oh, you like it, Chuck, because it looks most like your work." And he answered, "No, I like it because it looks least like my work."

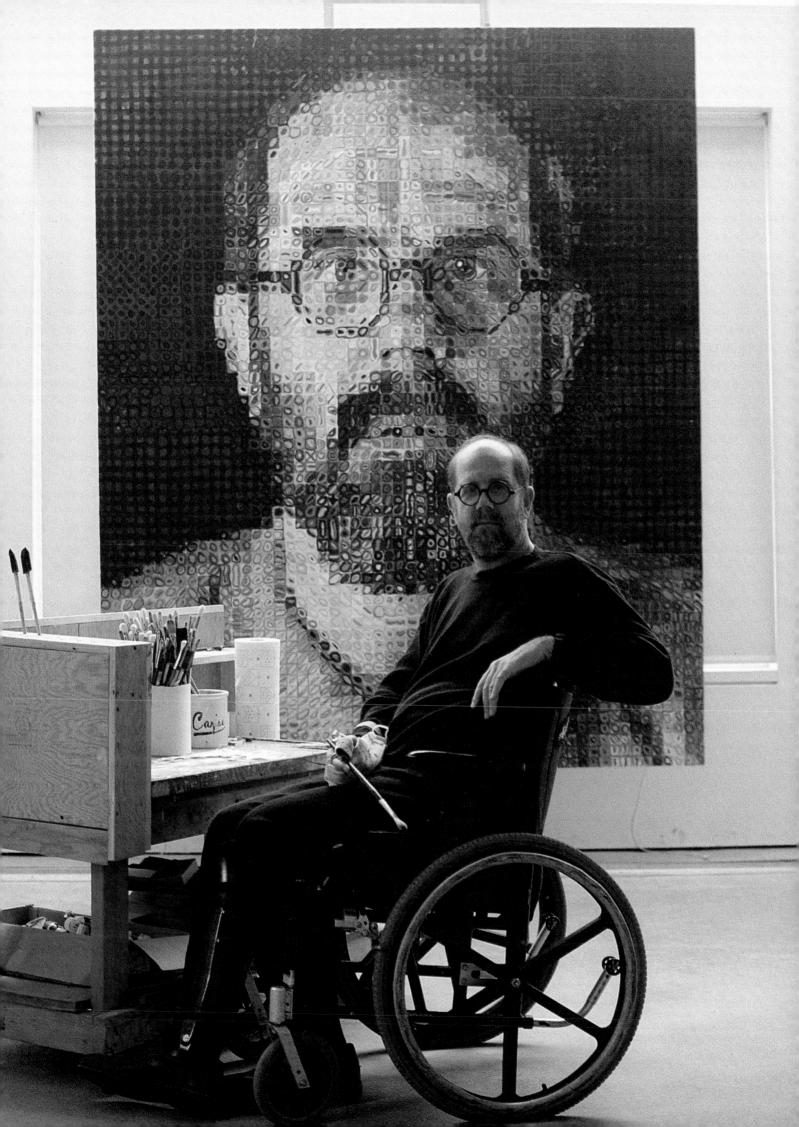

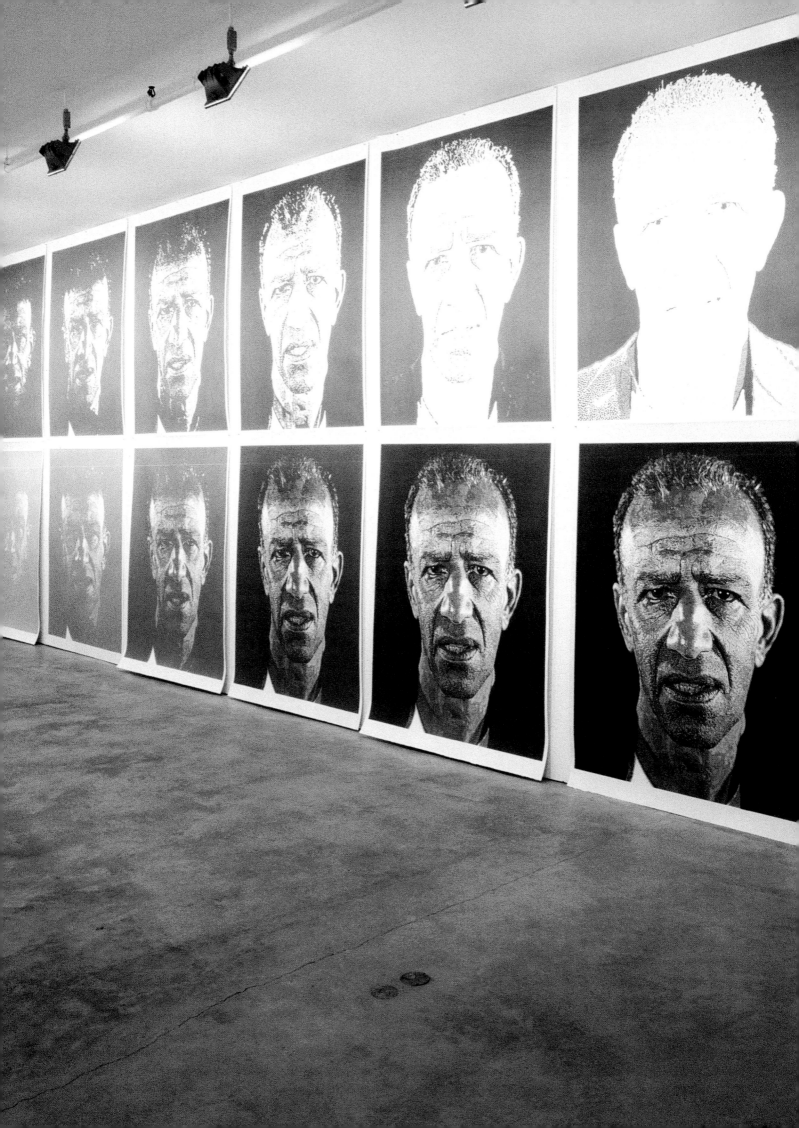

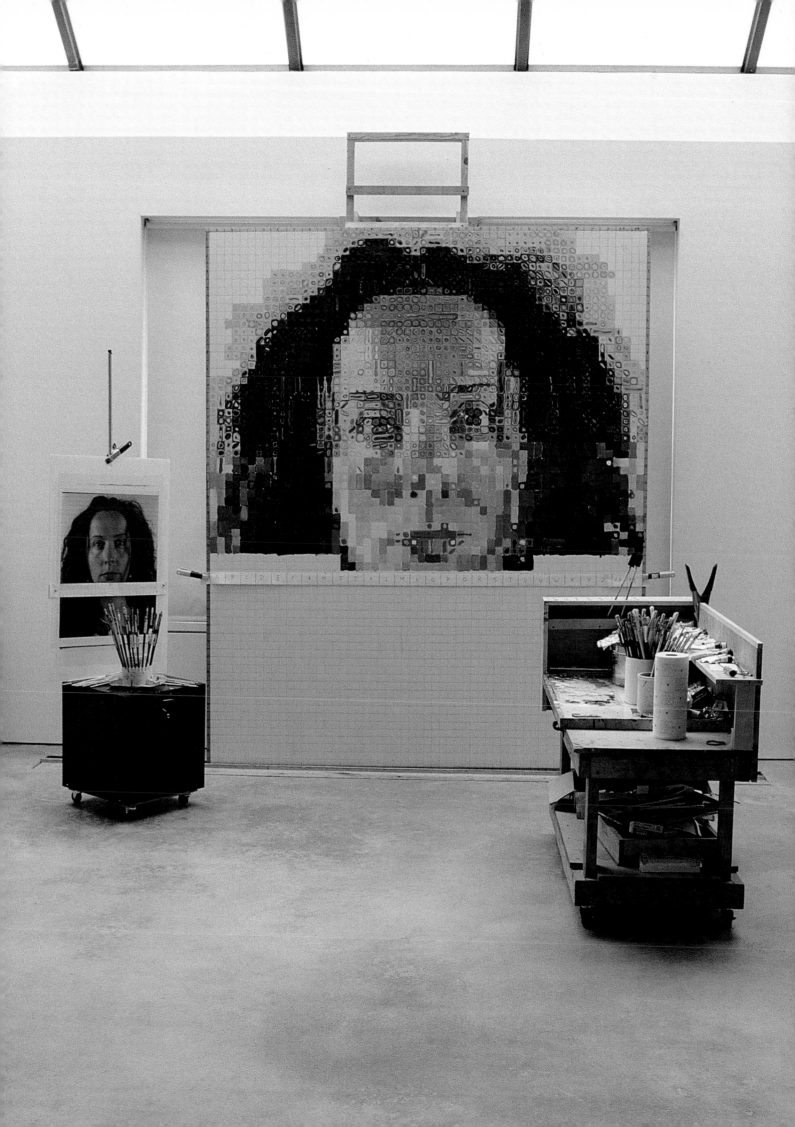

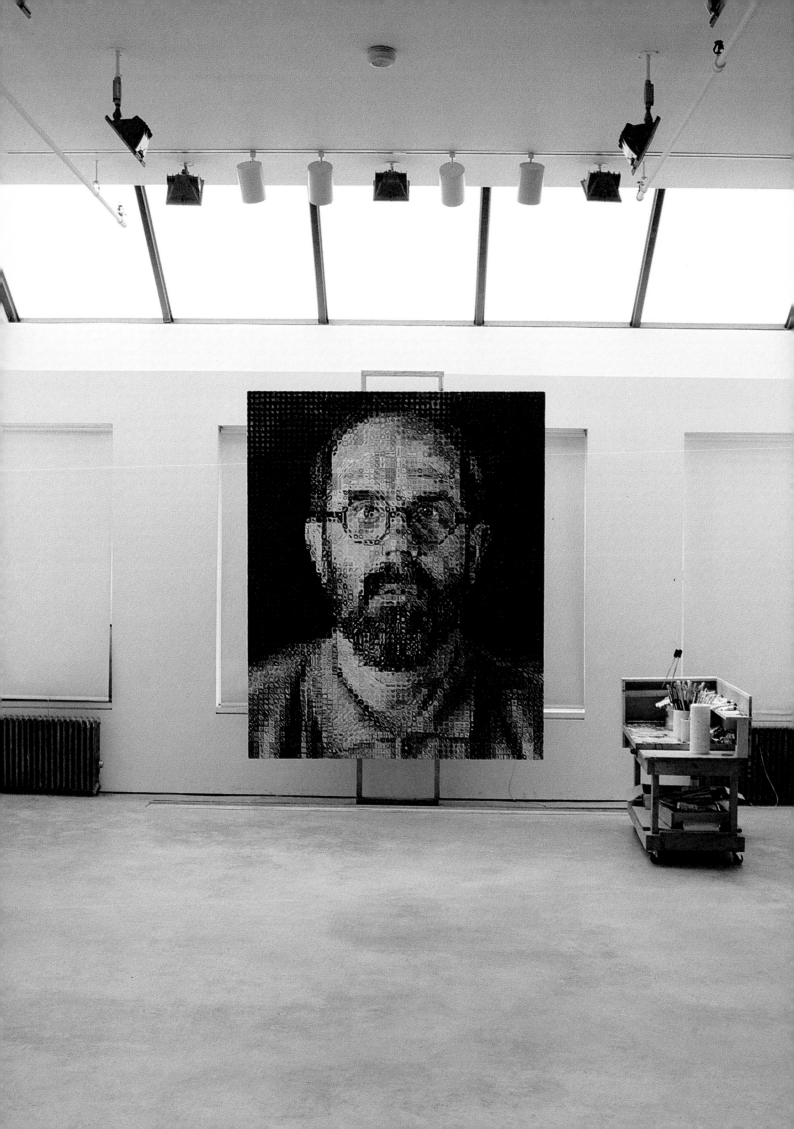

Roy Lichtenstein

Once an ironworks and electrical factory, Roy Lichtenstein's studio in the heart of New York's meat market was gargantuan in size and scale: sixty by eighty feet with soaring ceilings and skylights. He worked the way a broker might go to the stock exchange or a laborer to the factory: he got up everyday and painted. According to Roy, his life was uneventful, even bland. Yet, he thought of himself as the happiest man on earth. The most unusual thing he did was to jog around the inside of his studio. He had a place in the Hamptons, too, and shared both with his second wife Dorothy, a beautiful, chic, impeccable brunette who was the reigning beauty of the artworld when he married her in 1968. Our mutual friend Frederic Tuten introduced us when I was working on a series of artist's portraits and Roy's became the cover of the book. Above the studio was a living area in which he had hung an impressive art collection: Ellsworth Kelly, Twombly, Rosenquist, Brancusi, Picasso, Matisse, and more. Lichtenstein's rendition of the famous Oskar Schlemmer painting of the Bauhaus stairway, which hung for years in the stairway of the Museum of Modern Art, was here wittily hung in the artist's own stairwell. Mercurial, seeming not even to touch the ground as he walked, Lichtenstein had the quality of a wizard, a magic painter, a weird combination of Oberon and Puck in *A Midsummer Night's Dream*; the king of the fairies and prankster rolled into one. The working process, however, was more mechanized than magical, done clinically and methodically almost removing the subject from the composition.

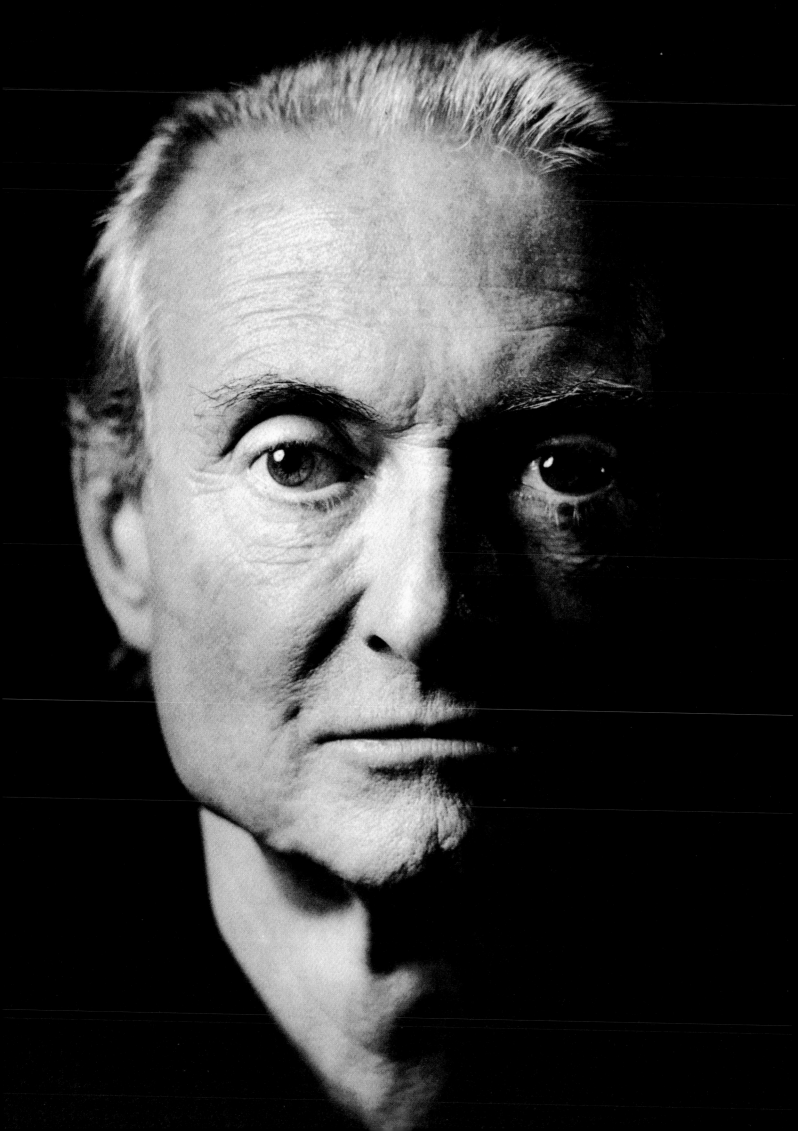

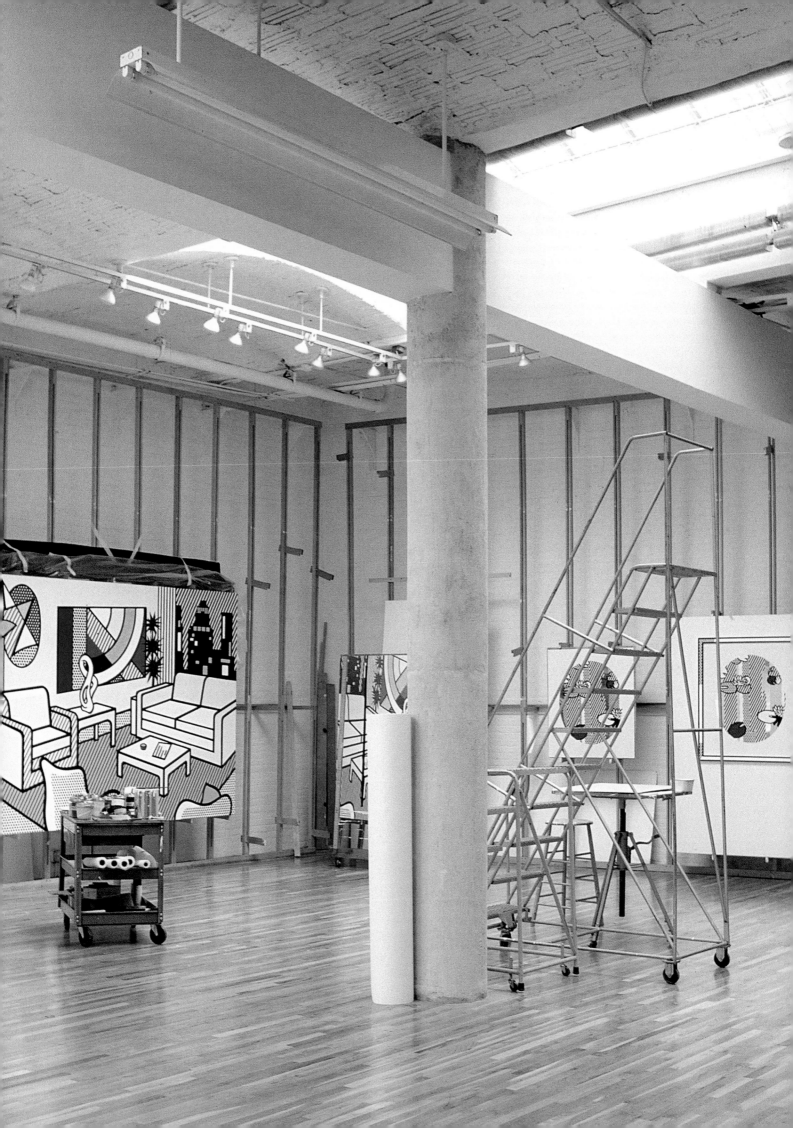

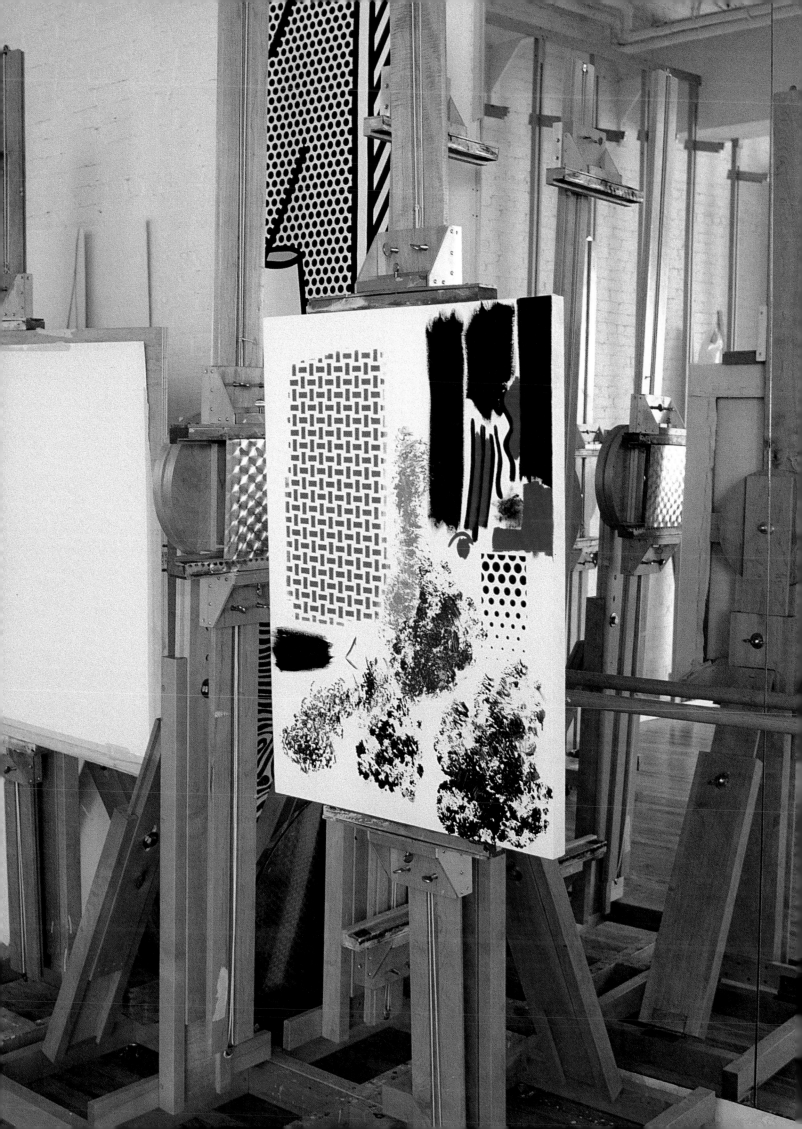

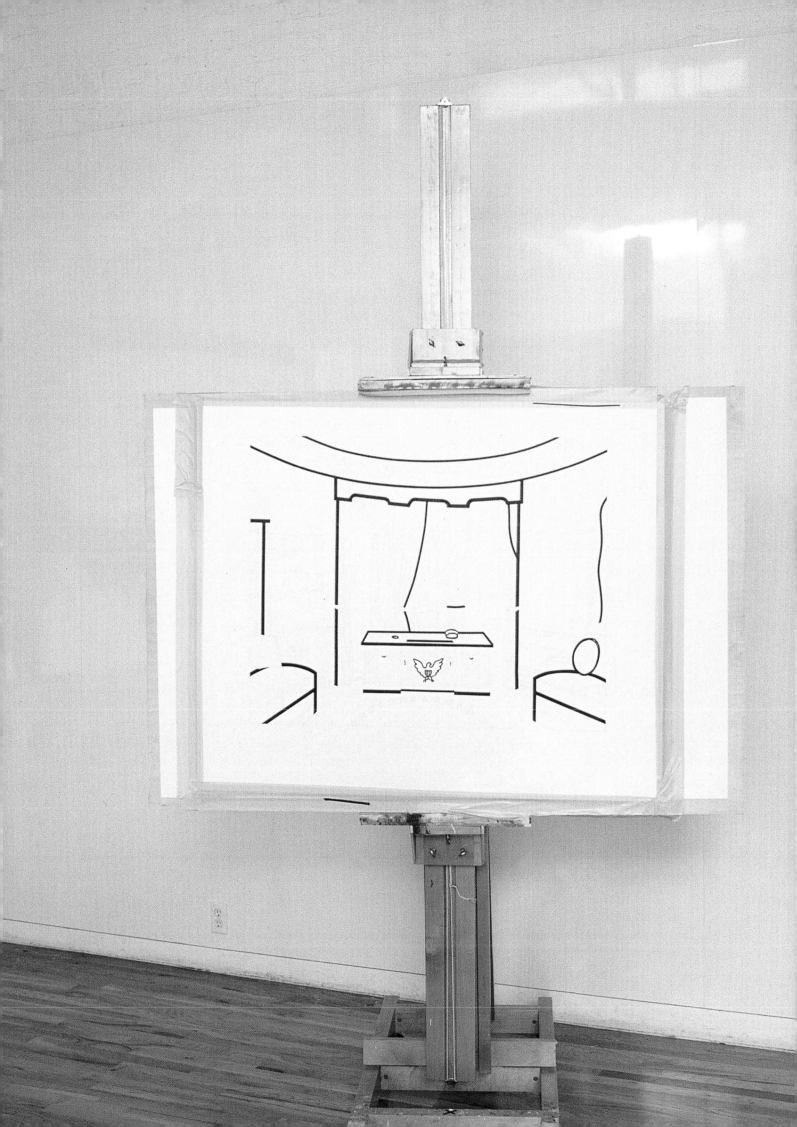

The easels in his studio were designed with an apparatus in the middle to be able to turn the canvas to all angles so that a good part of the time the picture was not being painted the way it would be seen. Roy thought that since Cézanne painting had become too utopian, "only looking inward, that reality is outside". The space was squeaky clean, more like a medical laboratory than an artist's studio. There was not a stray spot of paint anywhere in sight. Even the paint jars seemed to be wiped off, and everything was labeled. The order was intimidating—none of the Sturm und Drang of the clichéd artist toiling in the midst of a heated moment. The things I liked best were the studies and unfinished works: the project for the oval office that had only reached the black-tape phase and the small canvases that served as palettes to test different painting techniques. He was a wonderful man—happy, simple, uncomplicated, and successful. And what I remember most about him is his laughter.

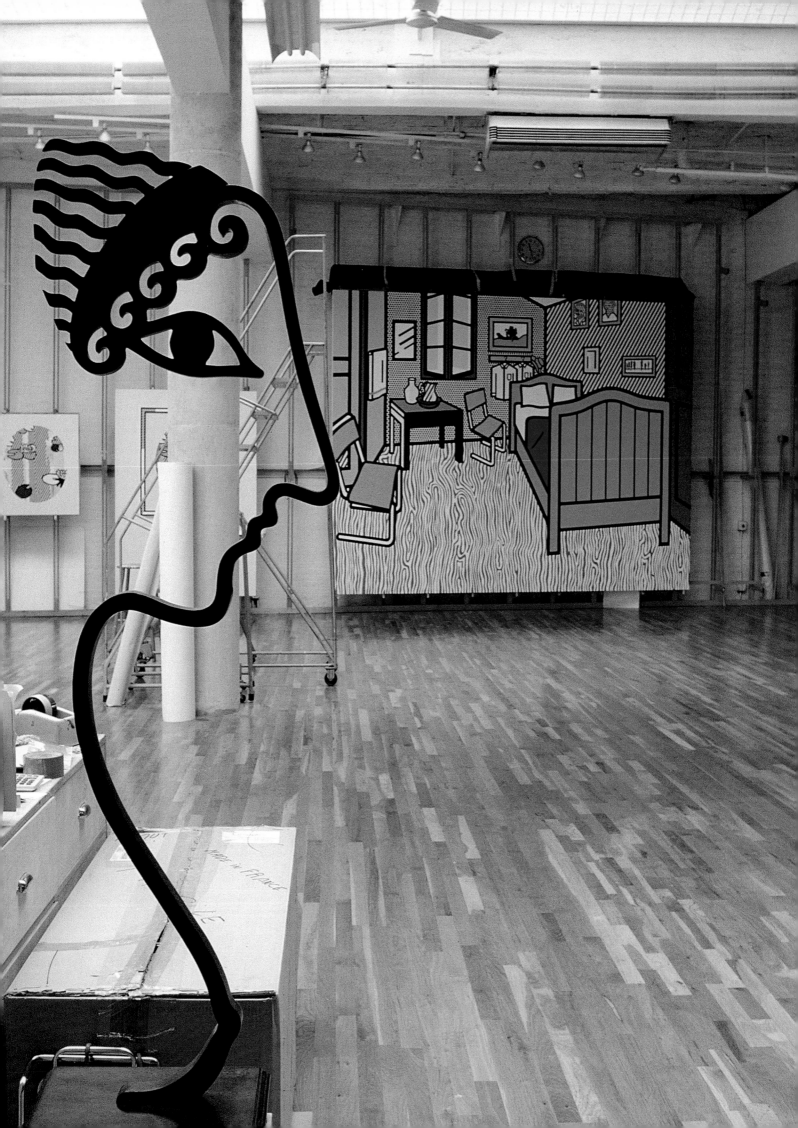

Roni Horn

This was Roni Horn's studio in Brooklyn, but she has since moved. When I was there, the space was bursting with work and ideas. Roni's art is an interesting mix of the literary and the postminimal; looking for a way out of the dead-end of minimalism without completely abandoning the form. She does this by infusing her work with actual texts, including Emily Dickinson poetry, and various organic shapes. The result is something much more personal and intimate than the typical production-line-type minimal art. Was it prophetic that this woman who looks and acts like a man was named Roni? Always dressed in man-tailored clothes with close-cropped hair, Roni has spent her life being perceived as a man. The pitch of her voice lies somewhere between the genders, and she speaks somewhat slowly, seeming to measure her words as she speaks, making a curious movement of her mouth and jaw, as if she were almost tasting what she was saying, often smiling. Her intensity and intelligence is offset by a basic good nature. She is hard-working and sincere and not given to any of the leftover, 1980s-style A-list art politicking. She is a serious artists' artist. Over the past few years, she has spent a lot of time in Iceland, working with organic shapes, the elements, and making beautiful books of photographs. The mixture of these concerns as they appear in her more formal sculpture has produced some very impressive, very beautiful work. I will never forget her installation of two large, poured, blue glass squares, each about two feet thick, cool and magical, like the contemplation of a pristine chunk of sky and water in one.

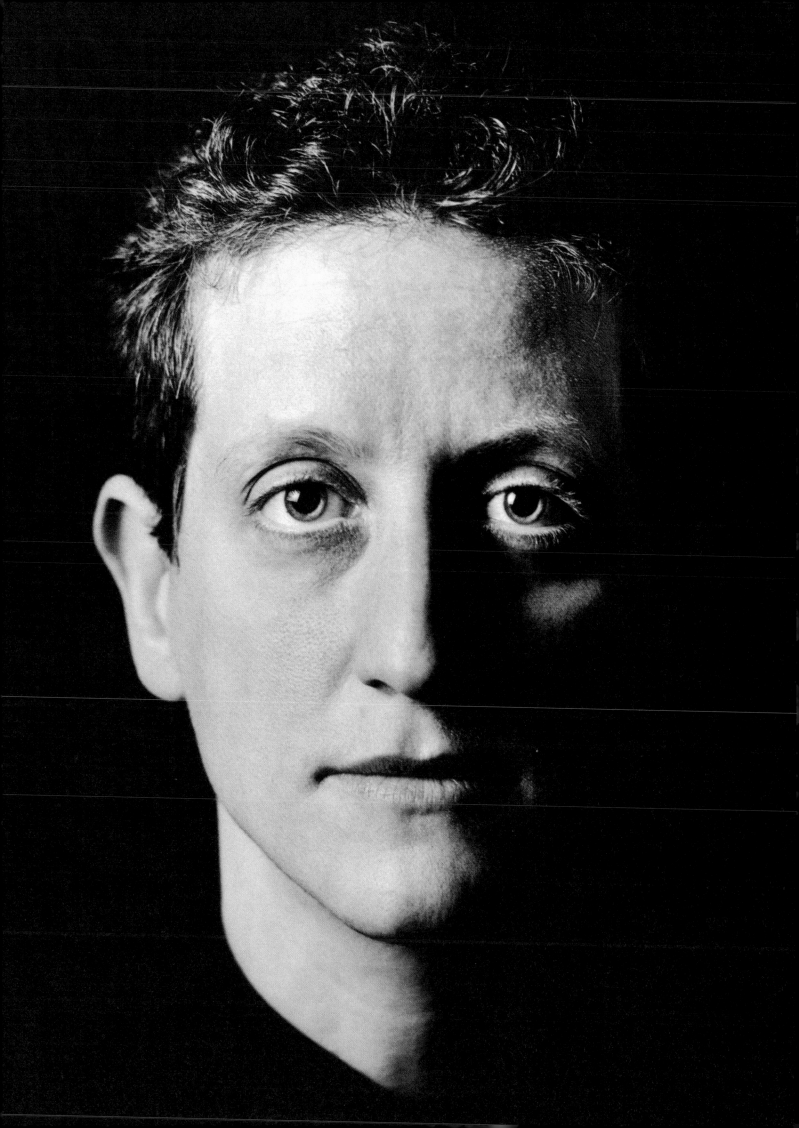

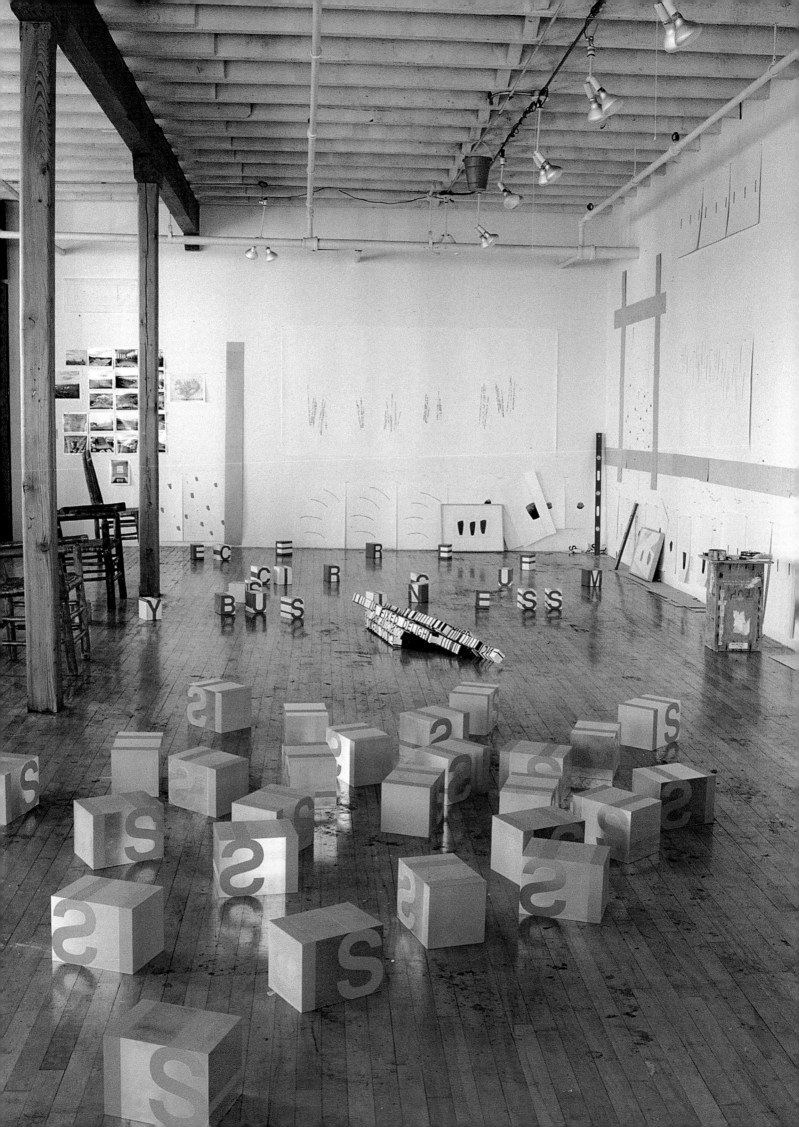

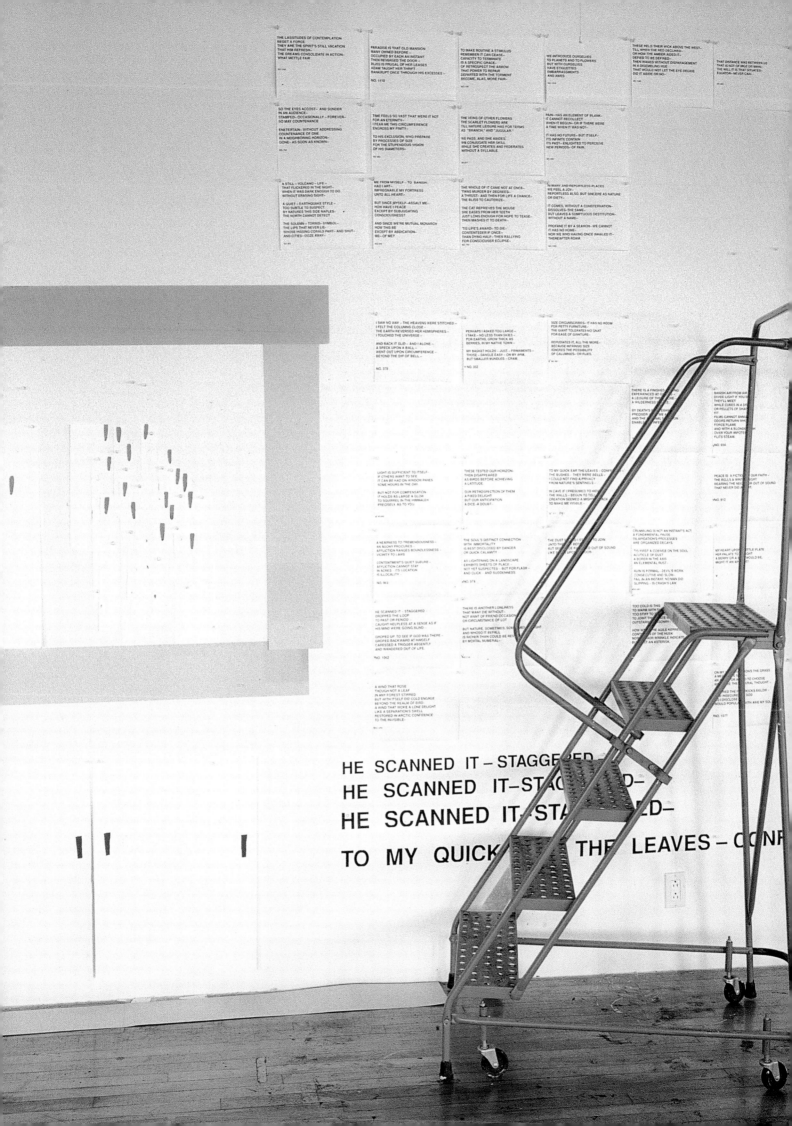

Brice Marden

Brice Marden's studio is a respite. Located on the Bowery above a noisy, congested block of restaurant-supply shops, it is a stunning contrast to the frenetic pitch of New York. After ascending a nondescript flight of wooden stairs, one penetrates the studio's aqueous world of cool, washed calm. I am always very impressed by how straightforward the place is. It is almost ascetic—clip-on metal lights, a neutral palette, an eastern exposure. Spartan, like a Zen temple to painting. Although there are often hints of color here and there—a blue bottle or a yellow painting, or a mark of orange—there is an overriding sense of neutrality, a suspension of time and place. The room is vast, about three thousand square feet, with columns, as in most downtown lofts, and very high ceilings. It is the perfect environment for the man, who is quiet, quirky, funny, and intense. His intelligence is razor sharp, his opinions are distinctive, and his logic concrete. But it takes a lot of time for him to unfold and reveal himself. Only Brice can explain, in the most unexpected and backhanded way, where the references in his work come from; one may allude to an esoteric Ming vessel, another may echo an ancient Japanese stone. I once asked him if he wanted to paint the unseen. He stopped and made a kind of square gesture with his hands, and said, "I always wished I could paint air." I first met Brice and Helen Marden at Claryssa Dalrymple's and John Abbott's gallery in the Cable Building on lower Broadway. I liked them instantly—Helen's feistiness and Brice's strong-and-silent-type demeanor and movie-star good looks. Shortly thereafter, Betsy Sussler, a mutual friend and the editor-in-chief of *BOMB Magazine*, asked me to do a portrait of Brice for an interview.

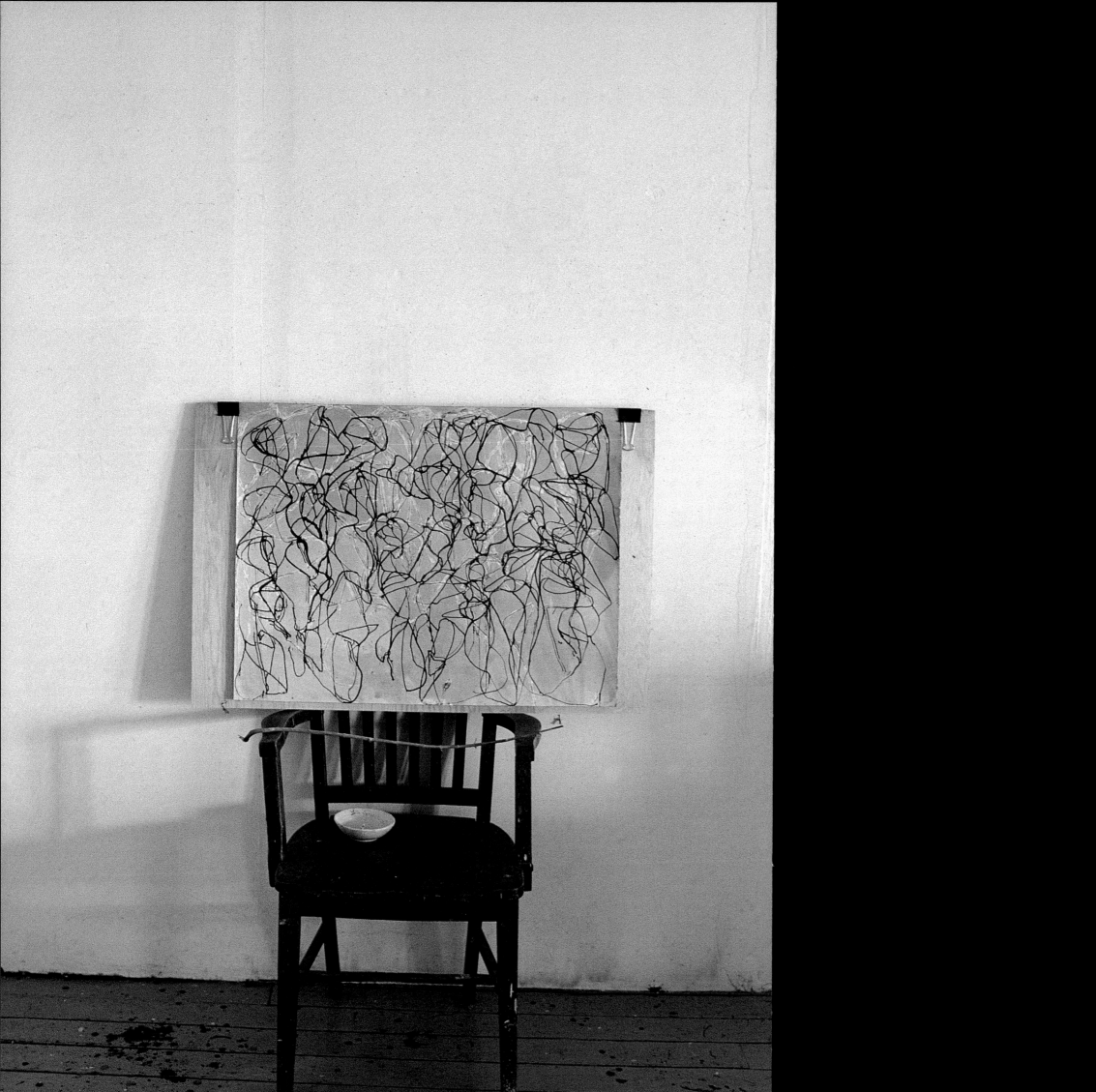

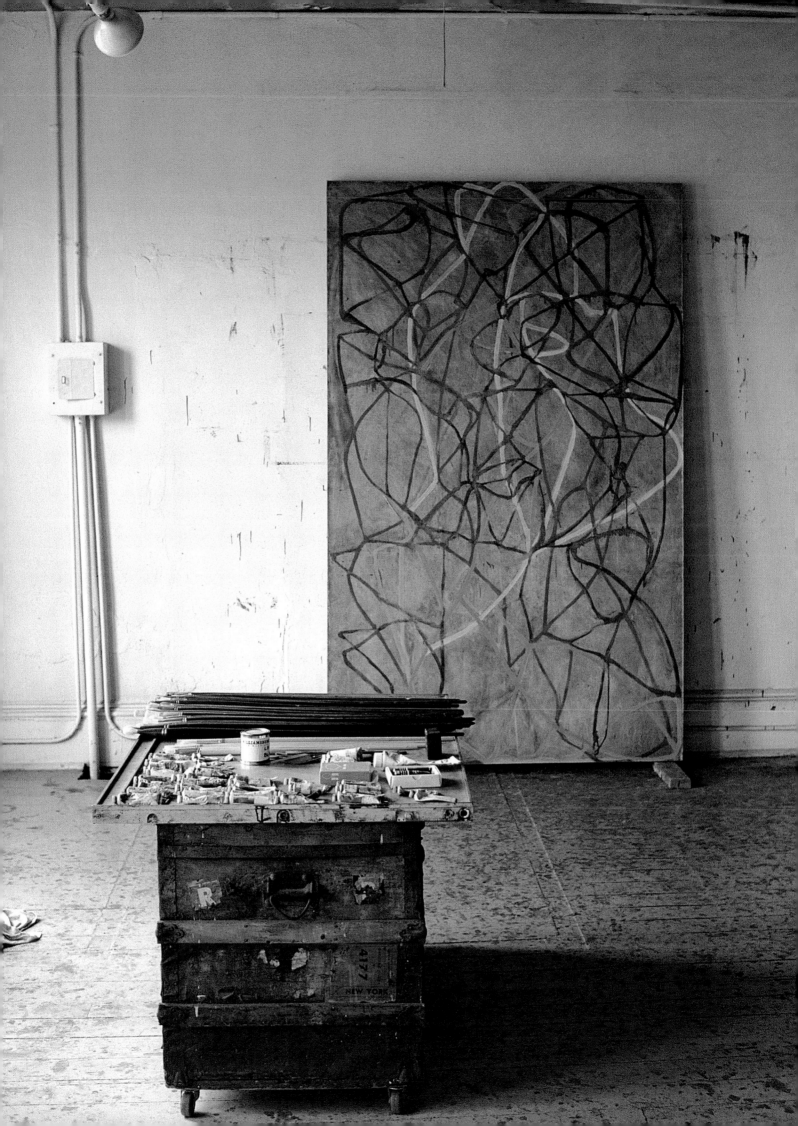

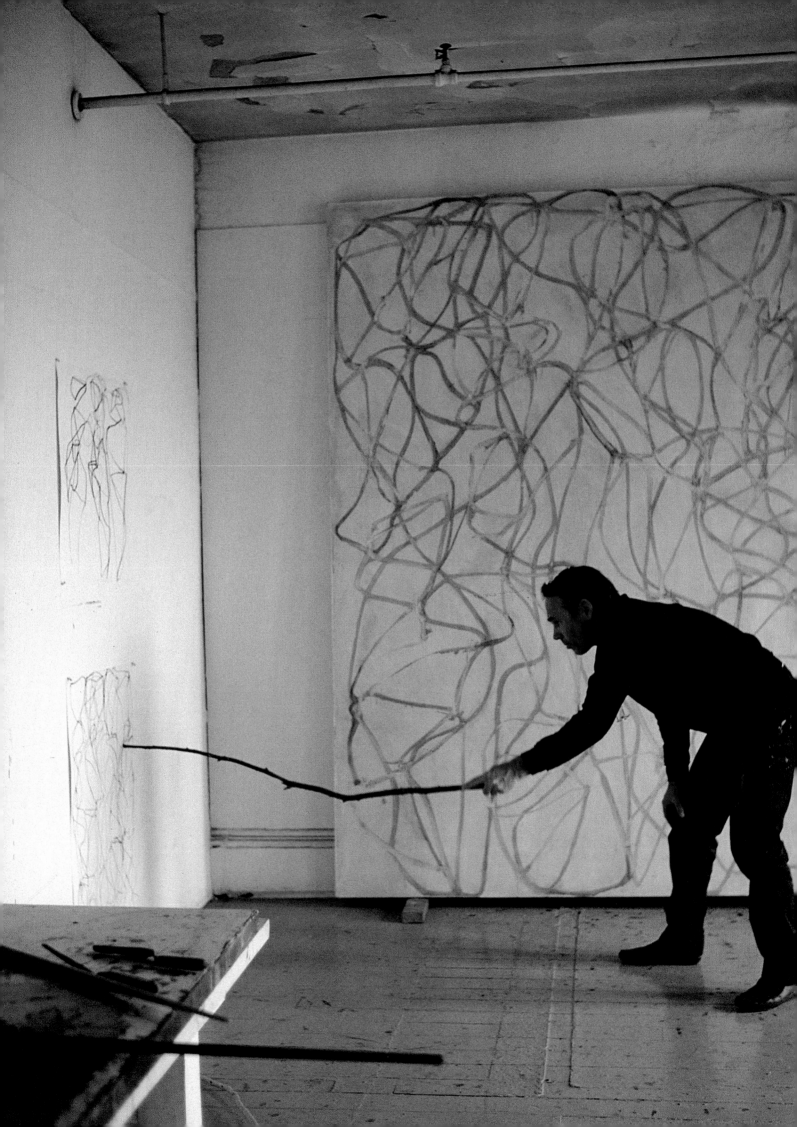

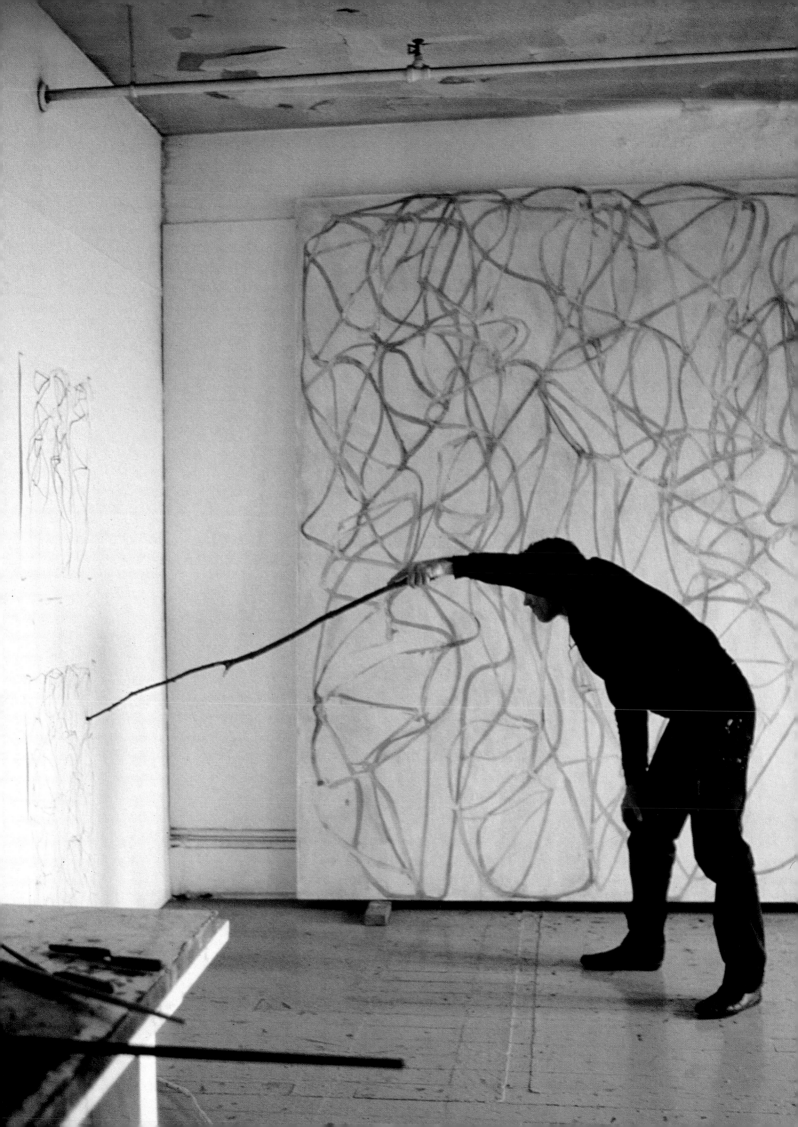

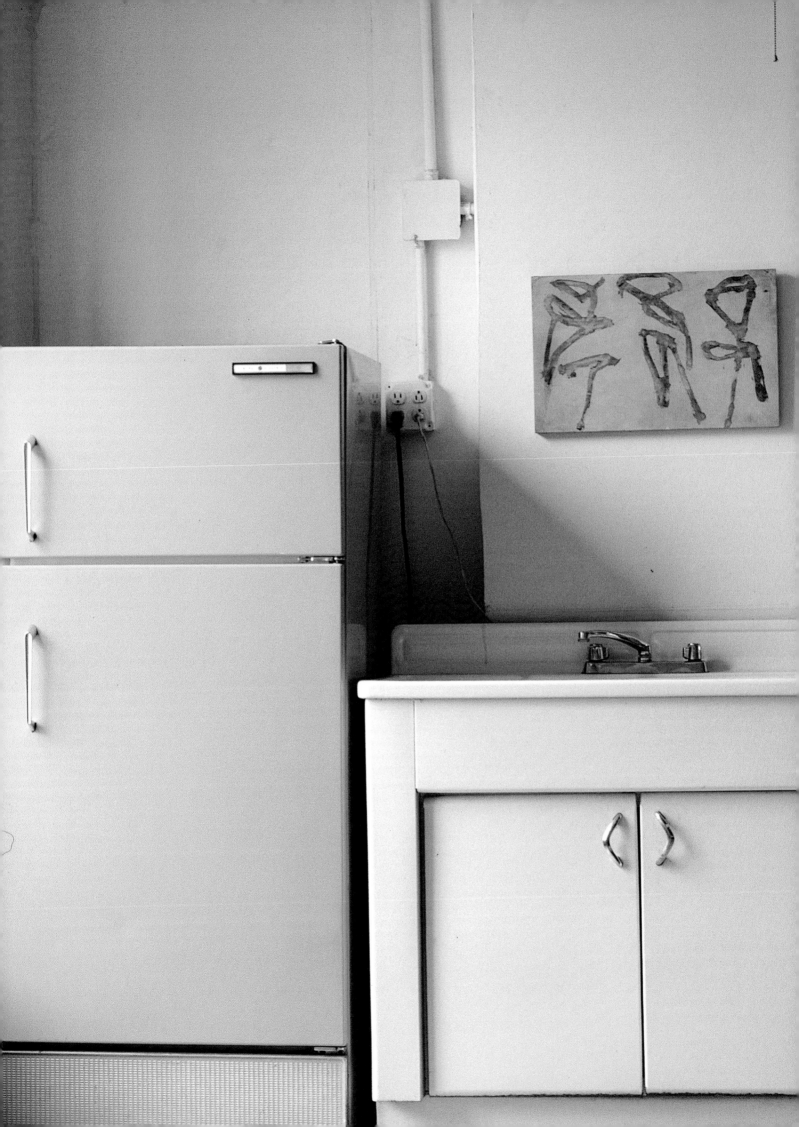

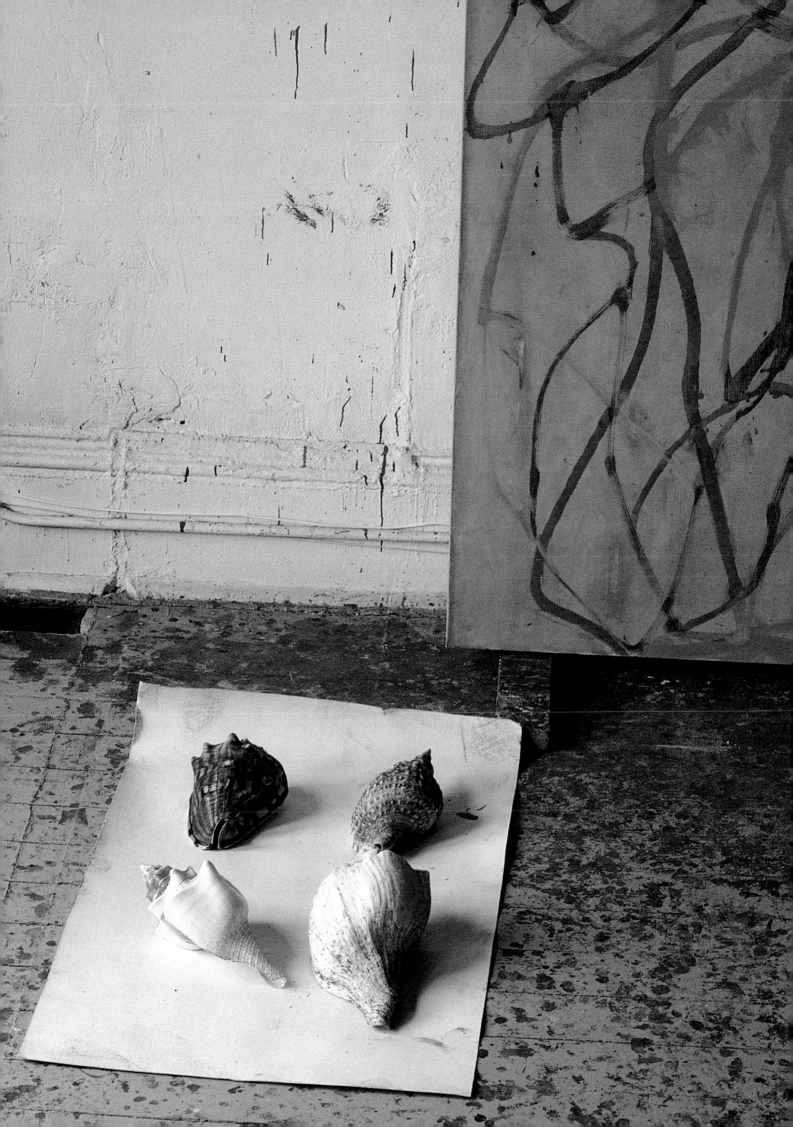

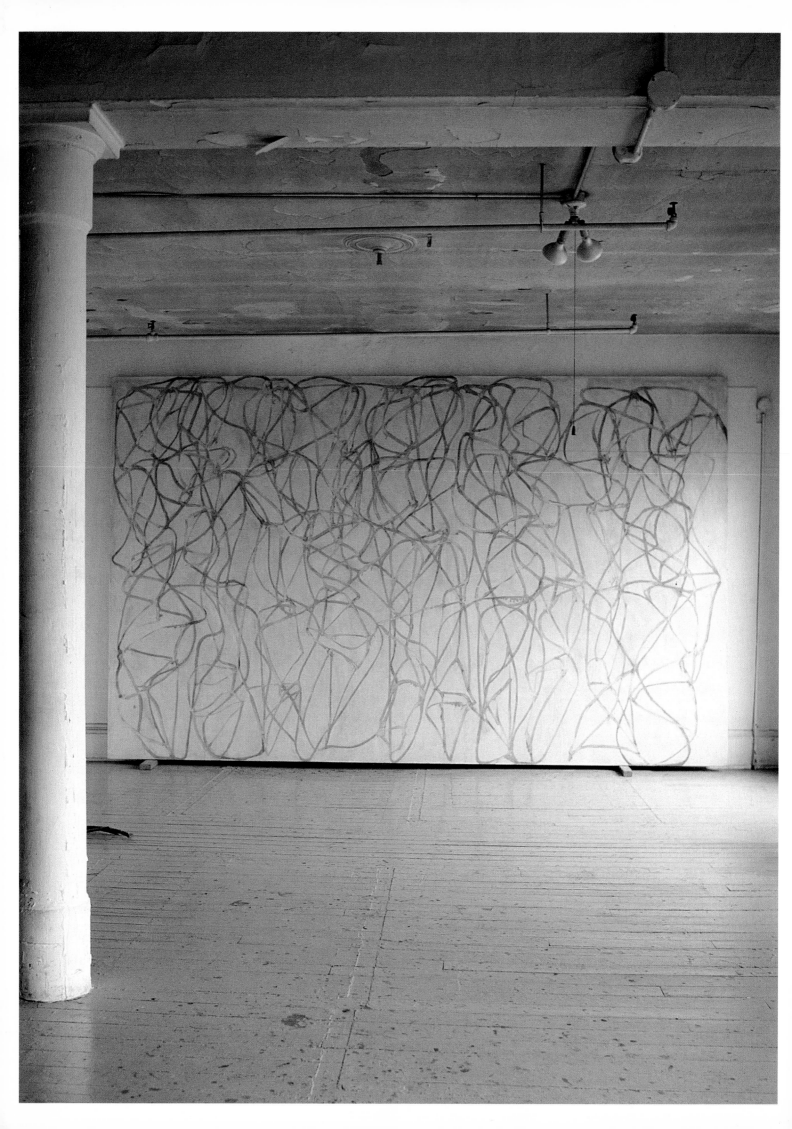

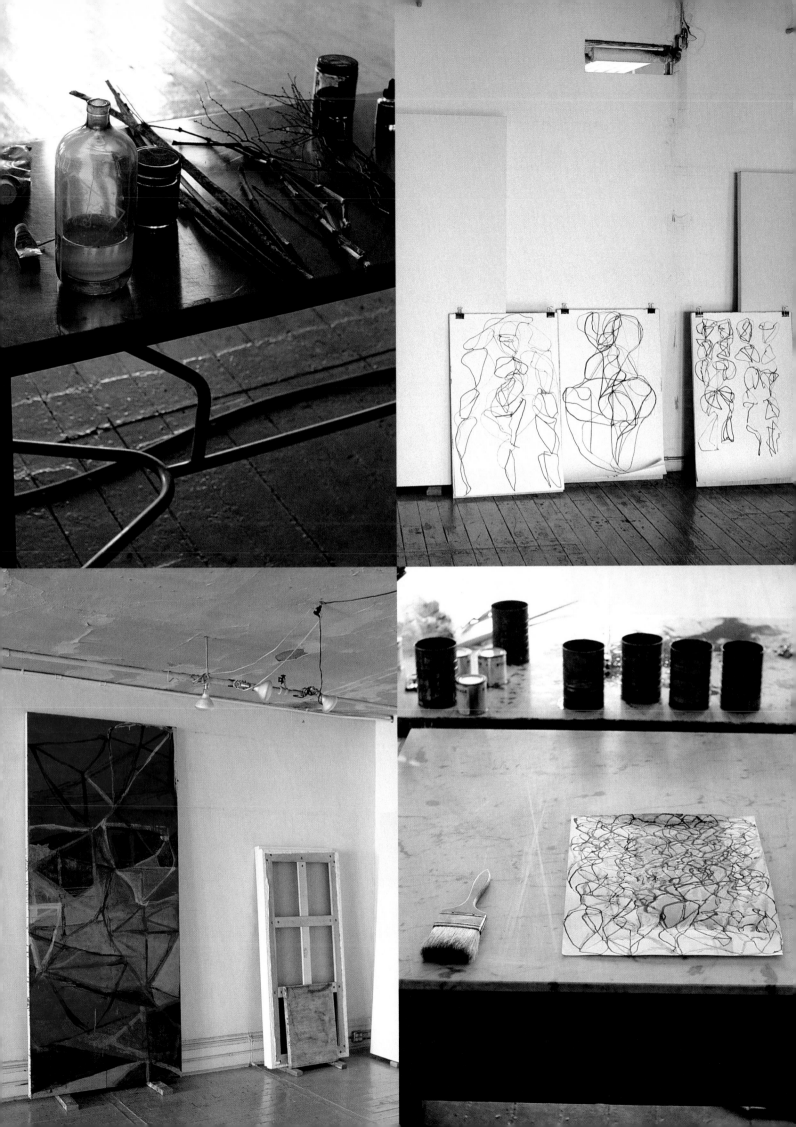

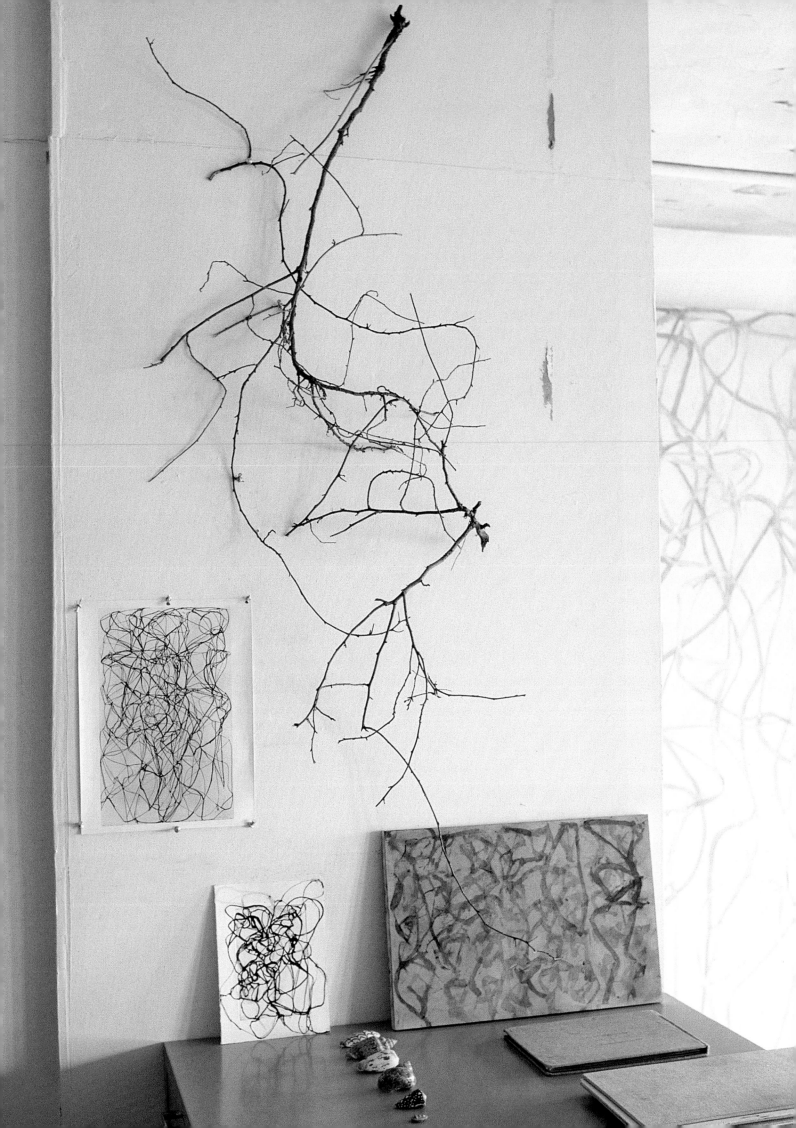

That was in the mid-1980s, and we subsequently developed a friendship. Over the years, we would connect through many mutual friends. I was very touched by Brice and Helen's support when a part of Tina Chow's costume collection was auctioned at Christie's. I prepared a small exhibition of photographs of Tina to be auctioned at the same time to benefit AIDS charities, and the Mardens stayed until the very end of the sale, bought one of the pictures of her, and hung it in the entry of their West Village townhouse in a sort of intimate gallery of friends. After the auction, Helen and I had a quiet dinner and I felt a real cameraderie was established. In all these years, I always wanted to do a portait of Helen, too. She is a talented painter in her own right. But true to the hectic pace and lifestyle of New York, it's something we have never gotten around to doing. They are two people I really care for, though, and quintessential fixtures of the New York scene. Gatherings at their home are always an interesting mix of writers, artists, thinkers—a meeting of the new and interesting and the established Bohemia. In addition to this sitting of Brice for French *Vogue*, we also made a small book together for an exhibition at Matthew Marks. And the portraits and studio photographs were later reproduced in various catalogues. There is a part of Brice that will always seem to me like a teenager. His looks and his physique—especially when he has his hair long and wears his black jeans—give him an eternally youthful quality about him. But he observes more than he participates. As with the kid who refuses to talk in class, words have to be coaxed out of him. Though spare, his words always deliver.

Joan Mitchell

Joan Mitchell lived and worked in a suburb about an hour from Paris, called Vetheuil. The house was a rambling stone structure, not grand but very comfortable. In the back was her studio, a separate traditional, skylit artist's atelier, down a corridor of paving stones set amid beautiful gardens created by Mitchell herself. From Mitchell's house one was afforded views of the green-grey Seine, and square and rectangular patches of wheat colored fields in the dusty June light. She talked a great deal about the "beautiful, grey, Ile de France light," how it brought colors to life. We were introduced by our mutual friend John Cheim. When these photographs were taken, she had not recovered from hip surgery and had to work on crutches—quite unlike the younger Mitchell, who was always scrambling up and down ladders. Mitchell painted very much alone and needed to isolate herself to do so. She never worked with an assistant. She identified herself as an American painter and hated when critics called her the continuation of French Painting. Yet, she stated, in an interview in the *New York Times*, "French artists have a sense of beauty—a sense of color—that isn't allowed in New York City. To me, painting is French." She loved to recite poetry, especially poems about nature, and one could so easily see in her the archetypal old-school artist: she swore and smoked and drank; she was ornery, cantankerous, and impossible. I adored her and we became instant friends. She described herself to me as being two people: "little Joan" and "big Joan." "Little Joan" was the creative child that toiled alone in her studio and "big Joan" went out into the world to protect "little Joan."

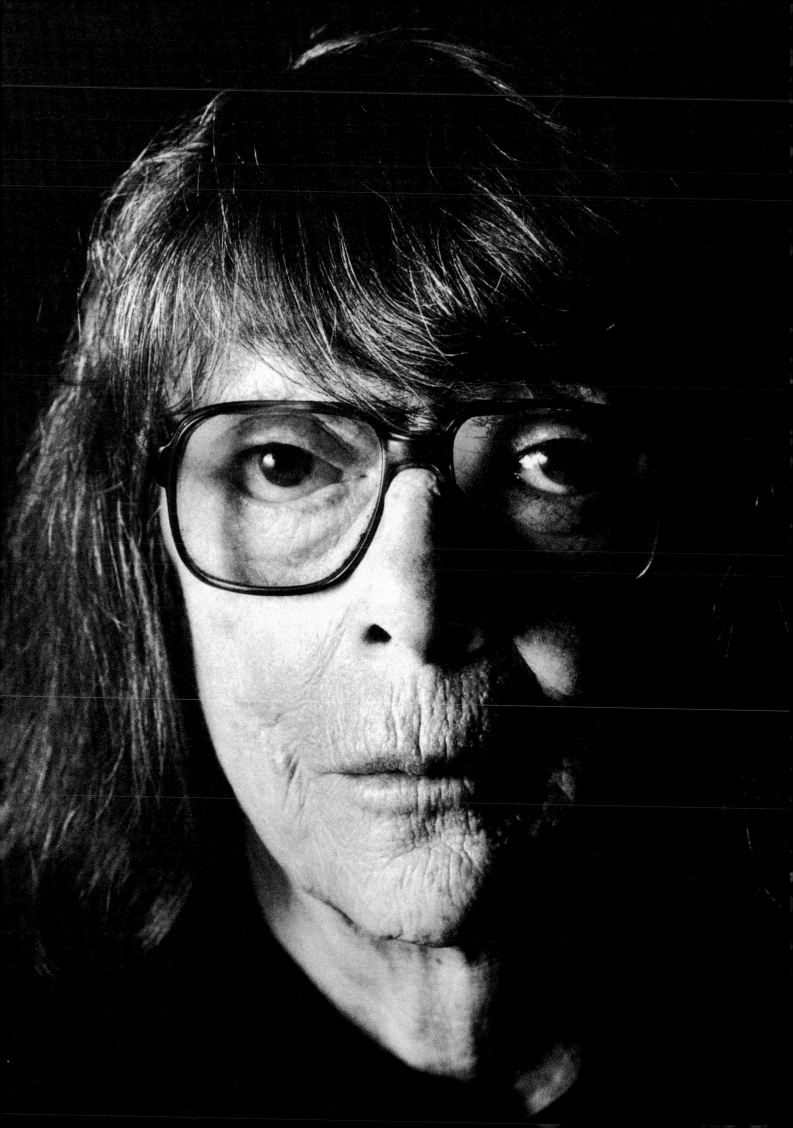

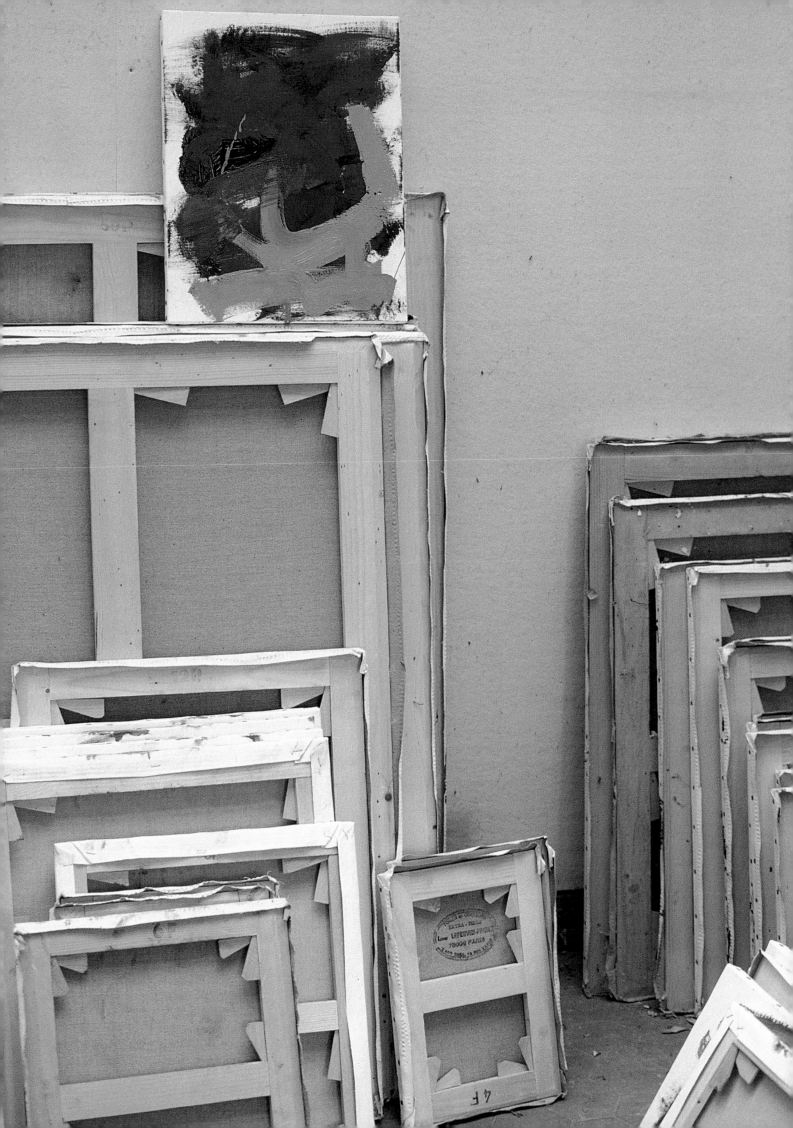

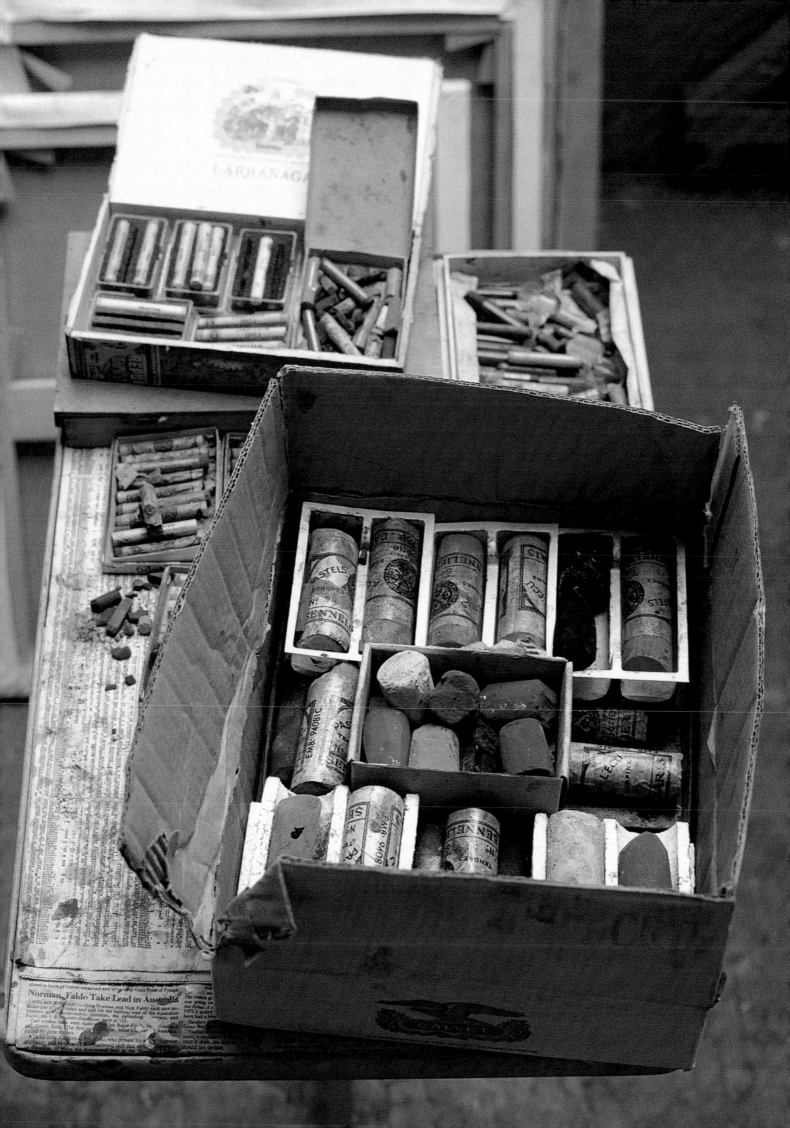

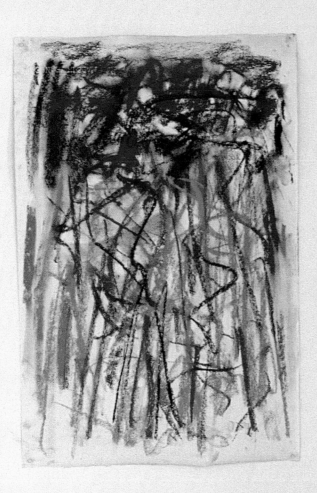
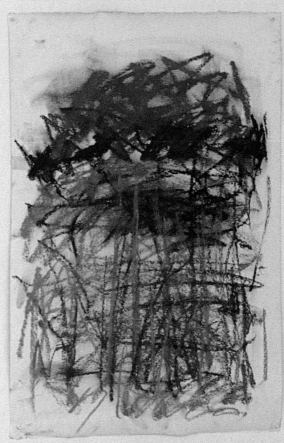

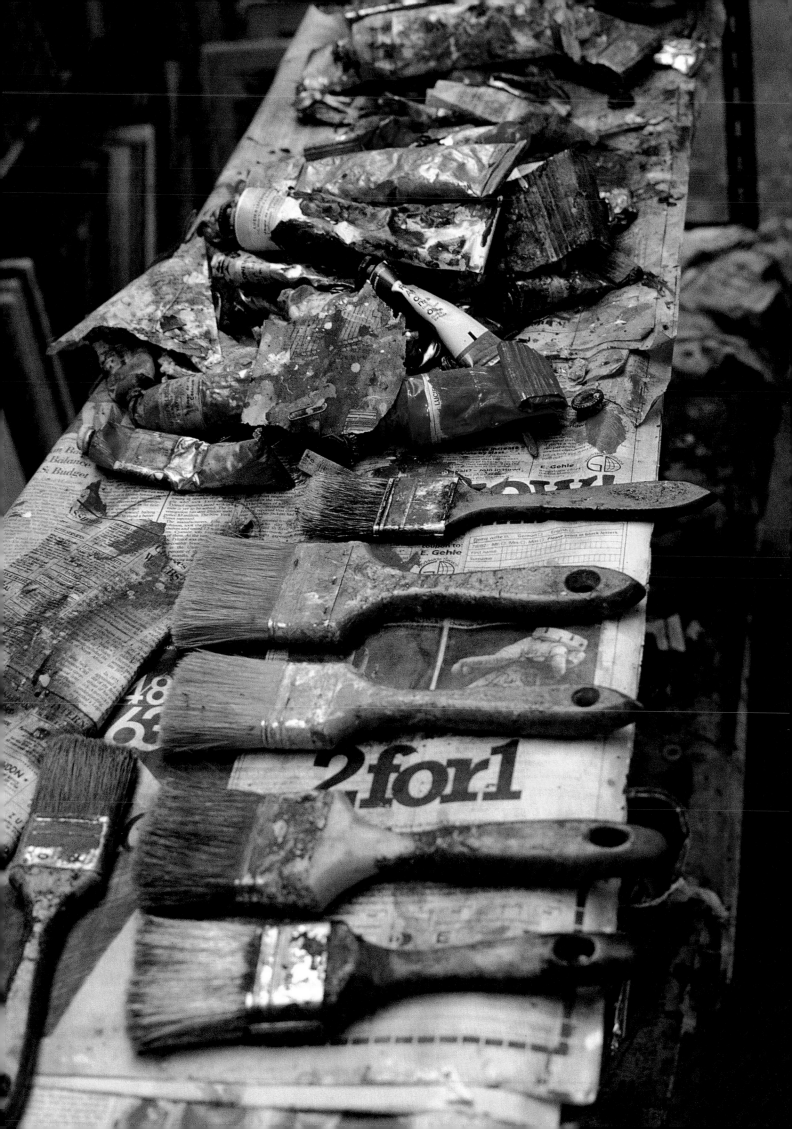

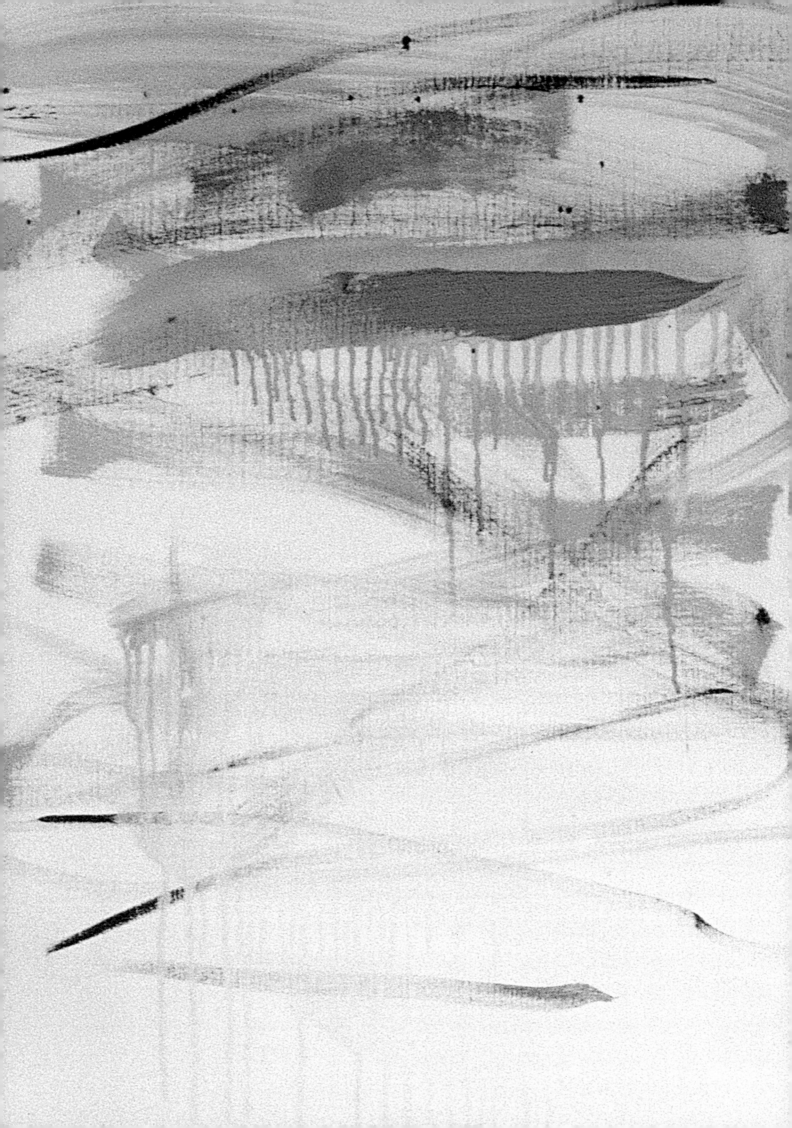

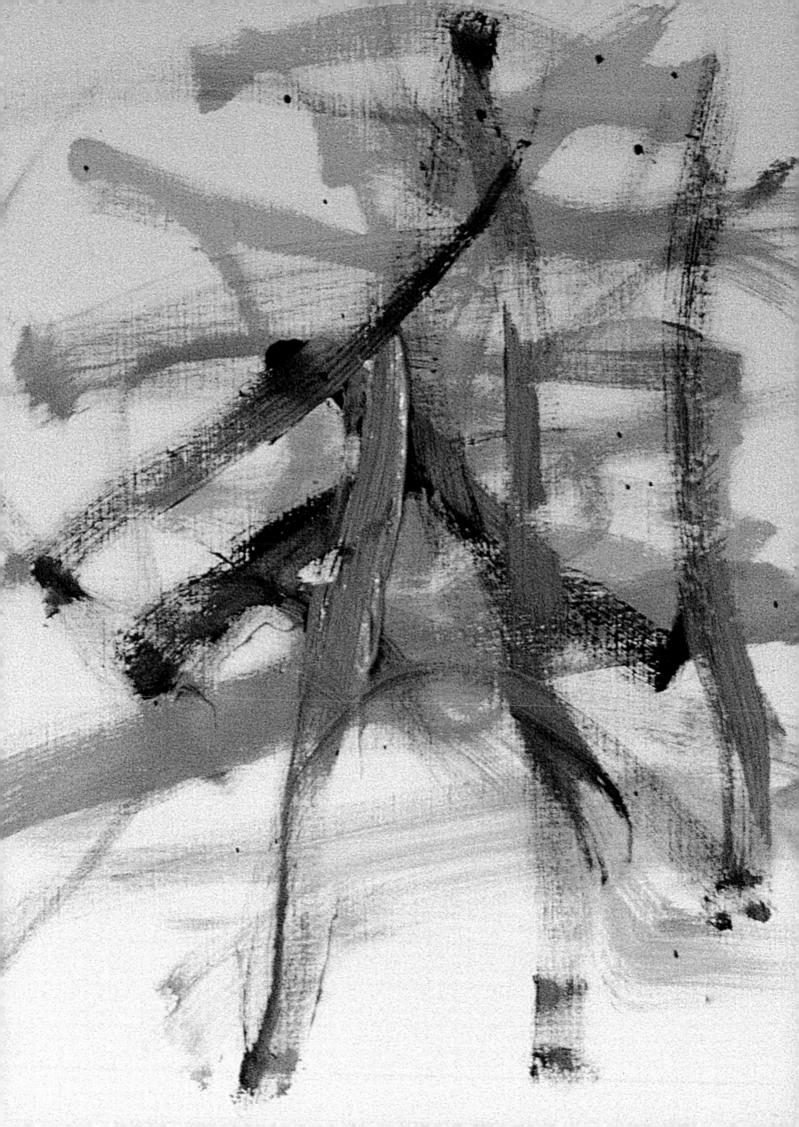

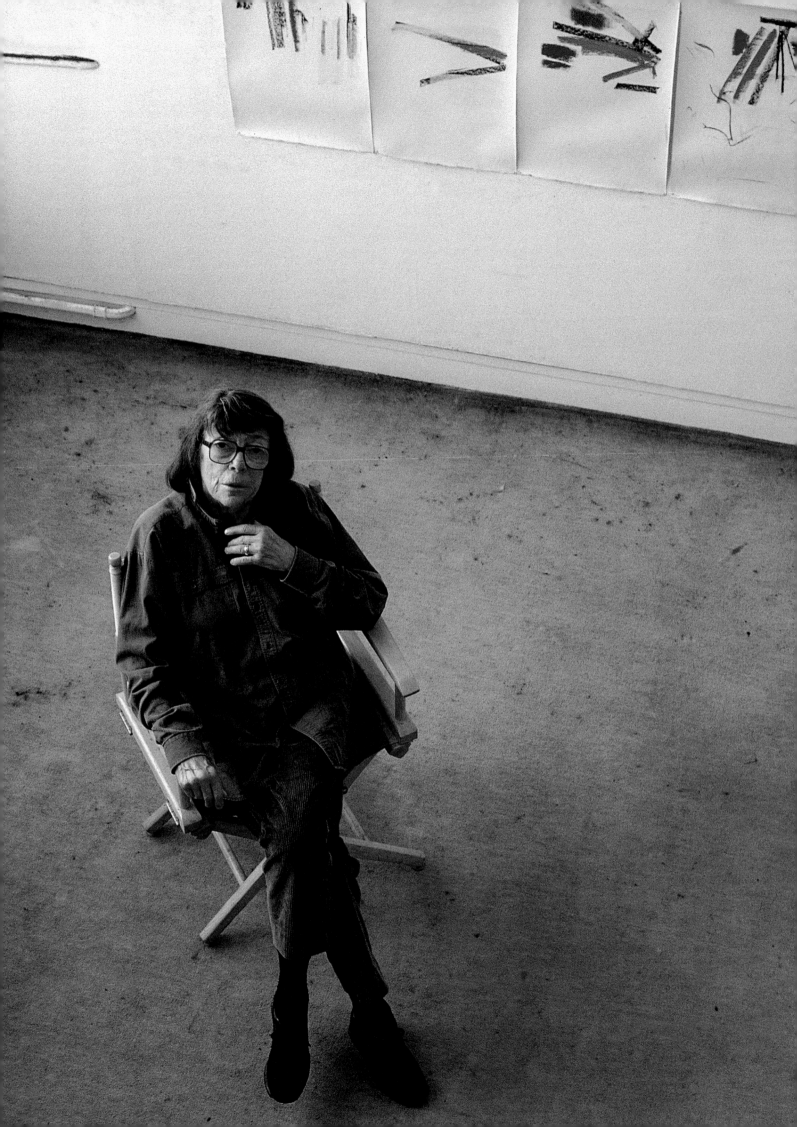

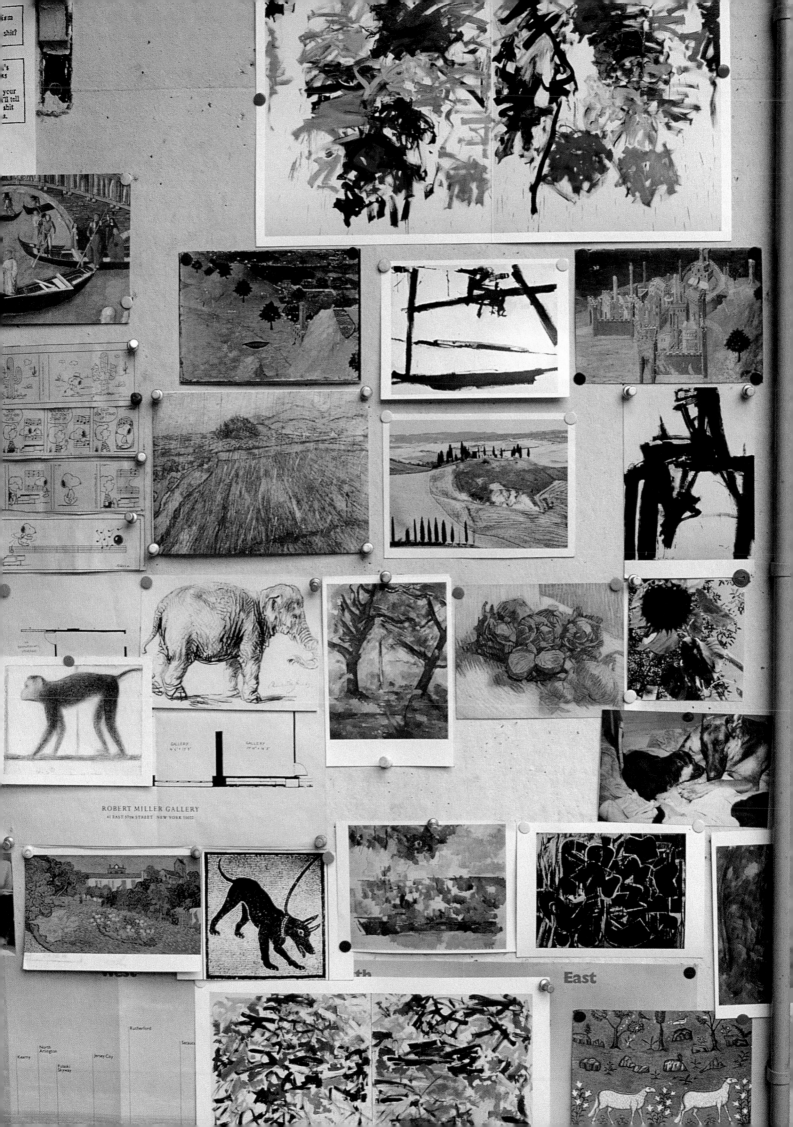

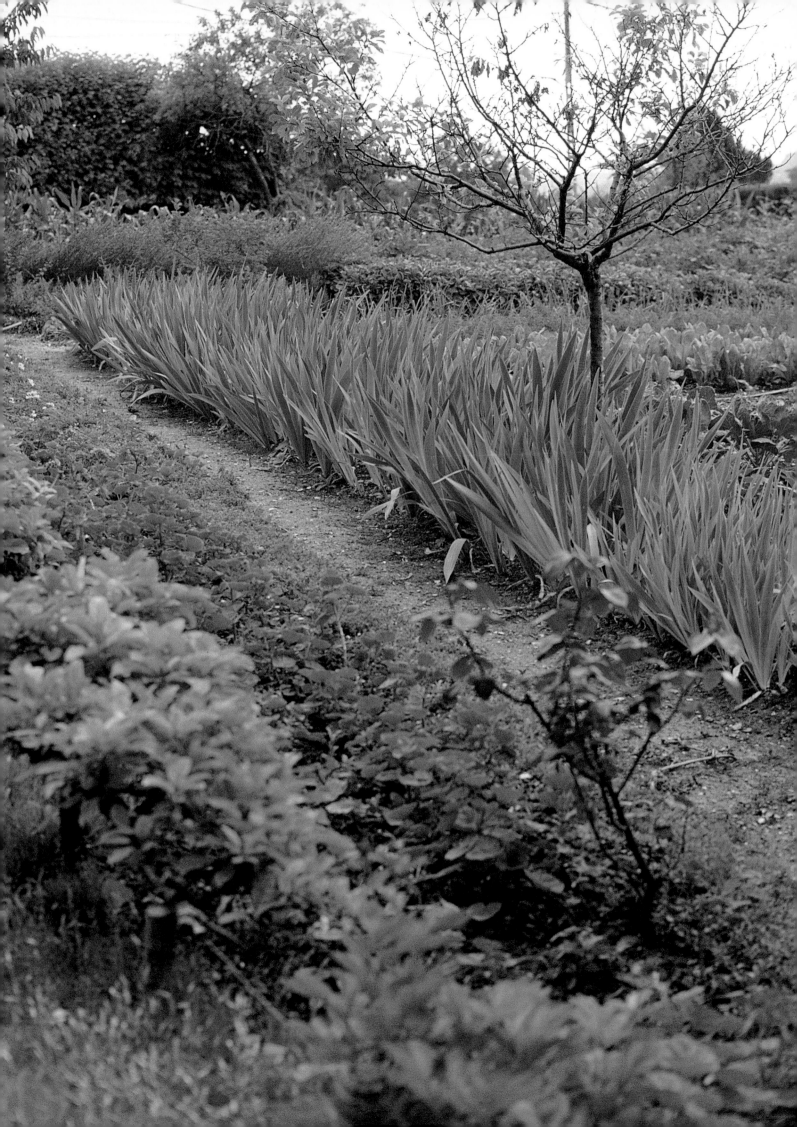

She was simple in appearance yet complex in demeanor, a little girl with a mature exterior. She was a great friend of Beckett's and a staunch defender of abstraction and the nonlinear. But she had an enormously sentimental side to her and at heart was an old-fashioned romantic. In addition to the time we spent together in her painting studio in Vetheuil, she once took me to a small pastel studio she kept in the city. It was in a traditional 1930s artists' studio building on the Rue Campagne-Première, a street made famous by Jean-Paul Belmondo in *Breathless* but also home to many famous artists, including Rilke, Man Ray, and Atget.

Jack Pierson

Jack Pierson had this studio on 42nd Street, before the renovation of the neighborhood. It was a plain, nice-sized room with a sink in it in an old office building. I don't know where Jack is now; we've lost touch. But we still run into each other around town, and I remain a big fan of his work. I especially love the way he uses sentiment to elevate the commonplace to the monumental. There is a Tobacco Road seediness to his work that seems nonchalant but is completely intentional. Jack is a natural artist; the ideas and feelings pour straight out of him, without the filter of theory or method. I first met Jack at Roberto Juarez's studio, the same night I met Philip Taaffe. At the time I was traveling a lot, so we lost touch. Then I started seeing his beautiful drawings and photographs around and was always impressed by them. Some of his work is based on melancholy, nostalgia, and longing, but it is never gloomy or negative. And even when the impetus is tragic, the reading is not. Jack puts his cards on the table about feelings. He says he has learned to objectify his experience by thinking of himself in the third person "because of the battered emotional journey we've all had." One can't help but think of folk songs and ballads and odes to lost love. This sitting was done for a now-defunct activist newspaper called *Queer Weekly*, and at the time Jack referred to himself as a romantic bohemian narcissist. He was trying to endow the ephemeral nature of his work with more formal qualities, as opposed to "just being emotional in public." When I asked him about the sense of loneliness and isolation in his work, he answered, "That's what maybe makes it universal. All art deals with loneliness on some level if it's doing its job."

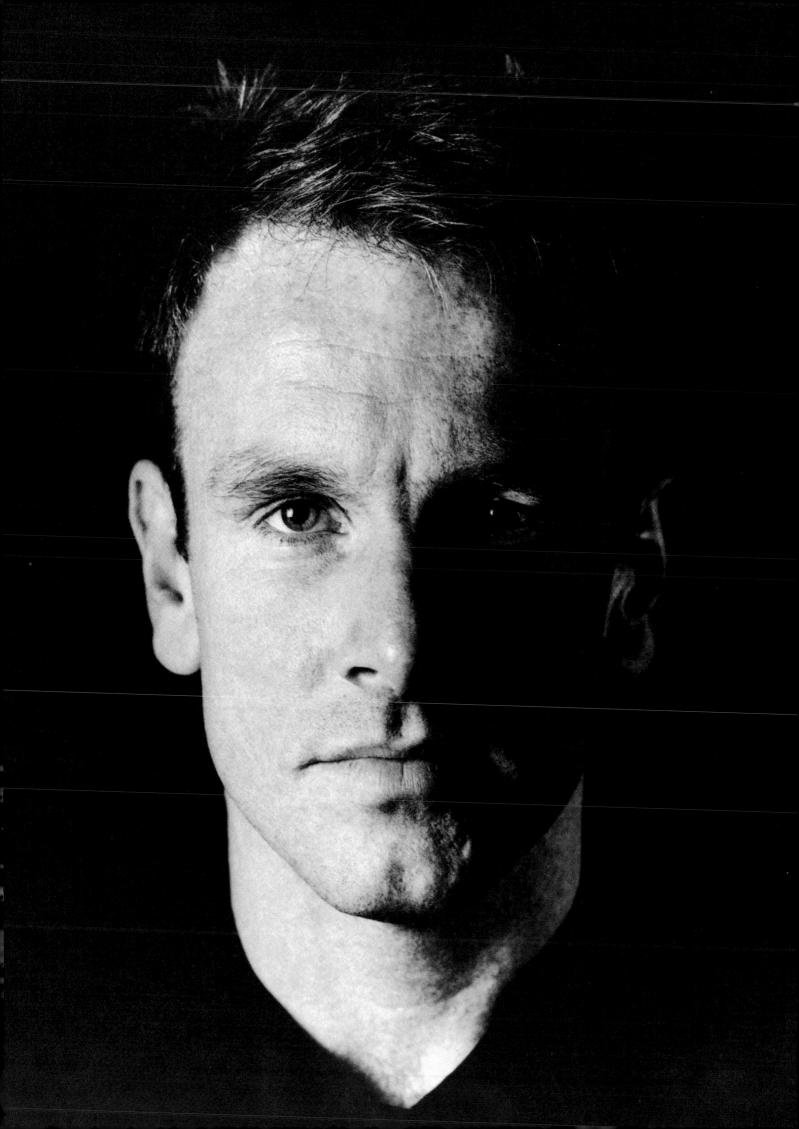

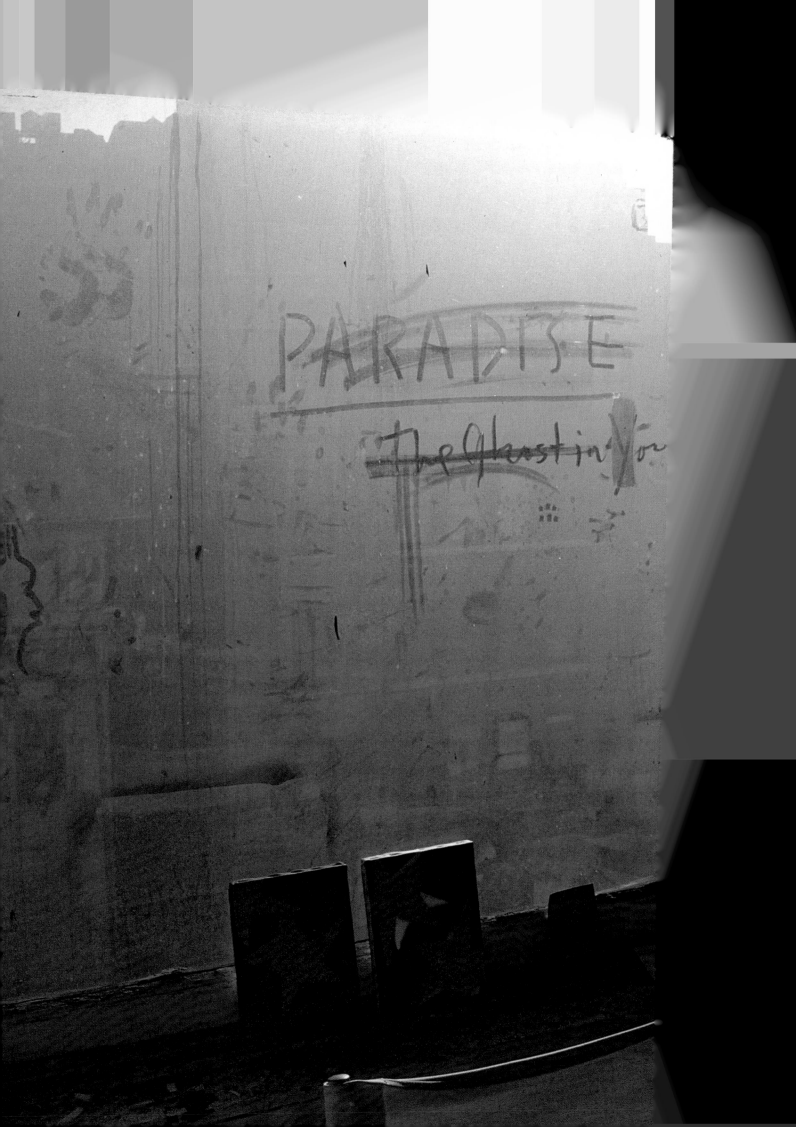

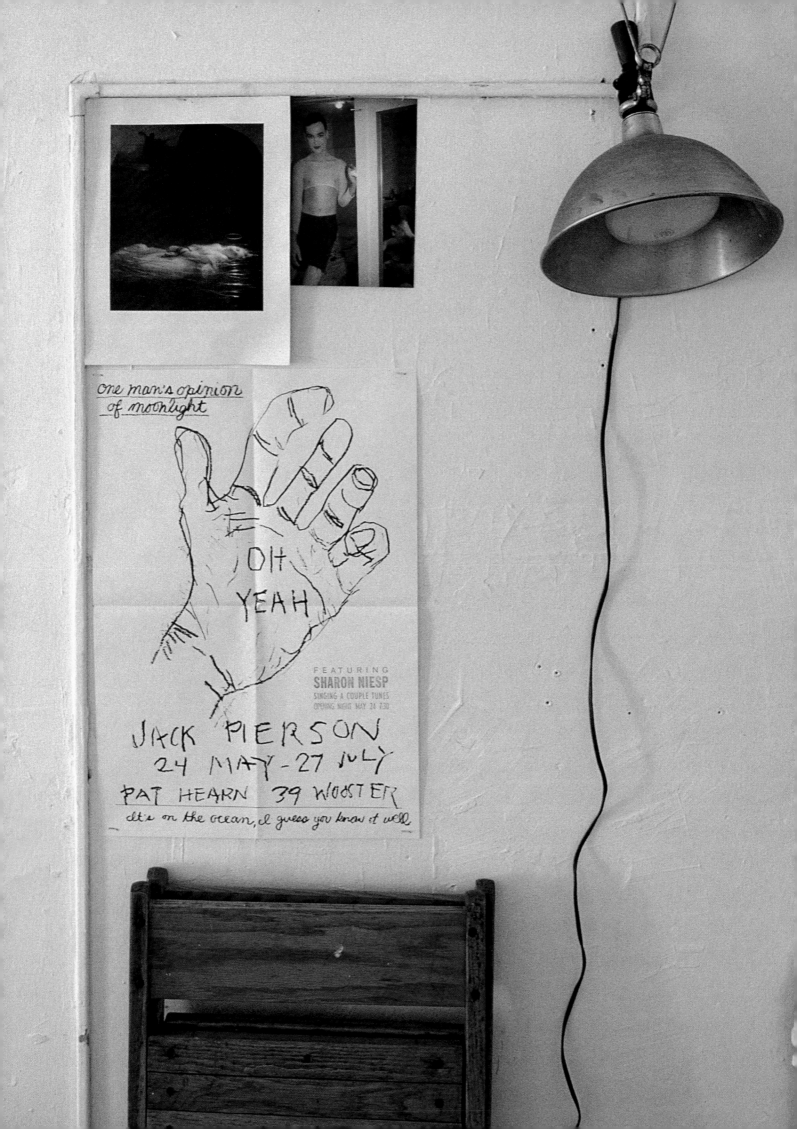

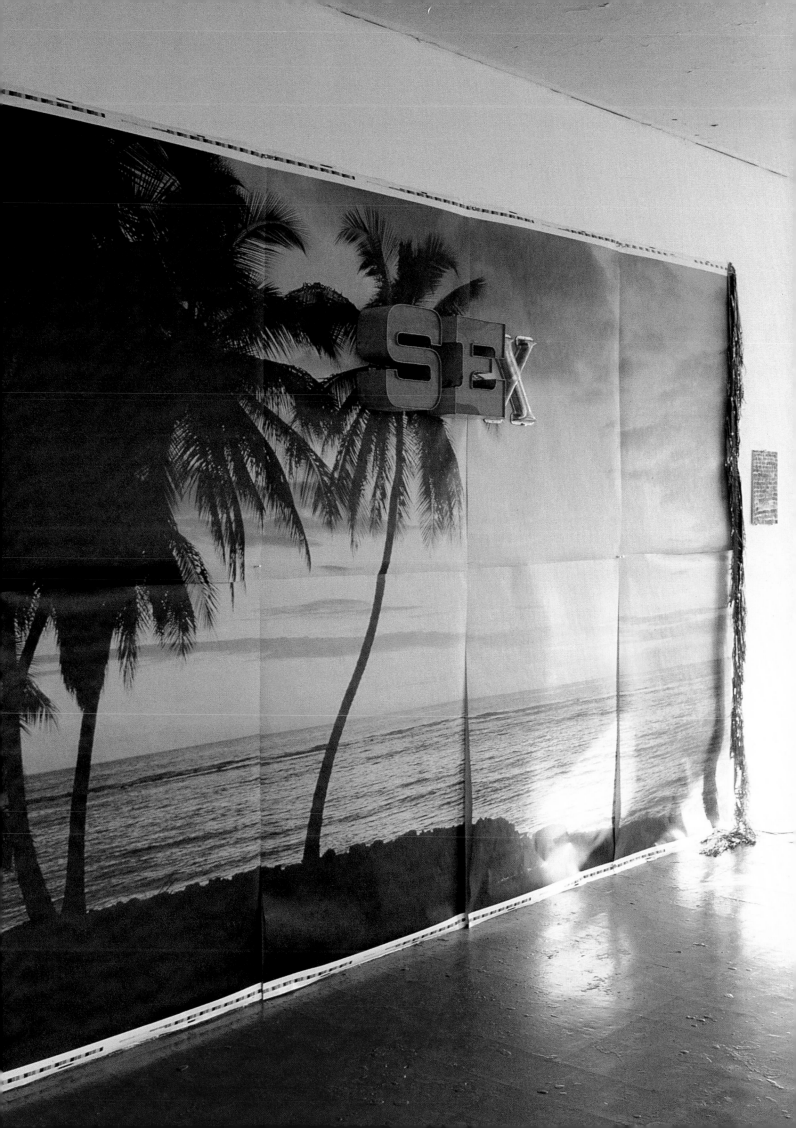

Richard Serra

Richard Serra occupies two floors of a building on a quiet street in lower Manhattan. In that neighborhood, the grid pattern of the streets starts to break up producing a large, triangular space that has a sense of emptiness and quiet. The mood is like a cross between an urban de Chirico and a seaside resort in the off-season. The loft he lives in with his wife Clara was designed by the British architect Max Gordon, who is known for his pristine, minimalist designs. The drawing studio is located on another floor, and contains Serra's personal office as well as a laboratory for developing ideas. There is a wall covered with posters and announcements spanning three decades, and on my last visit I found sandboxes with lead models of his "Torqued Ellipses," miniatures of those installed at the Dia Center for Art on West 22nd Street. In another part of the studio, heavy black sludge covered every surface imaginable. A profusion of oil sticks lay beside an old-fashioned manual meat grinder. The sticks, I learned, were melted down and cast into bricks, put through the grinder and made into a paste, then passed through a screen. The fine paste was then laboriously applied by the artist's hand to various surfaces. Black, oil-caked gloves were strewn about the floor, looking like petrified hands from Pompeii. Discarded shoes, pants, and papers were also covered with the oil-stick sludge. I said to his assistant, "It looks like a caveman has been working here." He answered, "A caveman has been working here." Serra has another studio for sculpture across the river in Brooklyn. Vast does not begin to describe the 7,500-square-foot space. It is more evocative of an airplane hangar or a shipyard than a sculpture studio. It dwarfs just about any work, including the fifty-five-ton sculpture pictured in these photographs.

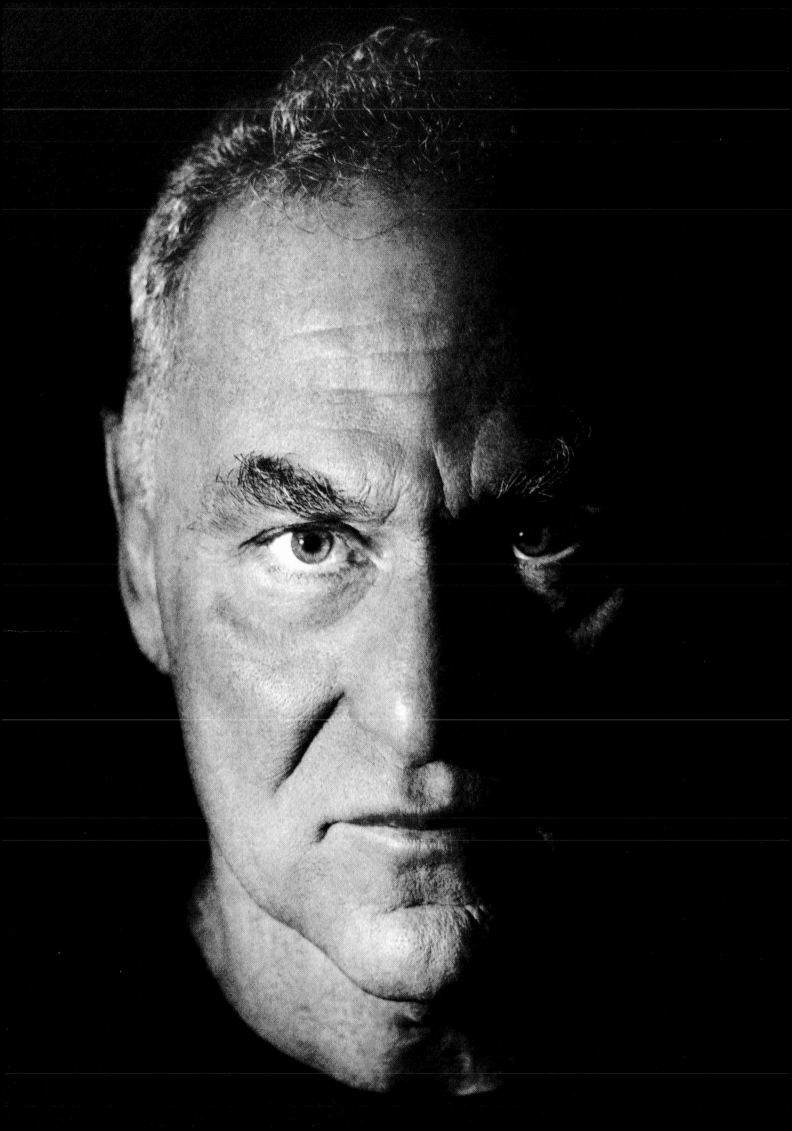

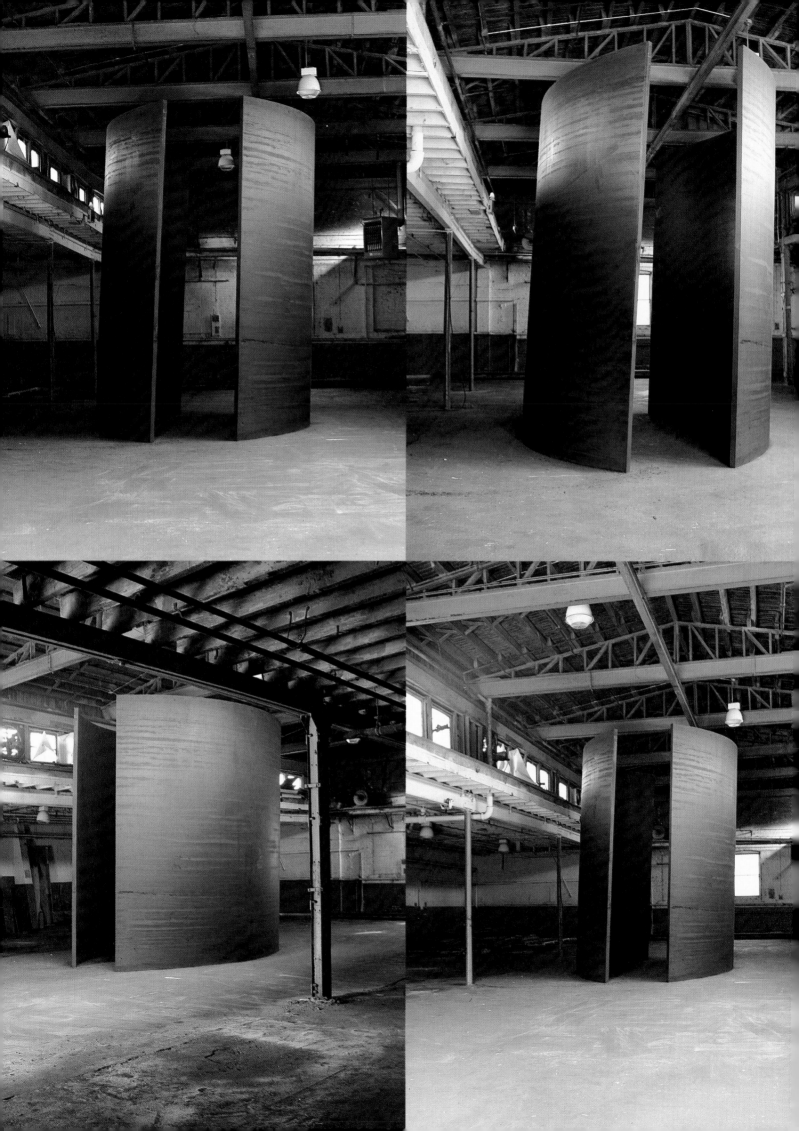

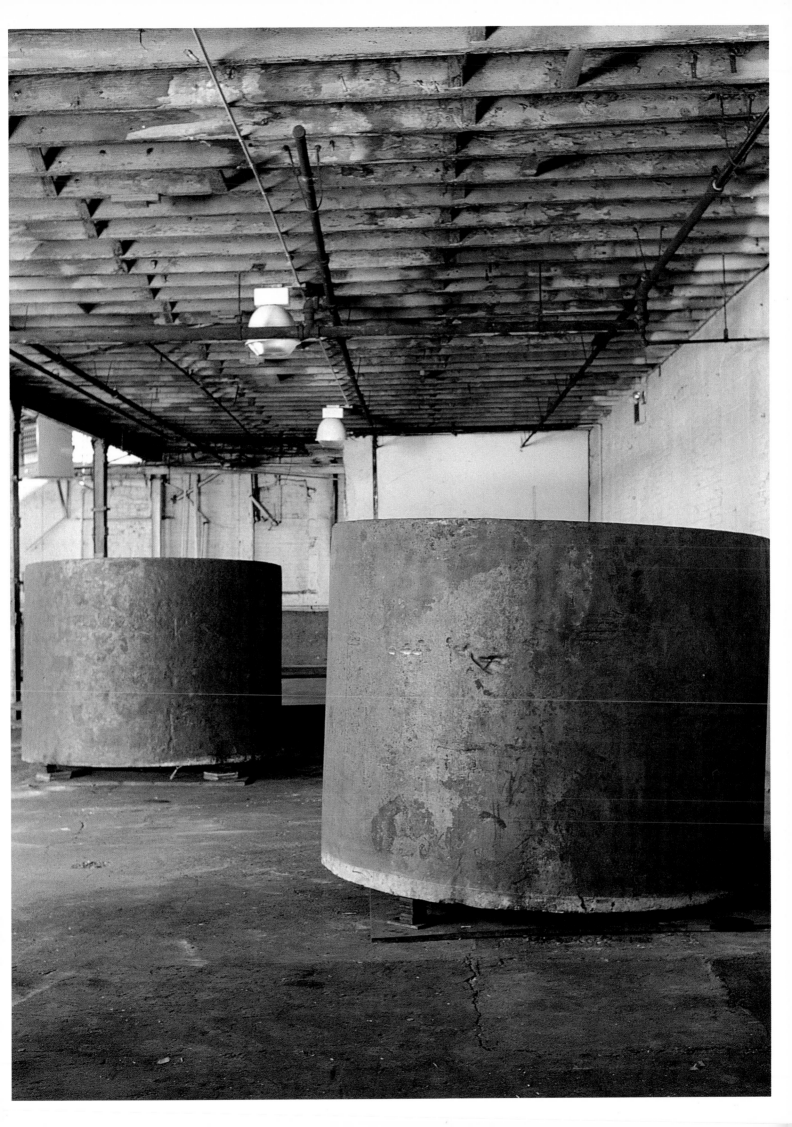

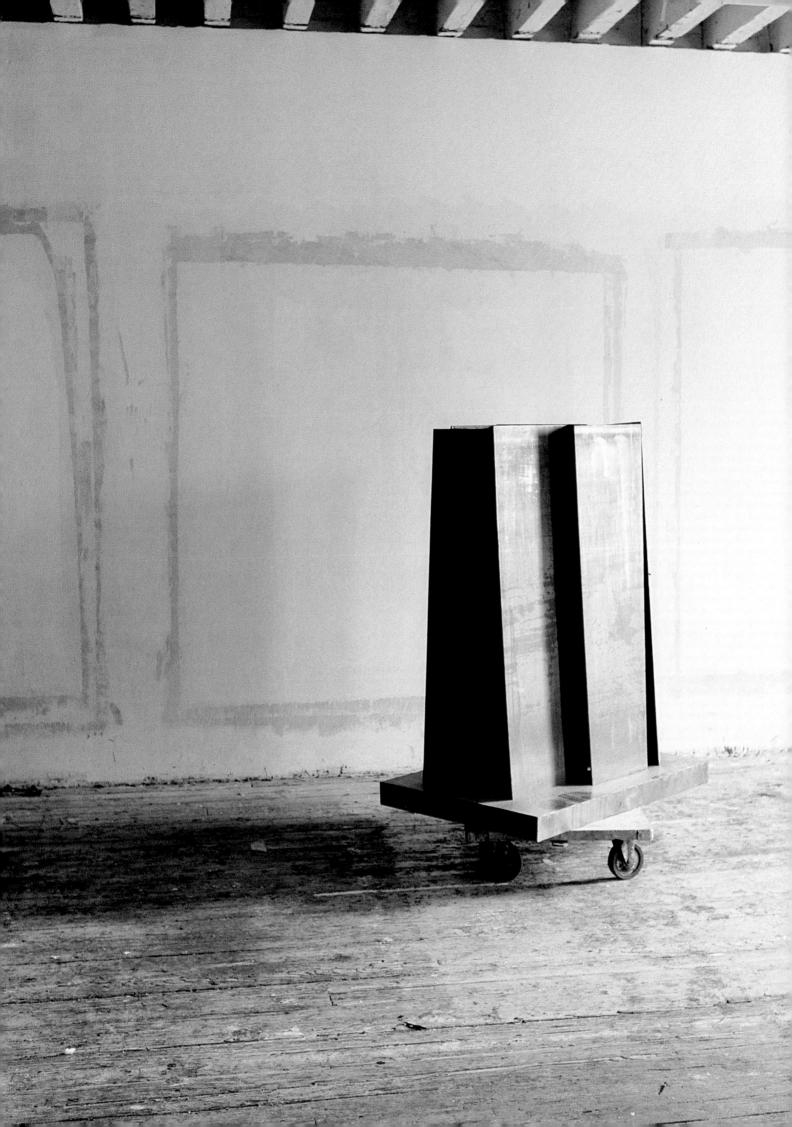

Serra says that he works by scale, not size. One of his earliest memories, from when he was growing up in San Francisco, is of driving over the Golden Gate Bridge to a shipyard where his father was a pipefitter. At the shipyard he saw a tanker being readied for launch. As the cables were released, and the huge ship ripped through the scaffolding on its way to the sea, he watched, transfixed. Suddenly, this dead weight became a graceful, buoyant mass of steel. Serra says of the moment, "All the raw material I needed is contained in the reserve of this memory, which has become a recurring dream." Everything about Serra is bigger than life. He is a fiery encyclopedia of knowledge and experience, and to spend time with him is one of the most exhilarating experiences imaginable. Like his work, he is compact, stubborn, and solid. He is possibly the most cultivated man I have ever met, knowing the location of countless works of art in museums and collections around the world and easily conversant on any number of subjects, including architecture, philosophy, and politics. He loves to argue and debate, and if he disagrees he will shoot you down with a wicked, unceremonious smile. The first portrait I did of Serra was in 1978 when a collector friend in Los Angeles, Elyse Grinstein, suggested that I call him. I had been a great admirer ever since I stood inside of his *Sight Point* at the Stedelijk Museum in Amsterdam and looked up at that framed triangle of sky during a weekend trip from school in Paris. We later did several more sittings together, and I interviewed him for both French *Vogue* and *BOMB Magazine*, and then photographed him again for *Elle Decor*. When we talked about the "Torqued Ellipses" at Dia, I told him that I much preferred the installation at Gagosian a few years earlier. I told him that had been like a religious experience for me. And he answered, "That's where it all started."

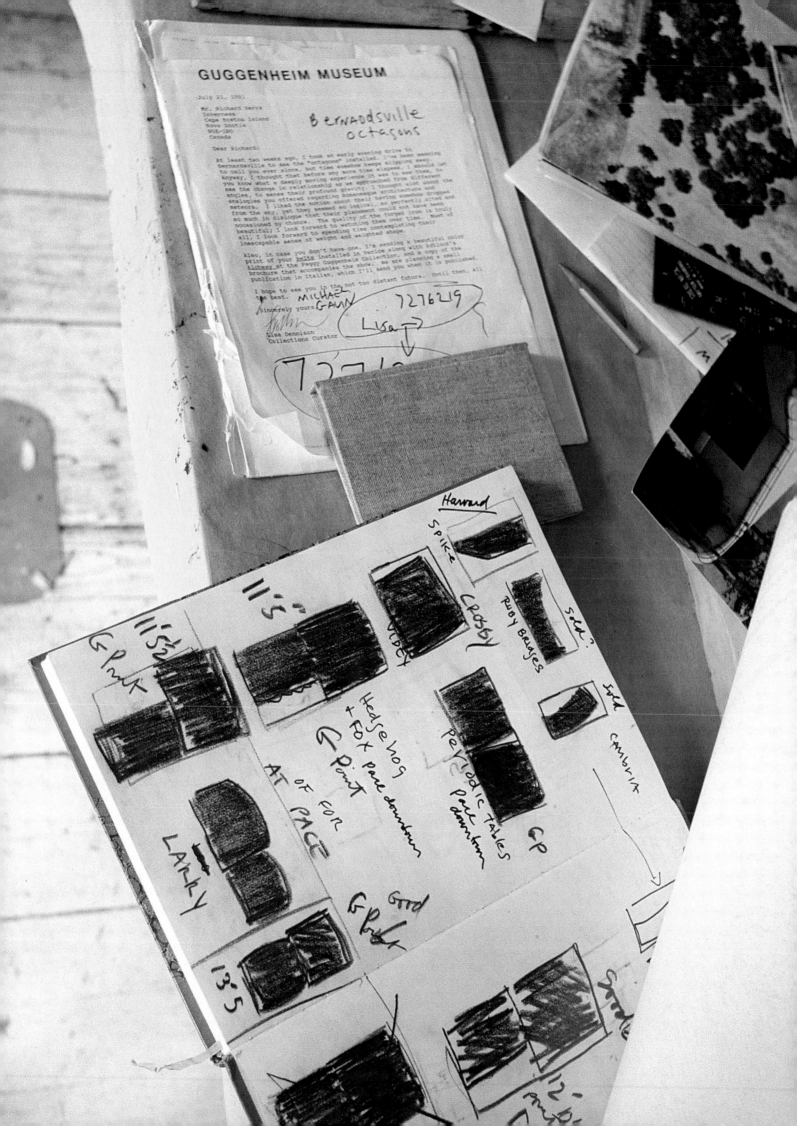

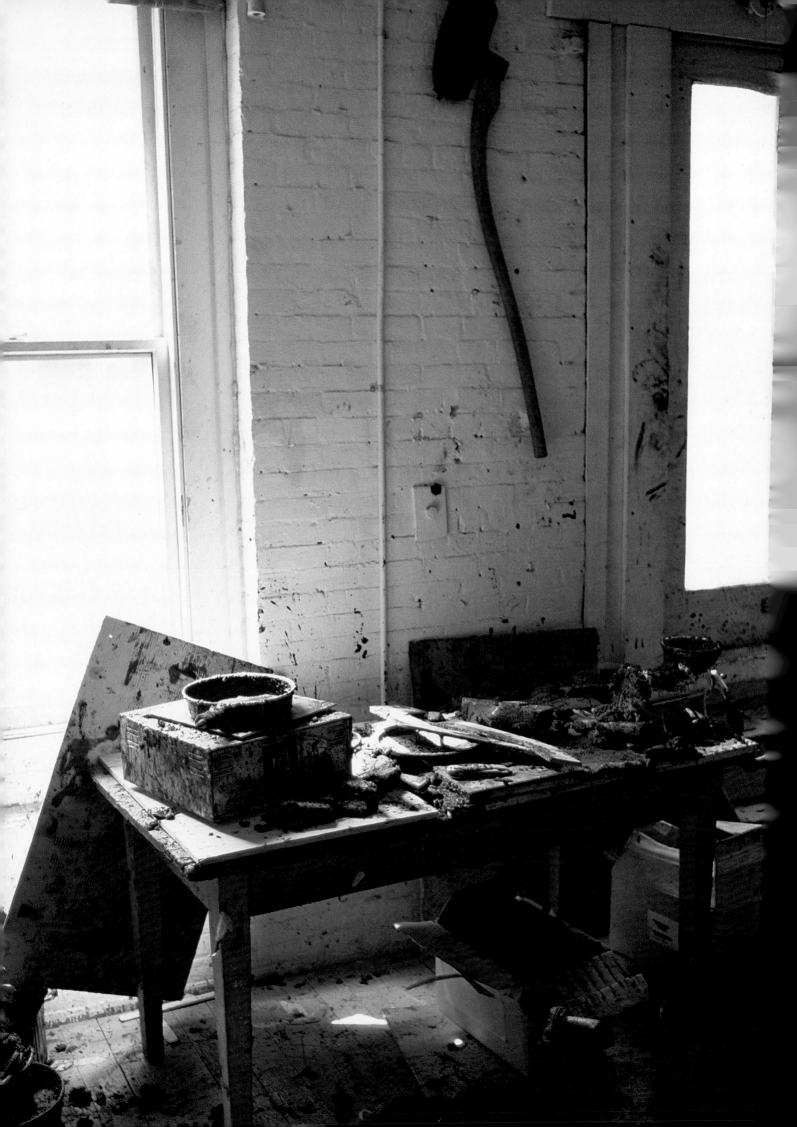

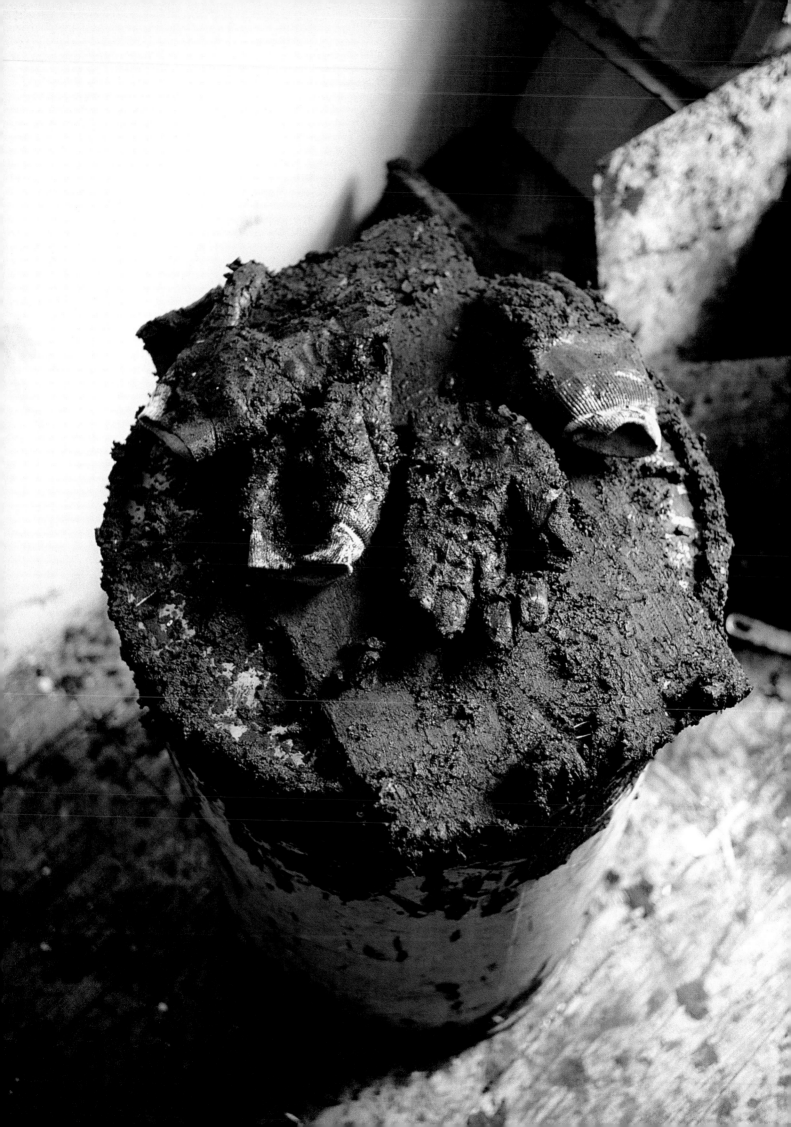

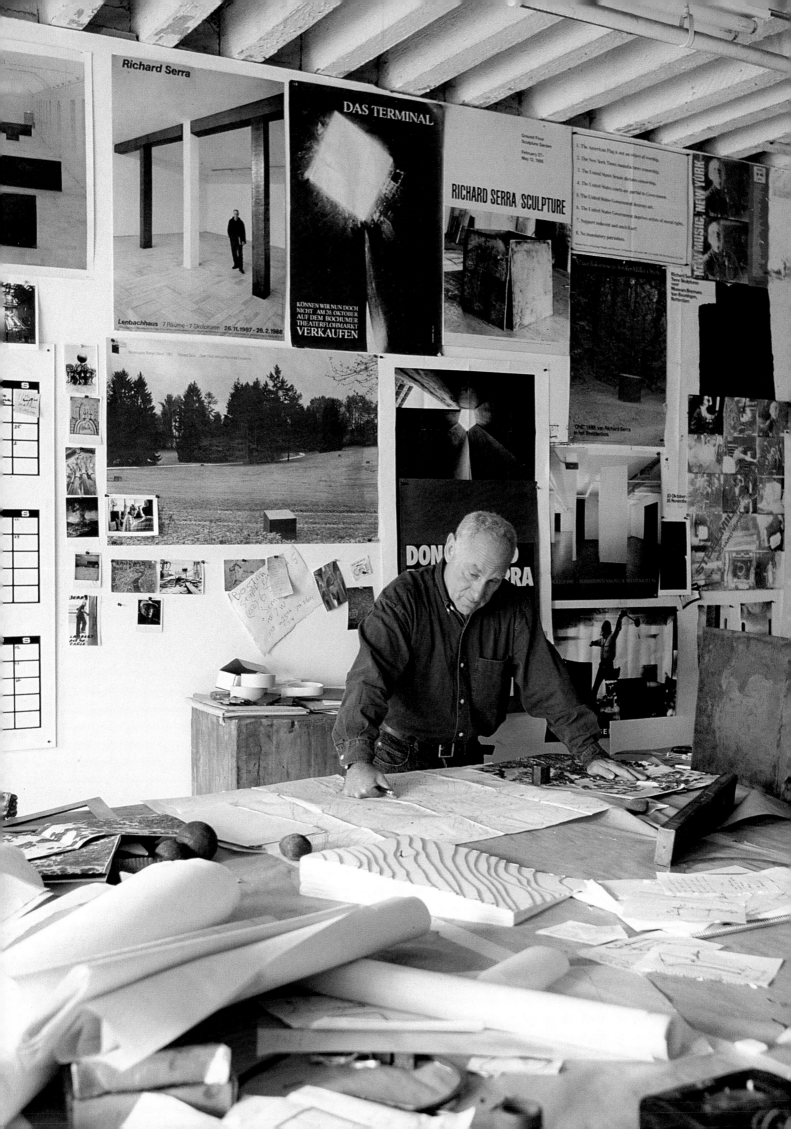

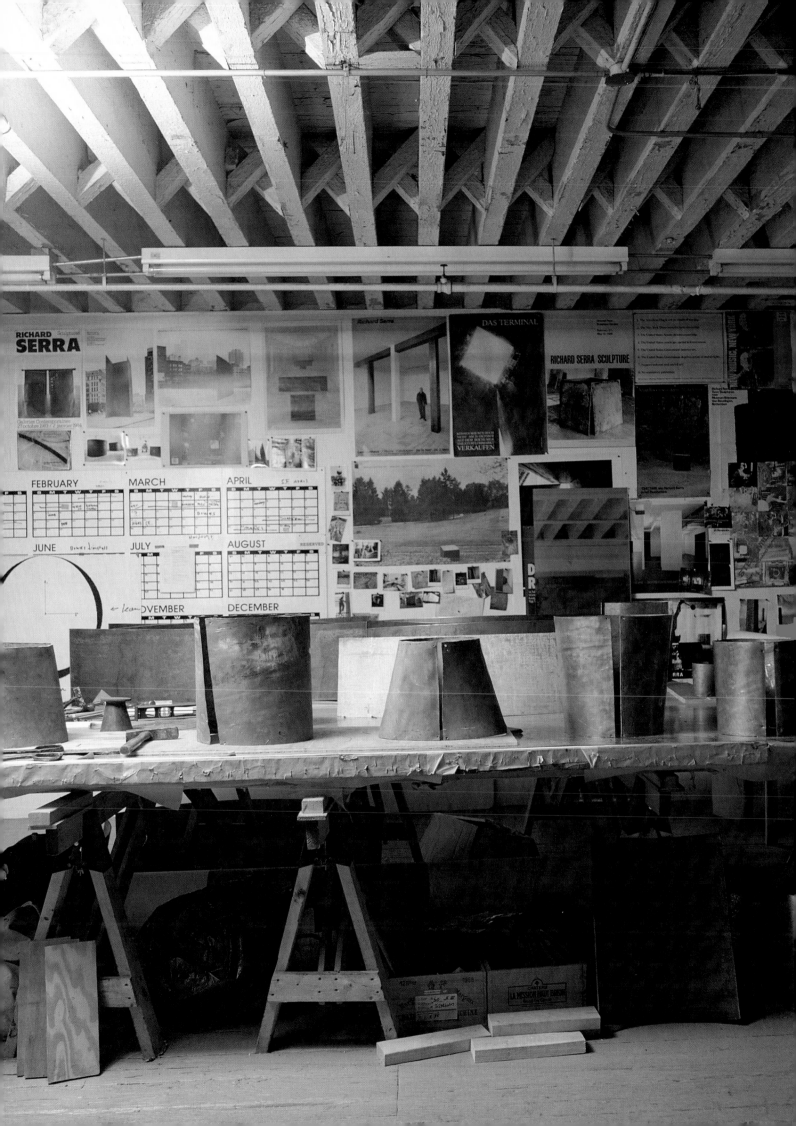

Philip Taaffe

Philip Taaffe's vast studio space in midtown Manhattan was once the gymnasium of an Afghani school. One has the impression of leaving New York and arriving in Italy. It is ten thousand square feet, with an enormous high-ceilinged central room with clerestory windows; a bright, sunny storage-and-viewing gallery along one side; and a long corridor with production rooms off the other, with windows on the north. The main room has an east/west exposure and additional artificial work lights. In the back is a deep-green billiard room and den. Off the elevator, one is greeted by a beautiful copper door and a suite of doorways unfolding like Dalí's dream sequence in *Spellbound*. Through the first doorway is a room full of exquisitely carved empty frames and small painting studies. The following rooms are used for stenciling or painting or whatever the work requires at the time. At the end of the hallway is a kitchen and bathroom. The main room usually has large paintings in it and tables covered with books and reference materials. There is also an impressive library in the back of the loft. Philip and I met in the mid-1980s at a dinner at my friend Roberto Juarez's loft. Jack Pierson was there, too. Philip was about to move to Naples, and I thought he was crazy. I couldn't imagine for the life of me why an artist would want to move from New York to Naples. But I found out. Before he left, his work was a sort of reenactment of reductivist painting: imagine a Barnett Newman, but instead of a zip, it has a cable running through it. After he returned from Italy, though, he was exploding with ideas—a fabulous mix of the Italian Baroque, heavily influenced by Islamic art, with the texture and patina of history.

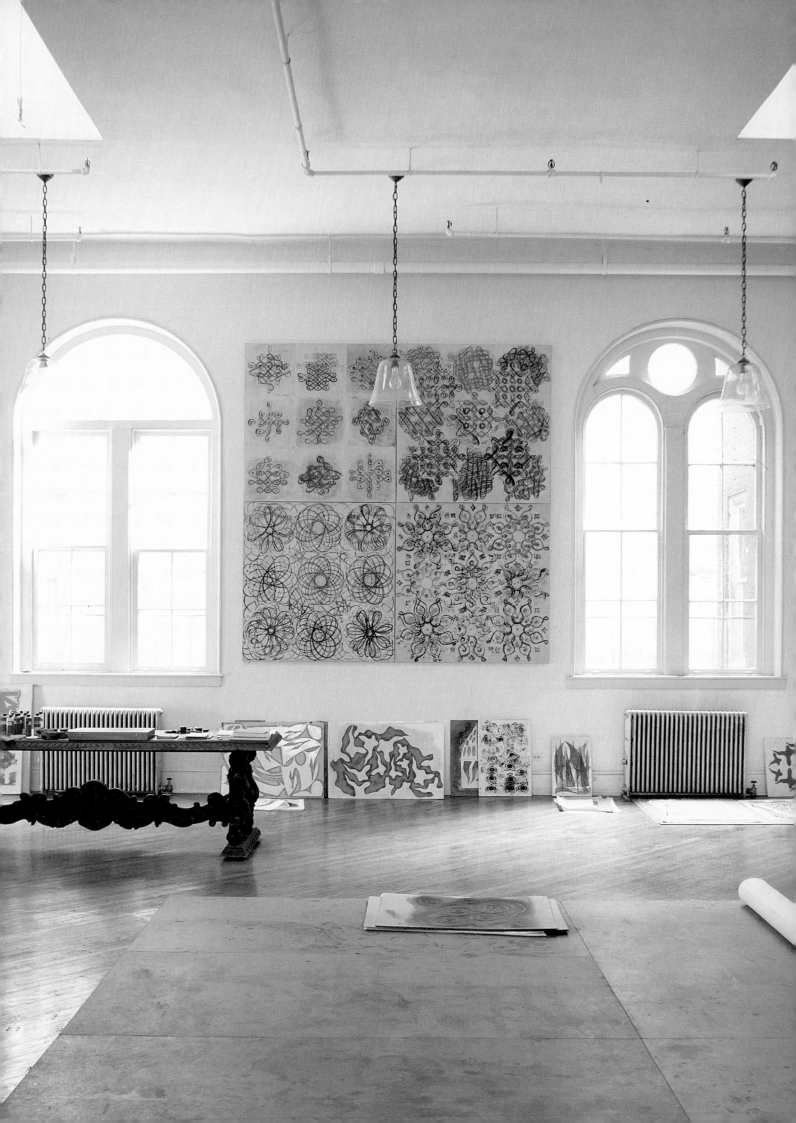

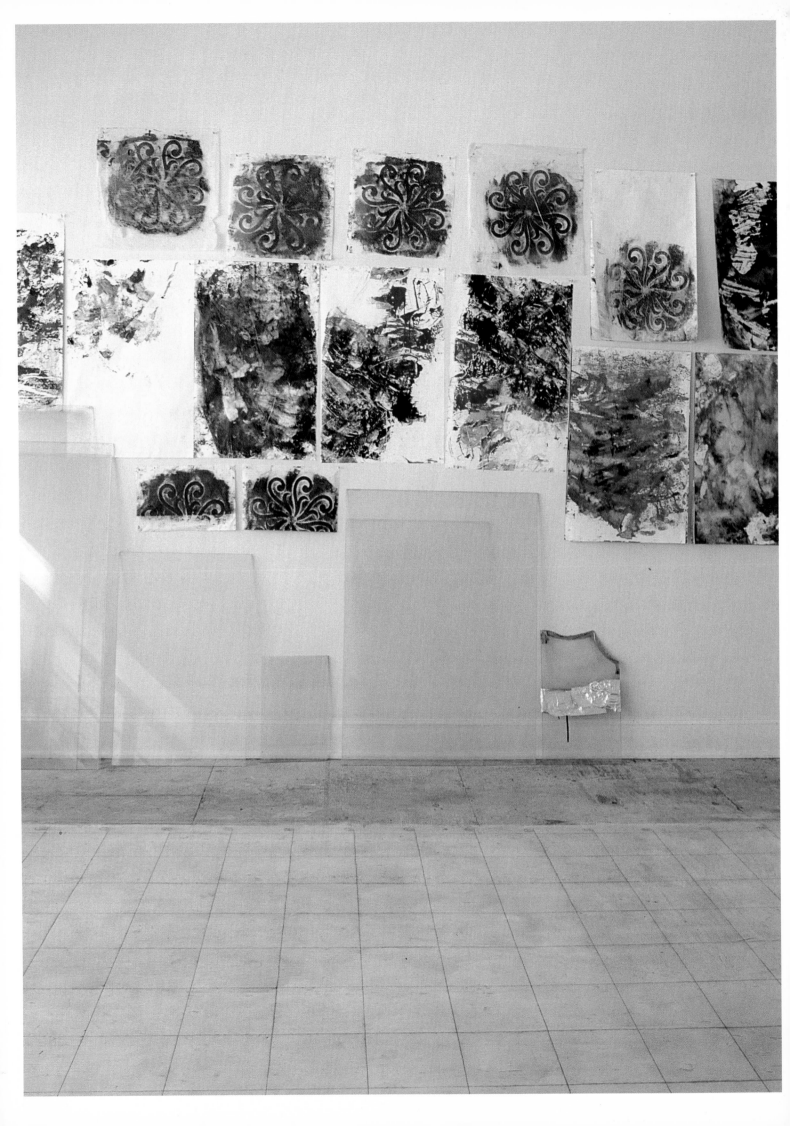

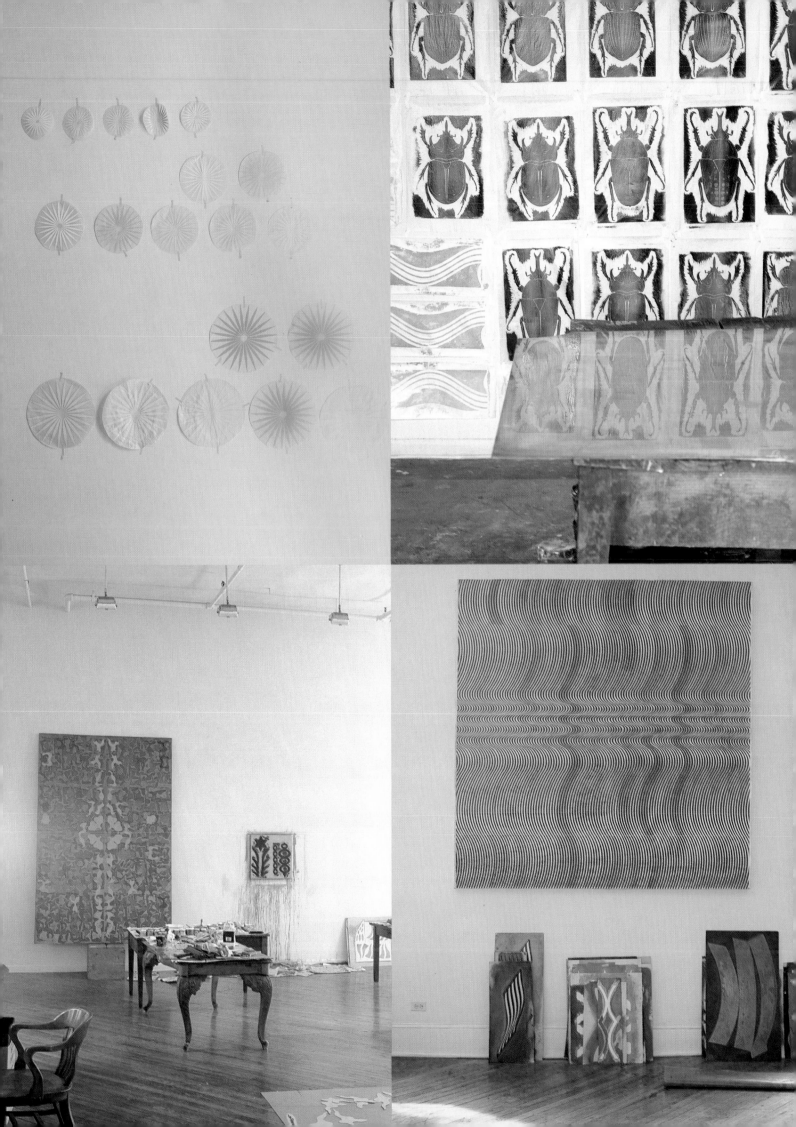

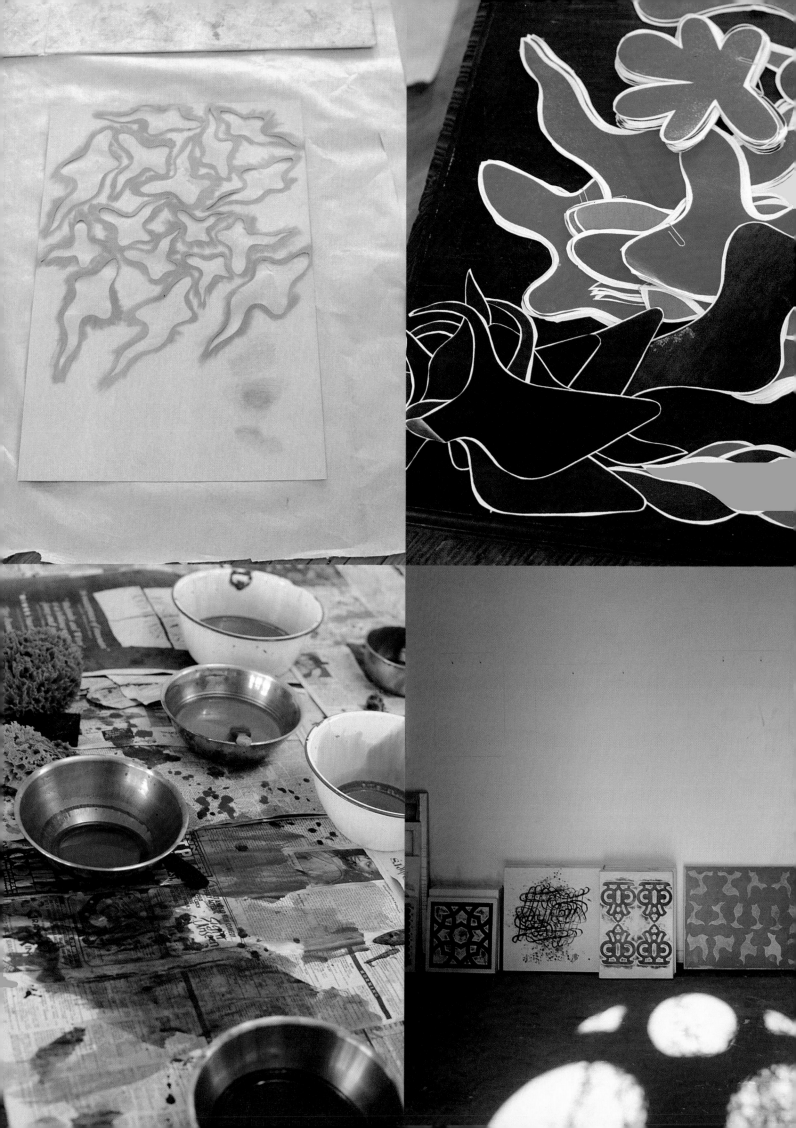

Philip is a dandy. He was once described as a beauty addict. In Philip's case, taste is not the enemy of art. He has impeccable taste, and his world and his work are a solidly integrated whole. His working and living spaces are exquisitely refined. The tables in his studio are carved, the rooms in his apartment are stenciled—everything about him is embellished, neat, and tasteful. I always imagine him with his top button done—a gentleman—natty. I didn't know Philip that well before he left for Naples, but on our first meeting I was impressed by his ease and discretion. There is something almost secretive about him. He speaks sparingly and intelligently, and as a person he is kind and gentle, humble and gracious, serious and very productive. The amount of work generated by that one man is staggering. He is so industrious and hard-working that a trip to his studio is always an inspiration. He has traveled a great deal and brought back influences from around the world that often end up in his work. Calligraphy and ornamentation from North Africa, woodblocks from India, sword guards from Japan. Whether or not he goes to specific places, his sense of the world and his global fusion of aesthetics is a very important part of his work. Yet, he is unassuming and somewhat shy. He is soft-spoken and he moves slowly, having adopted the Italian way of life, in stark contrast to his Northeastern upbringing. What he didn't bring back from Naples is any of the chaos. A visit to Philip's loft is always an event: he has a unique gift for gathering large groups of people in this wonderful space.

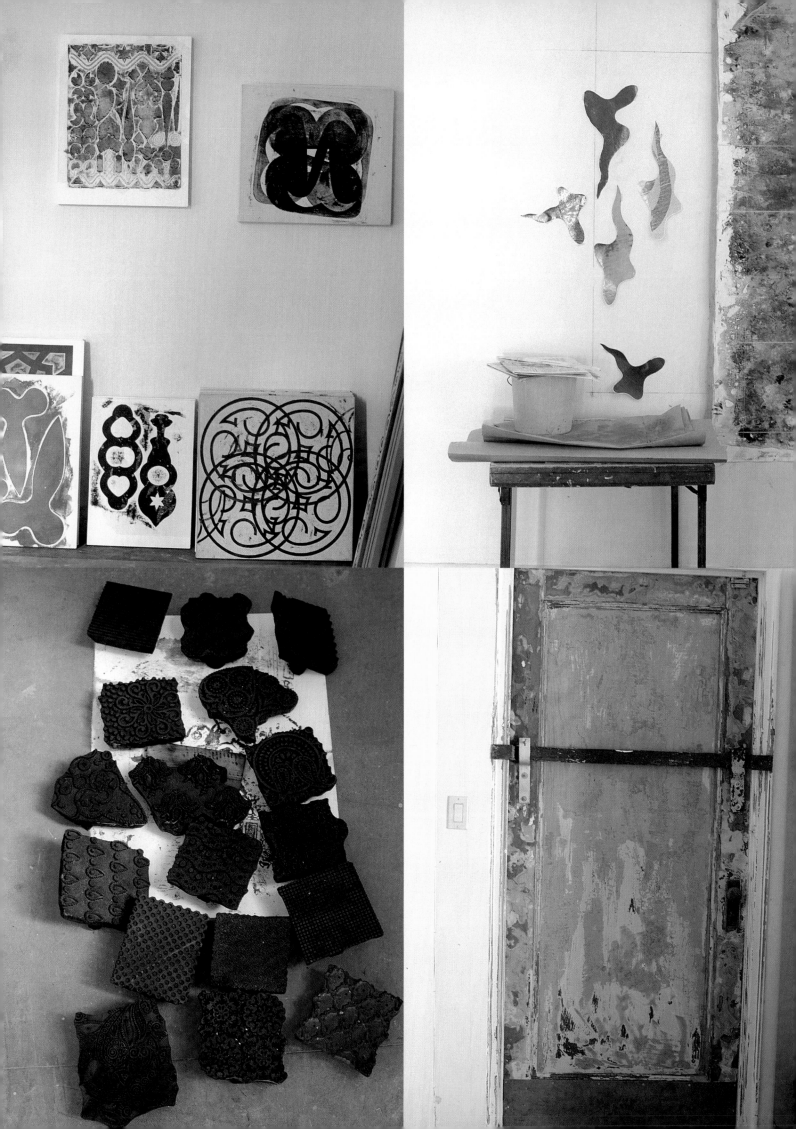

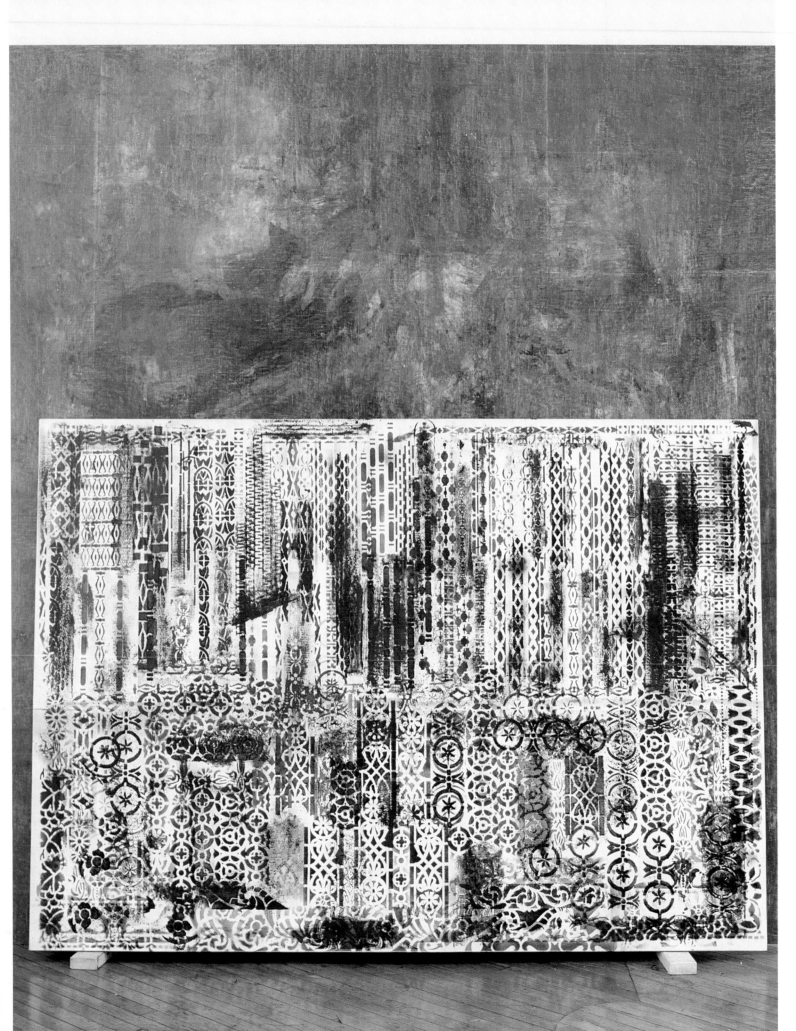

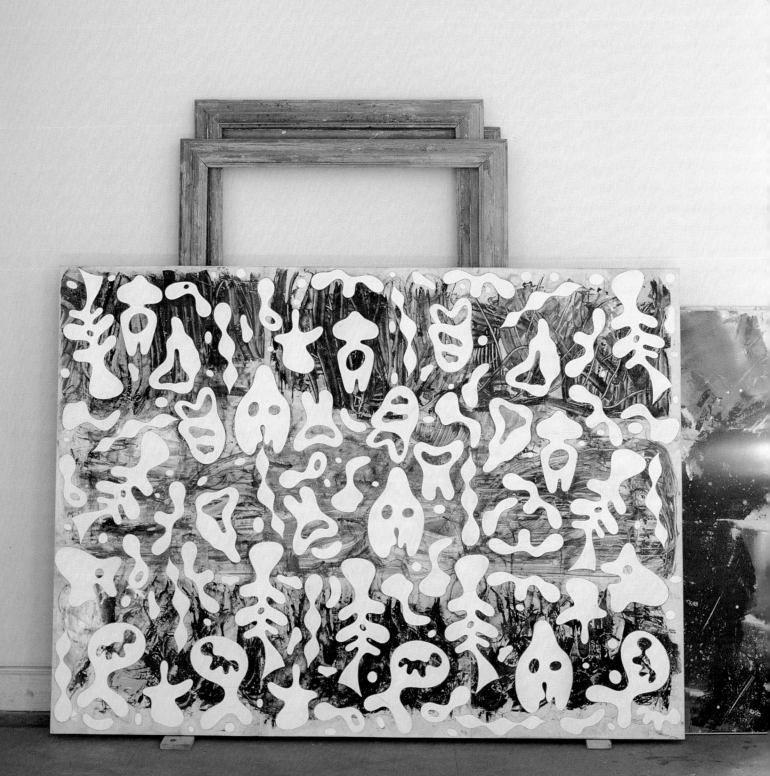

Cy Twombly

Cy Twombly's studio is in Lexington, Virginia, his original hometown. Though he now commutes between Lexington and Rome, and has spent a good part of his life in Italy, he has never lost the slow drawl of a Southern gentleman. These photographs were taken on a glorious spring day, a bit cool and foggy in the morning but clearing to reveal great expanses of green rolling hills. Lexington is horse country and the home of a famous military institute. Everywhere gorgeous cookie-cutter cadets in starched and pressed uniforms marched about with impeccable posture. Cy's father was an important political figure in this part of the country, and a high-school gymnasium is named Twombly. We began our day with a quick visit to his simple white clapboard house, homey and comfortable at the end of a long drive. Then we went to the makeshift studio—a warehouse that is about a five or ten minute ride from the house. The painting, later shown at the Gagosian Gallery, was tacked to the wall in three different panels and filled the skylit space. It was a narrative of a great voyage, full of color and boats. Cy's work never hits you over the head; it unfolds slowly, musically. When I asked Cy about the near absence of brushes, he said, "Oh, I never use brushes." "What do you use," I asked. And he answered, "Oh, rags, sticks...whatever I can get my hands on." The only photographs of Twombly I can remember seeing before his 1994 retrospective at MOMA were one by Horst, I believe from the 1960s, and one by Deborah Turbeville, from the 1970s. Or perhaps something else seen from very far away. Cy is the king of painters and the Garbo of the art world.

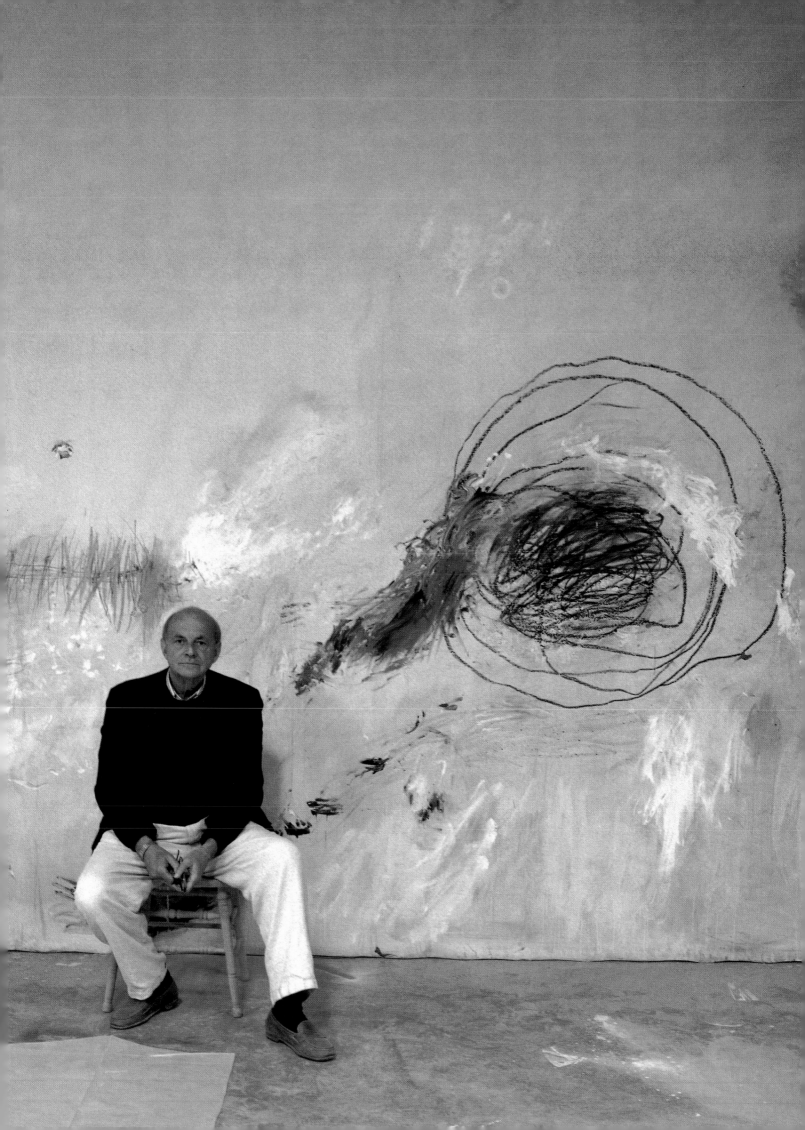

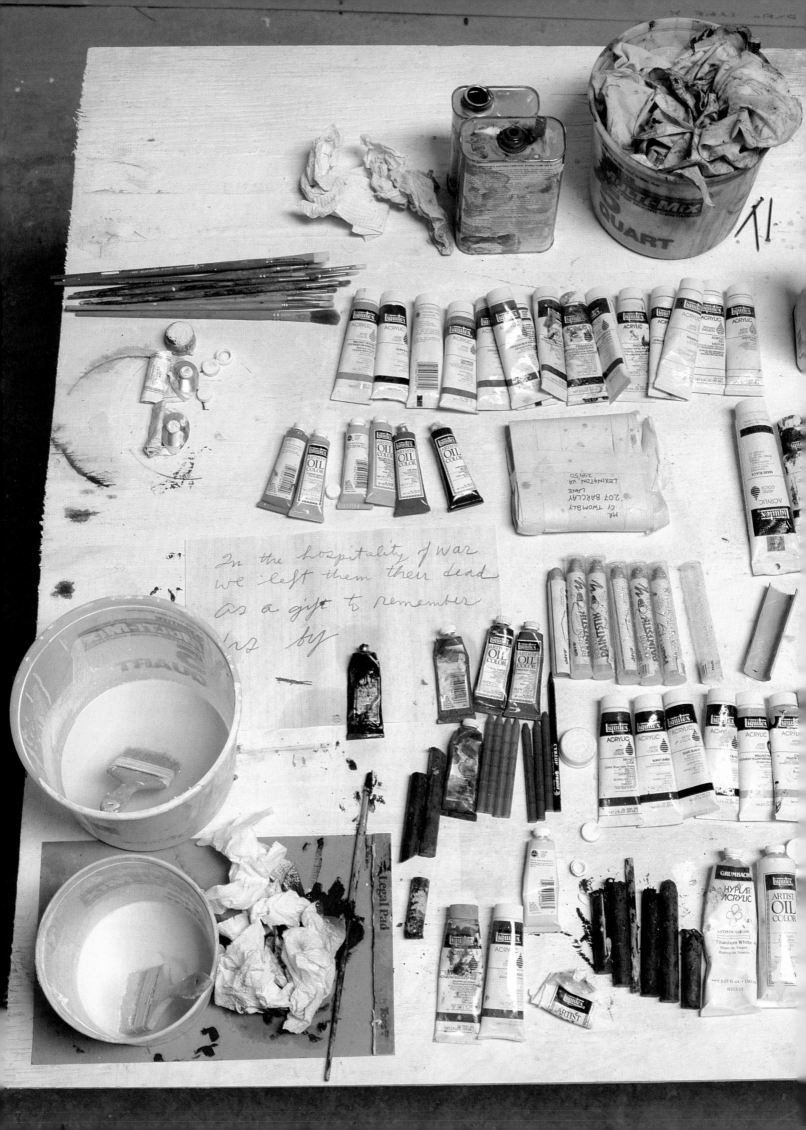

In the hospitality of war
we left them their dead
as a gift to remember
us by

I had been trying to get him to sit for a portrait since 1977, but he only wanted to be known by his work. But there were strong similarities between the man and the work: each was expansive, funny, spare, accessible, noble, discreet. Cy was never grand; he always stayed in the same modest Left Bank hotel in Paris, la Louisiane. Our lives often intertwined through mutual friends. In the 1970s, Cy was very close to a fellow Southerner then living in Paris, named William Burke. William had a gallery called La Remise du Parc with Samia Saouma, who was my mentor. Cy often traveled with a beautiful and gentle Italian friend, Nicola del Roscio, and we once spent a memorable day in Paris together, walking across the Luxembourg gardens with Thomas Ammann. Rows of chestnut trees were in bloom, and we stopped at an antique fair in the Place St. Sulpice before ending up in Montparnasse. It was a carefree and idyllic day full of joy, surrounded by the beauty of Paris in early summer.

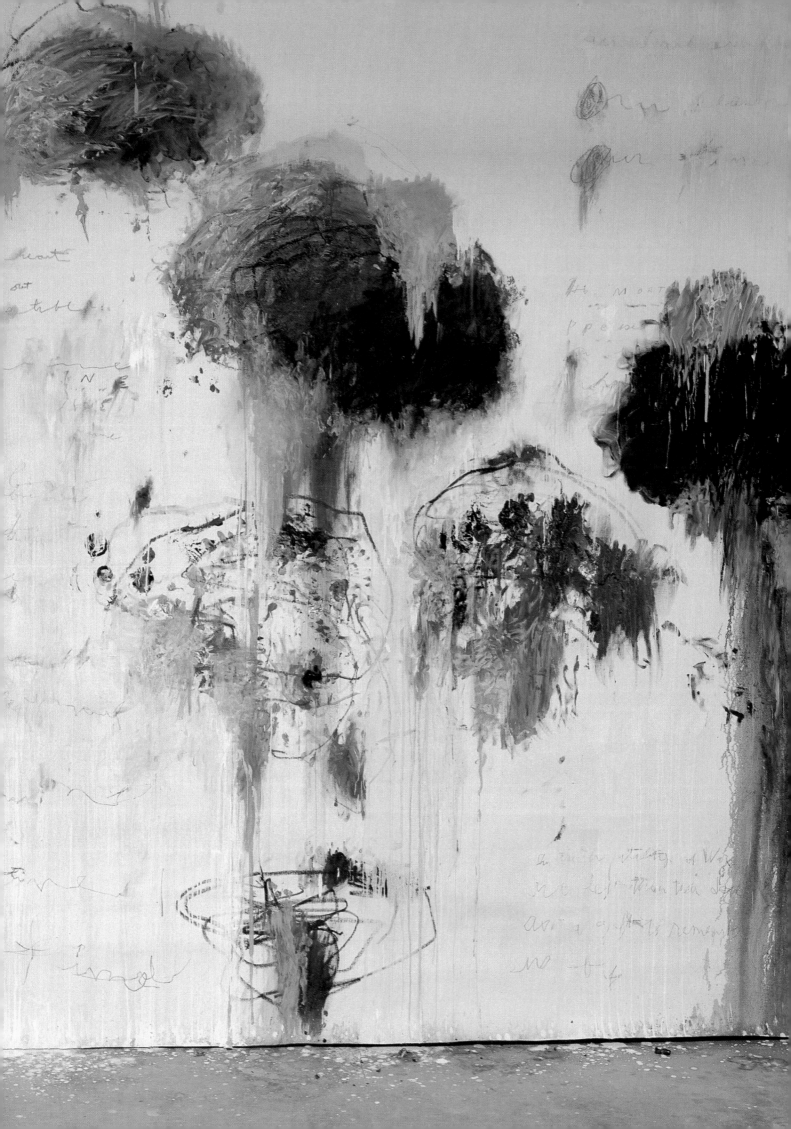

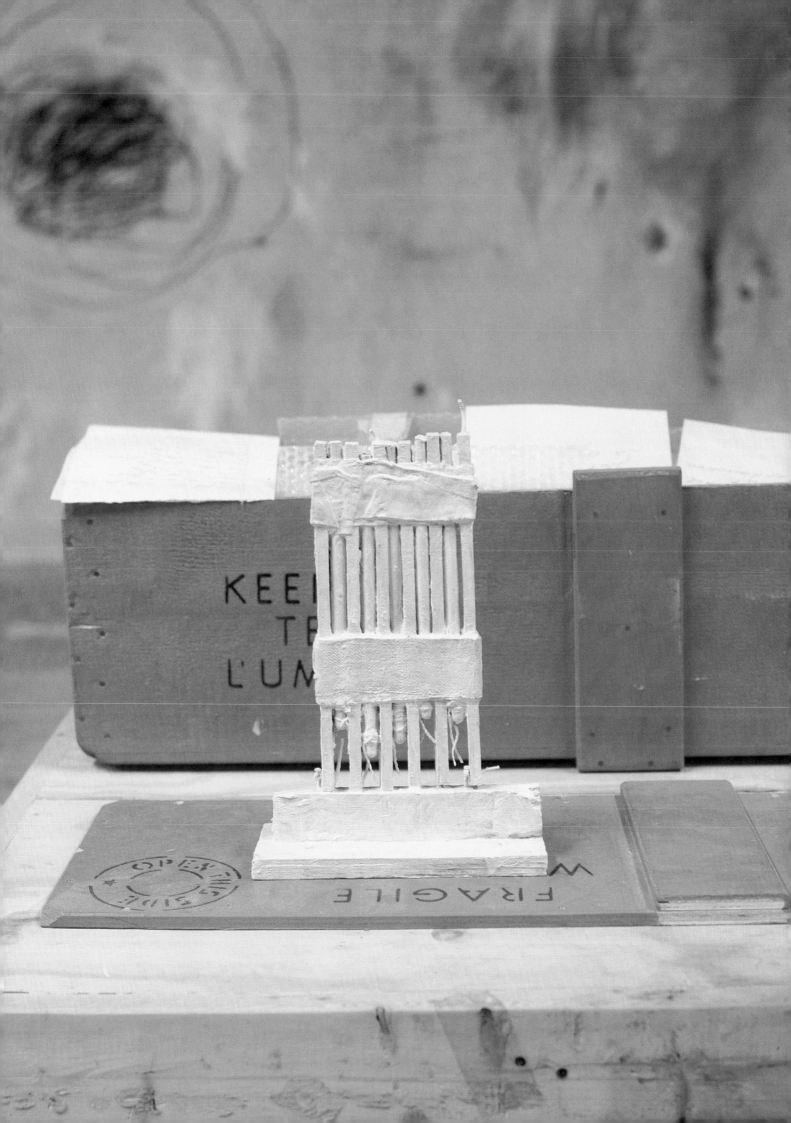

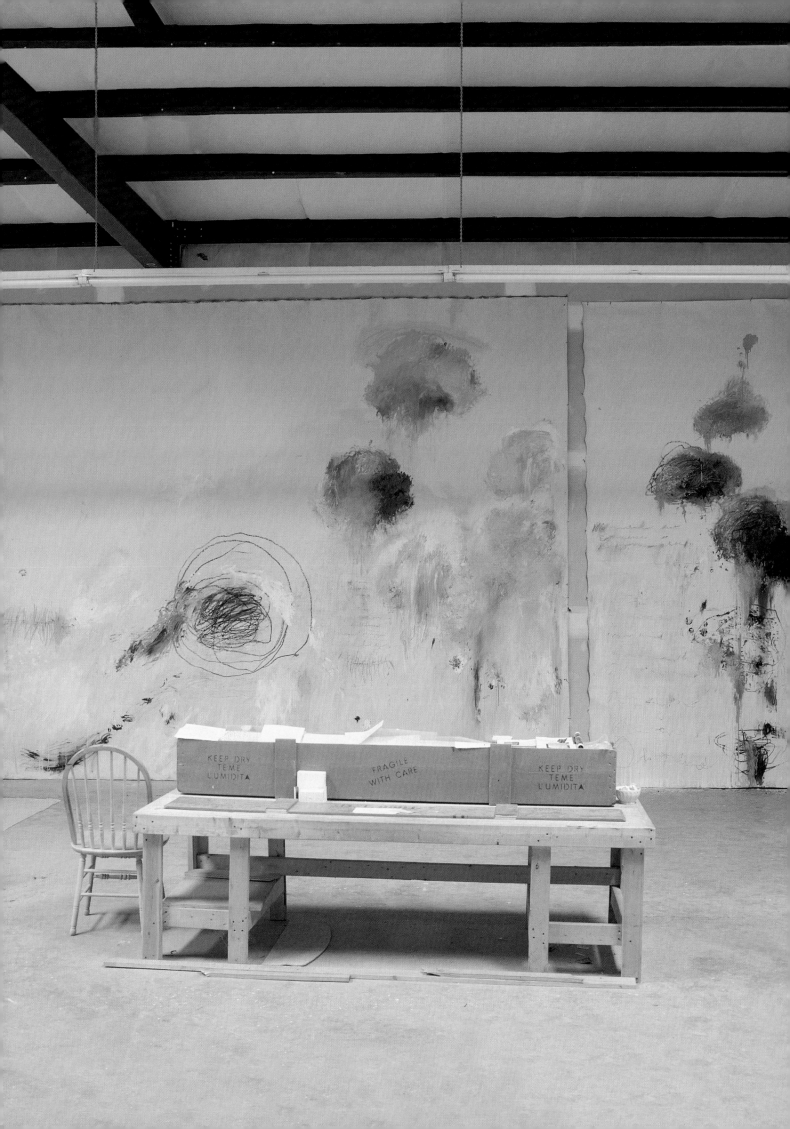

Terry Winters

Terry Winters' studio occupies three floors of a building in Tribeca that he shares with his Swiss-born wife, Hendel Teicher. The painting studio, on one of the floors, consists of two large, empty rooms, with a storage space in the middle. As empty as the painting studio appears, the drawing studio is full: drafting tables, filing cabinets, stacks of papers, Japanese brushes in padded rolls tied with ribbons, leaving an impression of order and refinement. There are things scattered around the spaces that suggest the impetus for Terry's work: fossils, plant samples, minerals. The drawing studio is attached to the office/library, which is the hub of the virtual computer-based universe that is reflected in Terry's new paintings. He is remarkably well-read, with a deep appreciation of culture and knowledge. And, for someone as learned as Terry, what comes as a surprise is his great sarcastic wit. He's incredibly funny in a way that's both loving and wicked. No matter what the subject of the conversation, it's always punctuated with laughter. When you know an artist well, it's hard to separate your appreciation for the person from the work. So I've grown to really love the work as I've grown to love the artist, and followed the journey from a kind of subjective vision of an imaginary microscopic world to the penetration of deep space. Terry and Hendel's life is a rich one, full of beautiful work, stacks of catalogues from exhibitions around the world, and interesting books. An evening in their home always features great conversation, delicious food, and close friends. Terry looks like a Roman senator, and Hendel has the sensuality of a belly dancer. This sitting was done for our mutual friend, Marianne McEvoy, who edits *Elle Decor*; another sitting was done for *House and Garden*.

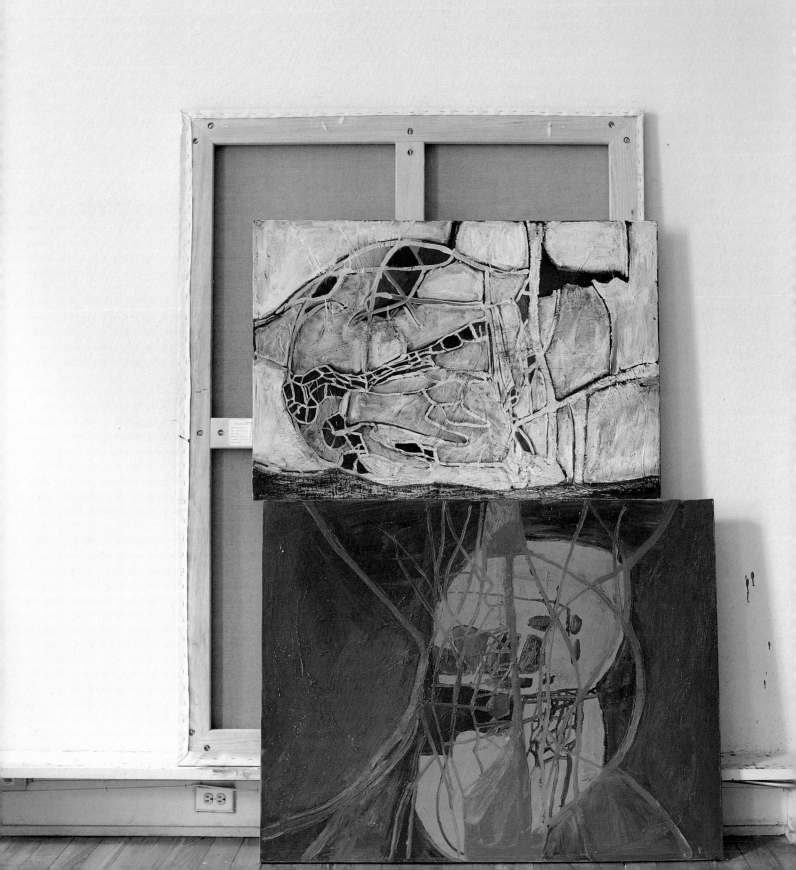

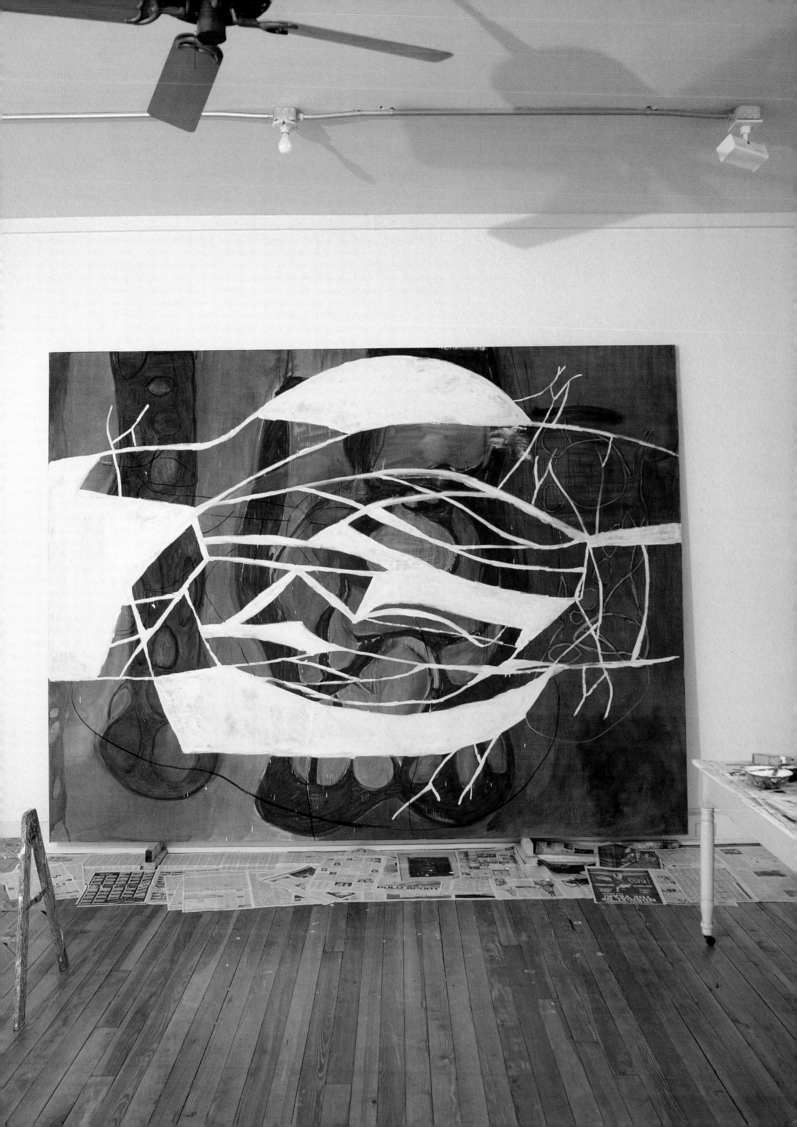

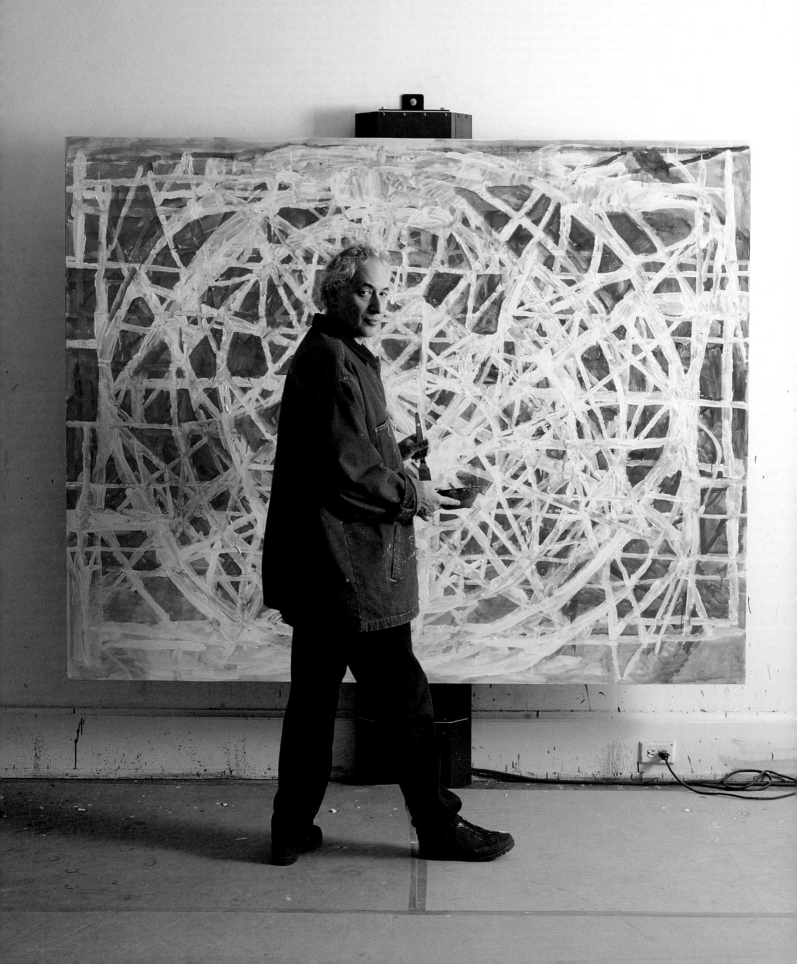

Francesco Clemente

Francesco Clemente has been in this studio on lower Broadway since the early 1980s. It is an old factory space with large columns and lots of Frank Lloyd Wright furniture. At the time of this sitting, it was bursting with work. The summer light came through a long row of south-facing windows, bouncing off the building across the street. It had a powdery quality to it that reminded me of being in India, and I understood that this dusty light was itself of Francesco's aesthetic. There was a painted meditation ring on the floor and little Indian photo postcards of a swami in twisted positions. The incense burners, the rock-crystal lingam, and the Eastern effigies created a fusion of worlds that made New York seem very international. This sitting came about because Francesco and I had been talking for years about trading portraits. I did several portraits of him and was fortunate enough to sit for a portrait by him. It doesn't often happen that I am on the other end, and I found that it's a very intimate experience. He worked quickly in pastel on a large sheet of paper, his eyes darting from me to the paper. But he wasn't looking at me as much as he was looking at my features. I became objectified, an abstraction. The result looked like a cross between the two of us, with very large eyes, like all of Francesco's portraits, and more of his mouth than mine. All of Francesco's portraits are equal parts him and the subject. Francesco has a smooth, felinelike way of moving through spaces. His posture is erect but all the lines are soft and rounded. He glides in and out of rooms silently, effortlessly. He is strikingly beautiful but his beauty is somehow diaphanous, like smoke. His presence can be very strong, yet he's a master of disappearance.

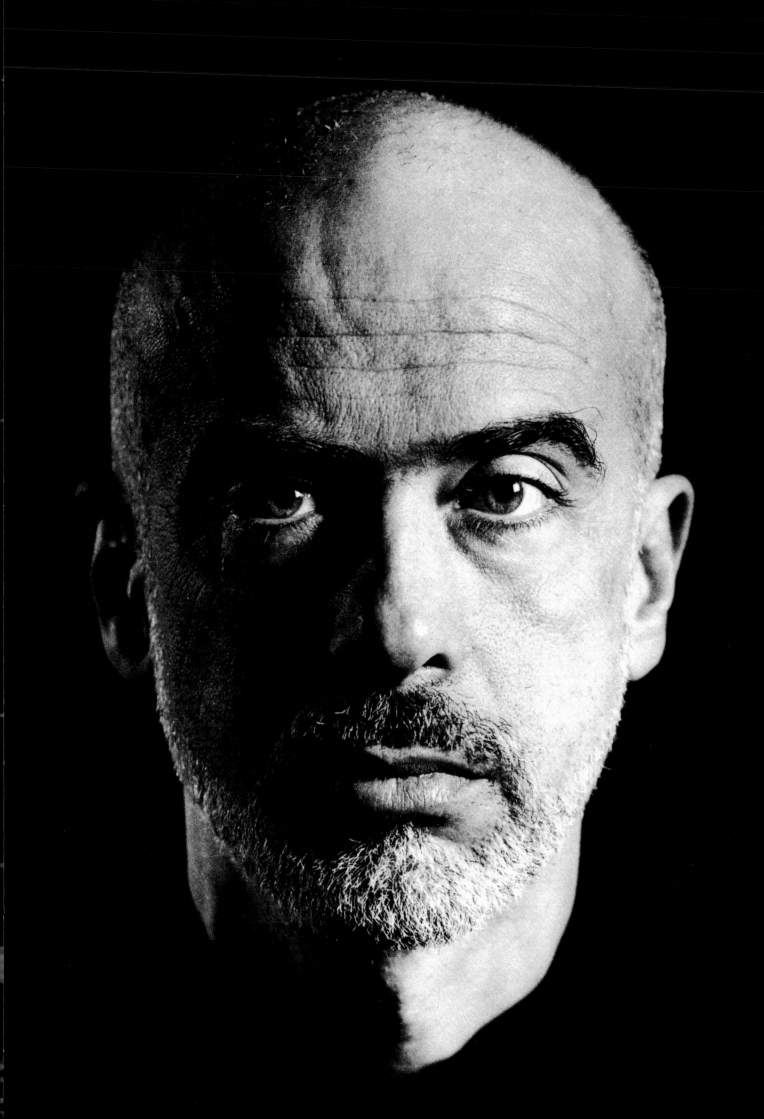

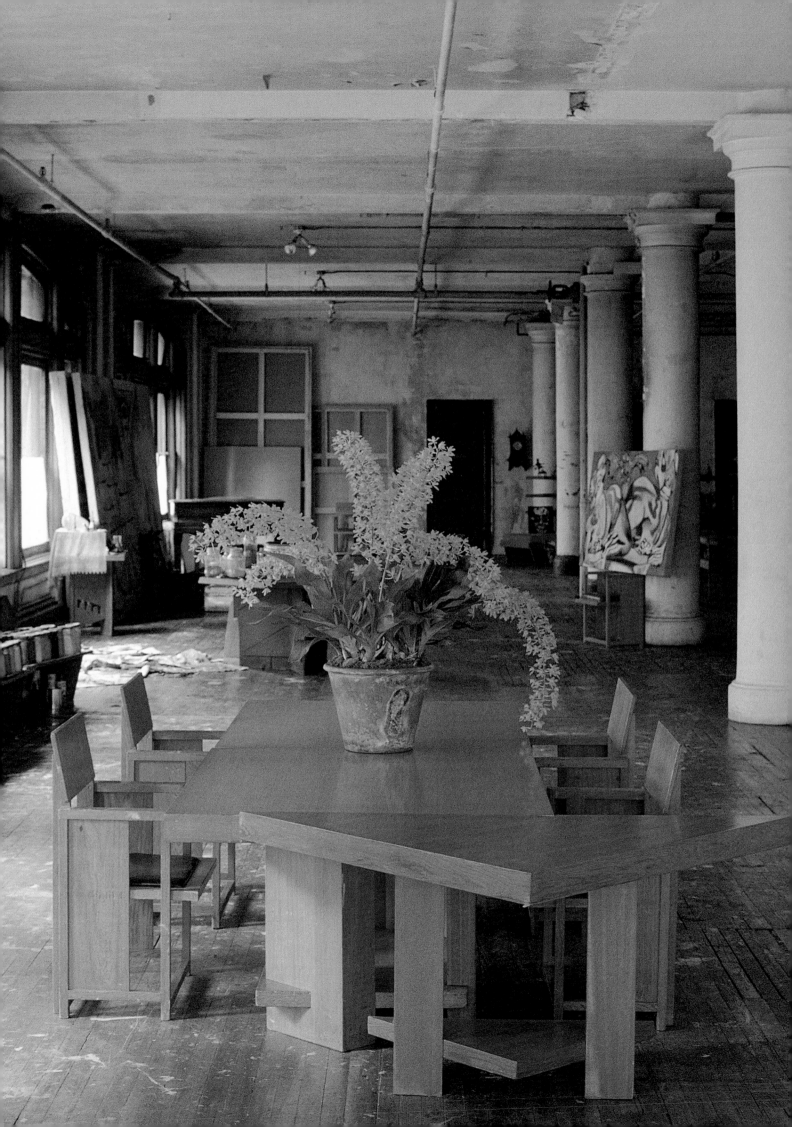

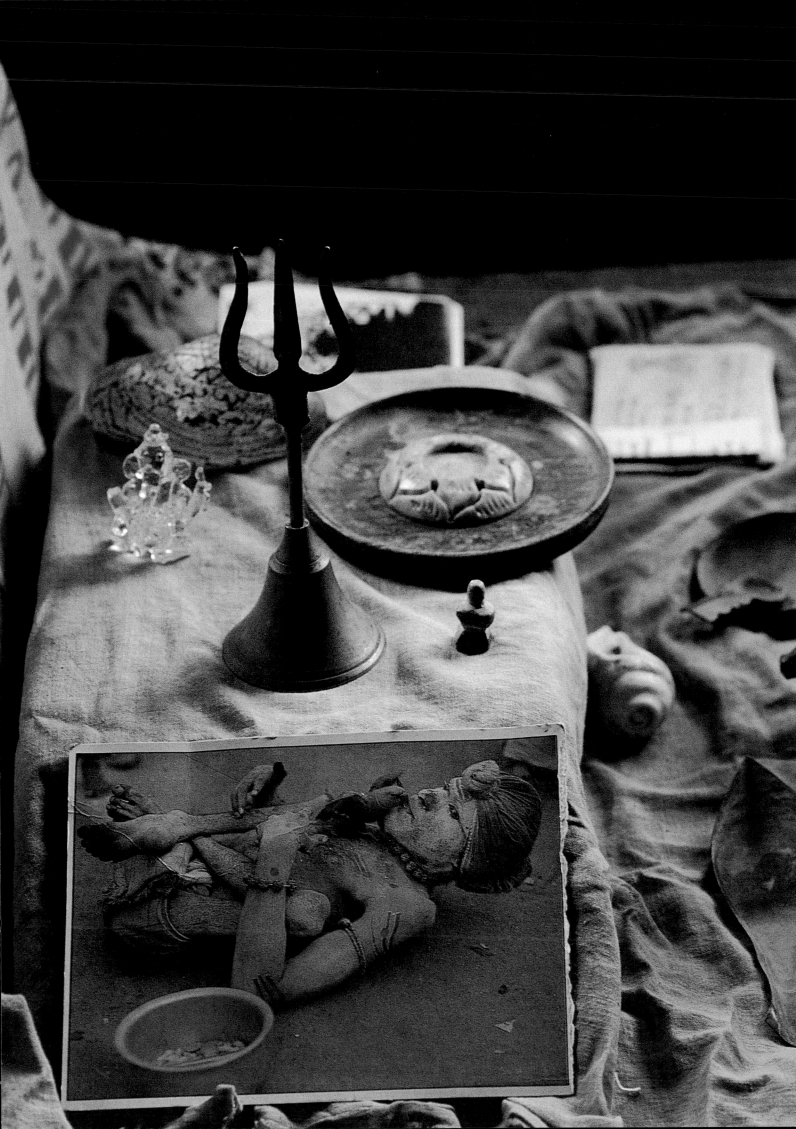

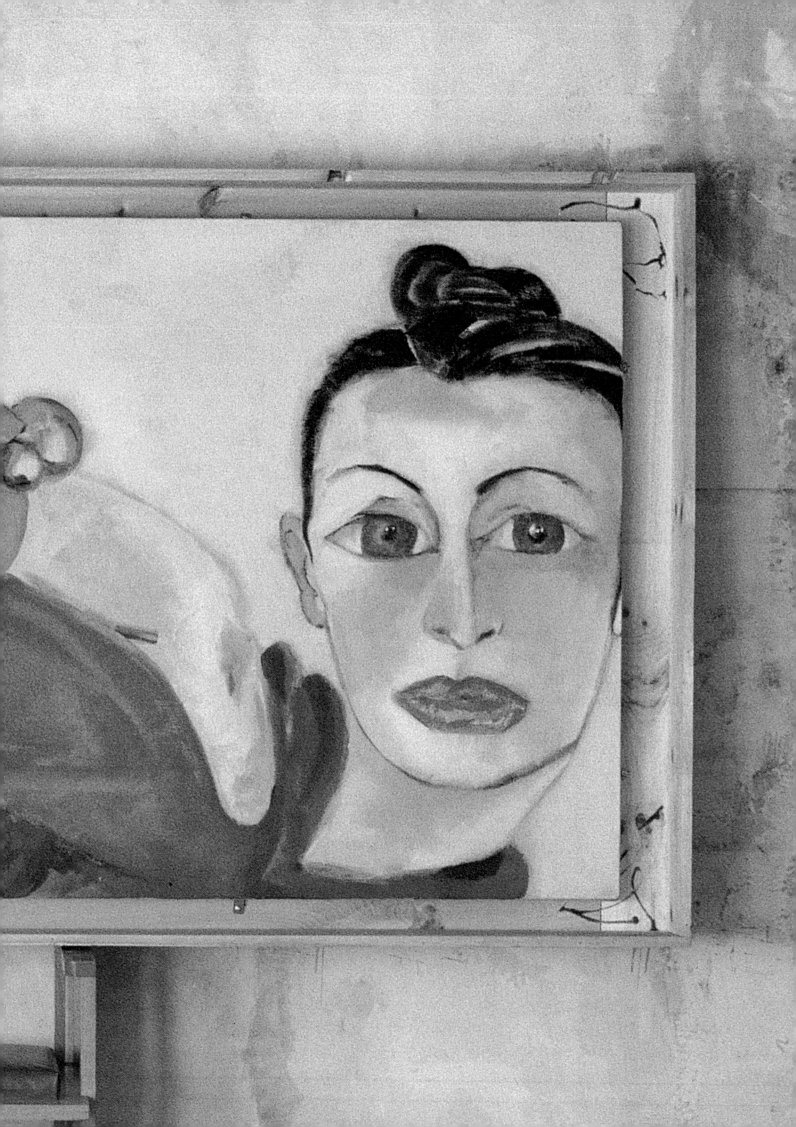

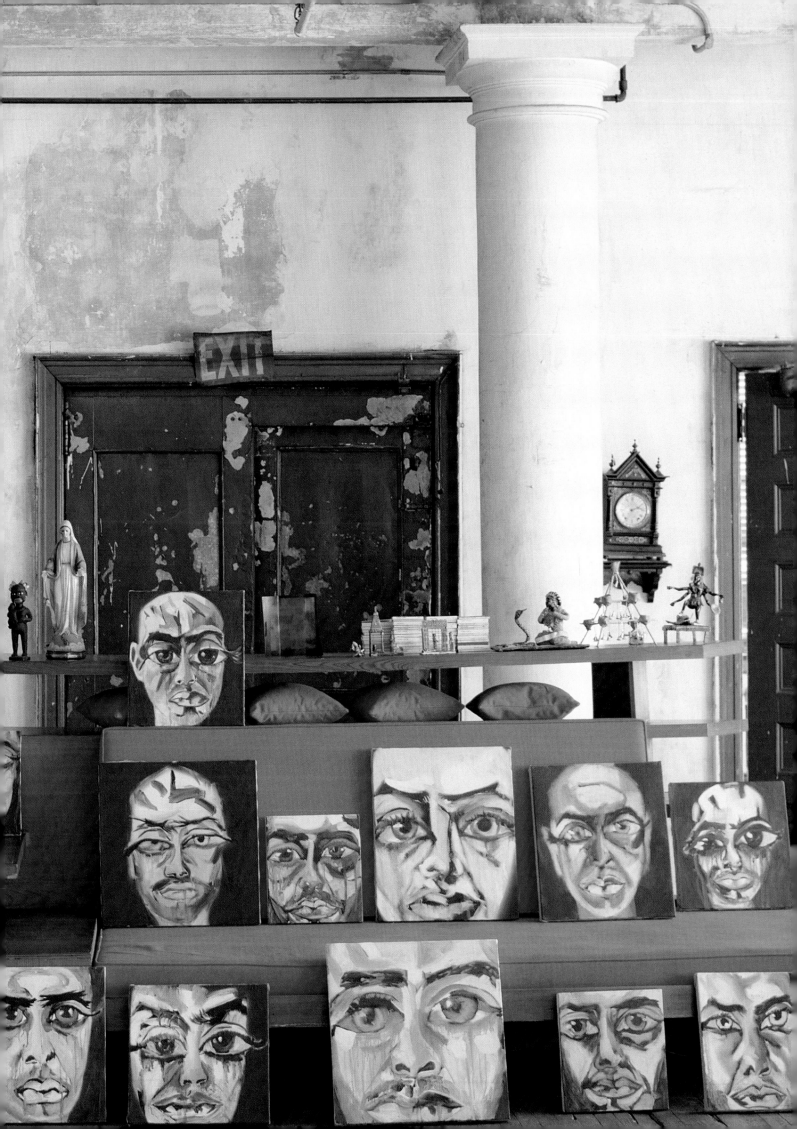

He is very soft spoken, with a high-pitched voice, and shy and retreating. After spending so much time in India, he has an almost religious presence to himself. He really does seem to be beaming. His wife Alba, a great Mediterranean beauty, is the gregarious one in the relationship and it would be hard to think of Francesco without Alba. They are the ubiquitous New York couple. As a couple, they are very dear to me, and this past summer, I kept dreaming of Alba in an ancient sacred Tibetan robe, purple and ochre with golden threads. It was a strange dream about meditation—Alba was the new incarnation of an old Buddhist spirit and privy to a sacred world. She was a maternal figure, a demi-goddess. It was striking how casual she was with the precious garment. That's a fitting metaphor for both Francesco and Alba, who don't take their celebrity as seriously as their Italian talent for living well.

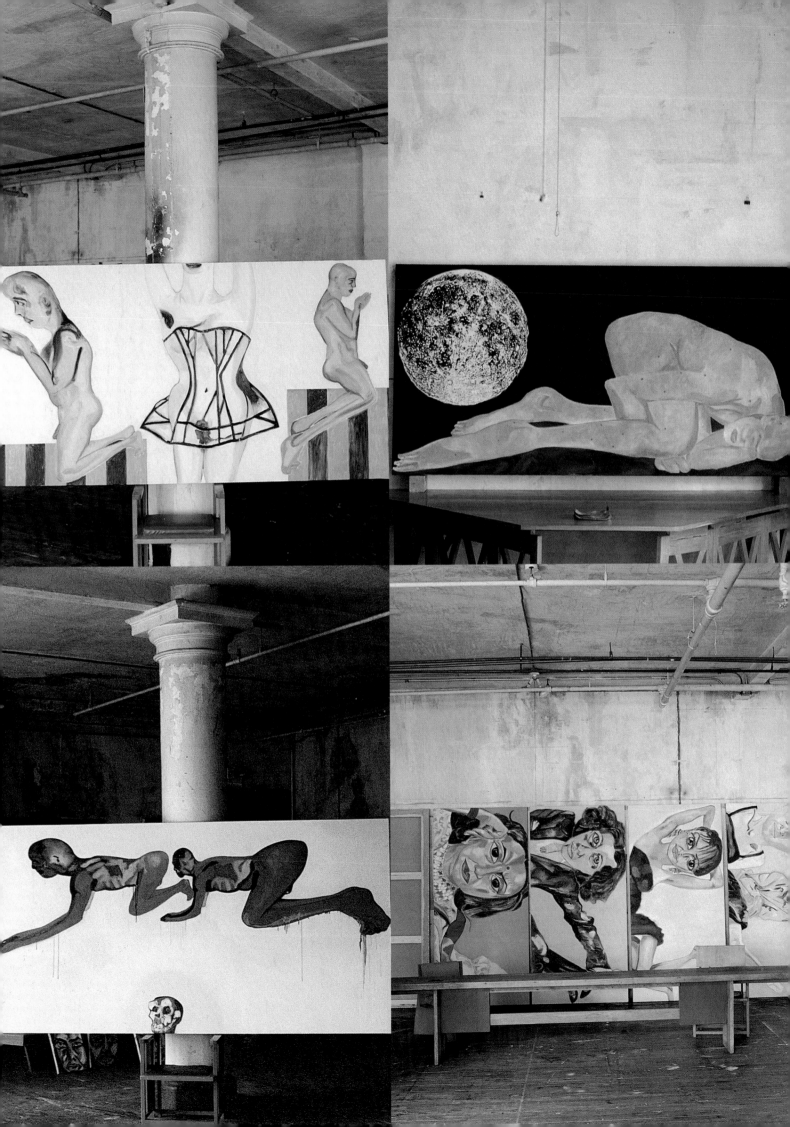

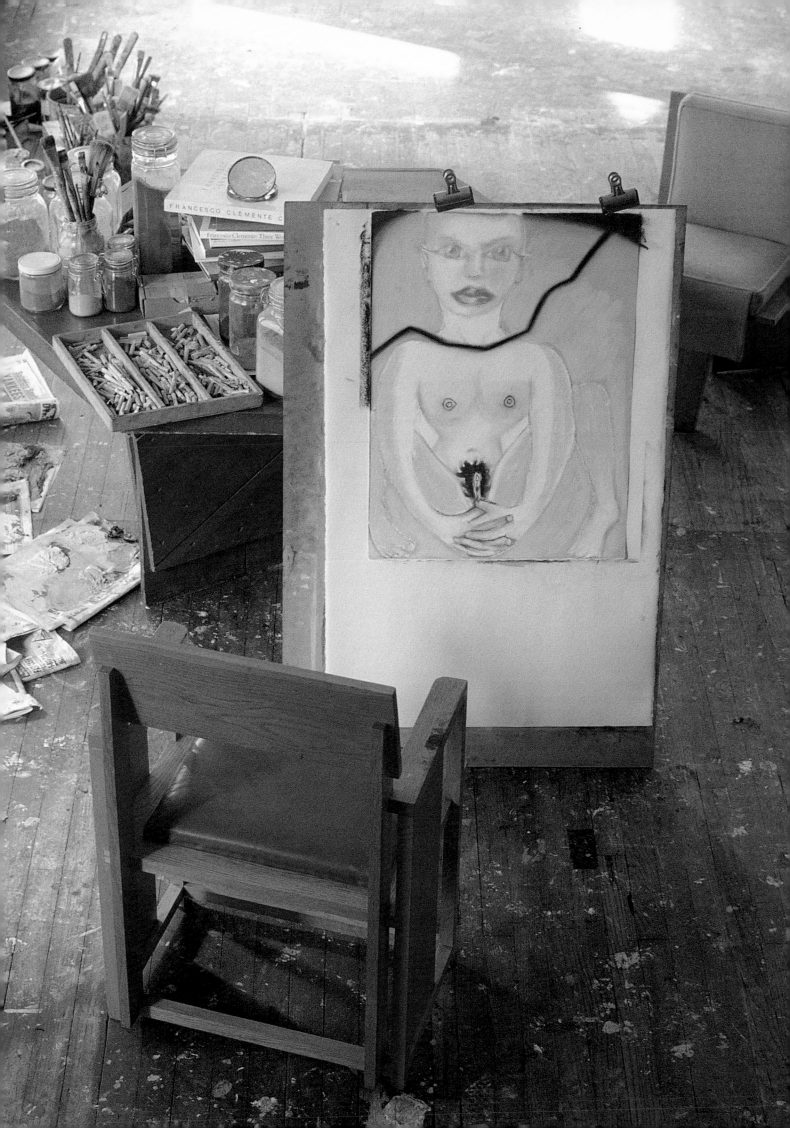

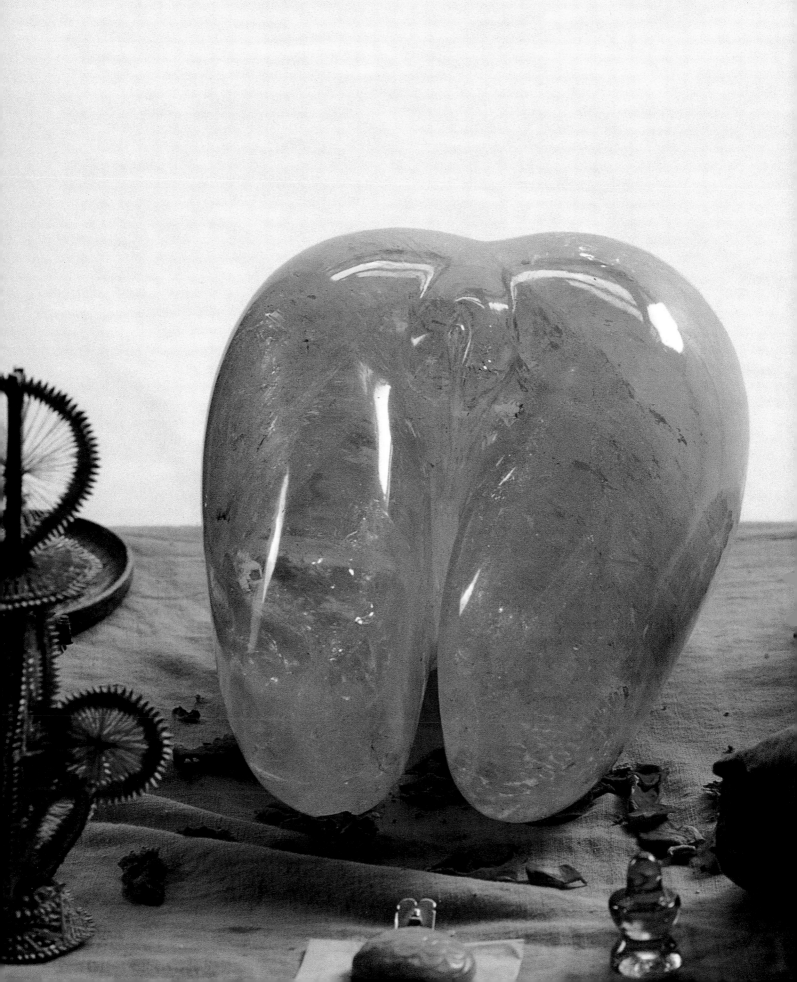

Milton Resnick

The journey to Milton Resnick's studio was like time traveling. Down a quiet, narrow street on the Lower East Side without much light: mostly small apartment buildings and townhouses, but tucked into the middle of it was an old synagogue, where his studio must have been for decades. After making beautiful, monochromatic paintings full of texture in the 1960s, he had returned to figuration and easel painting. The atmosphere in the synagogue was the closest thing to the romantic painter's studio of lore that I had ever seen in America. He was quite advanced in age and had difficulty getting around. He didn't speak much but seemed to enjoy the attention. With his white beard and his shock of white hair, he looked like a figure out of mythology. The light was crystalline and pure, like it is on those cold, clear, northeastern days. The walls were deep-toned, as were the paintings, and all the surfaces seemed to absorb the light rather than refract it. I had identified Milton Resnick with large expanses of brightness, but here was a body of work very sober in tone. Not sad, really quite beautiful, but not bright. He lived downstairs in a small section of this vast space. Very simply, with a mattress behind a plywood wall. A life completely devoted to work.

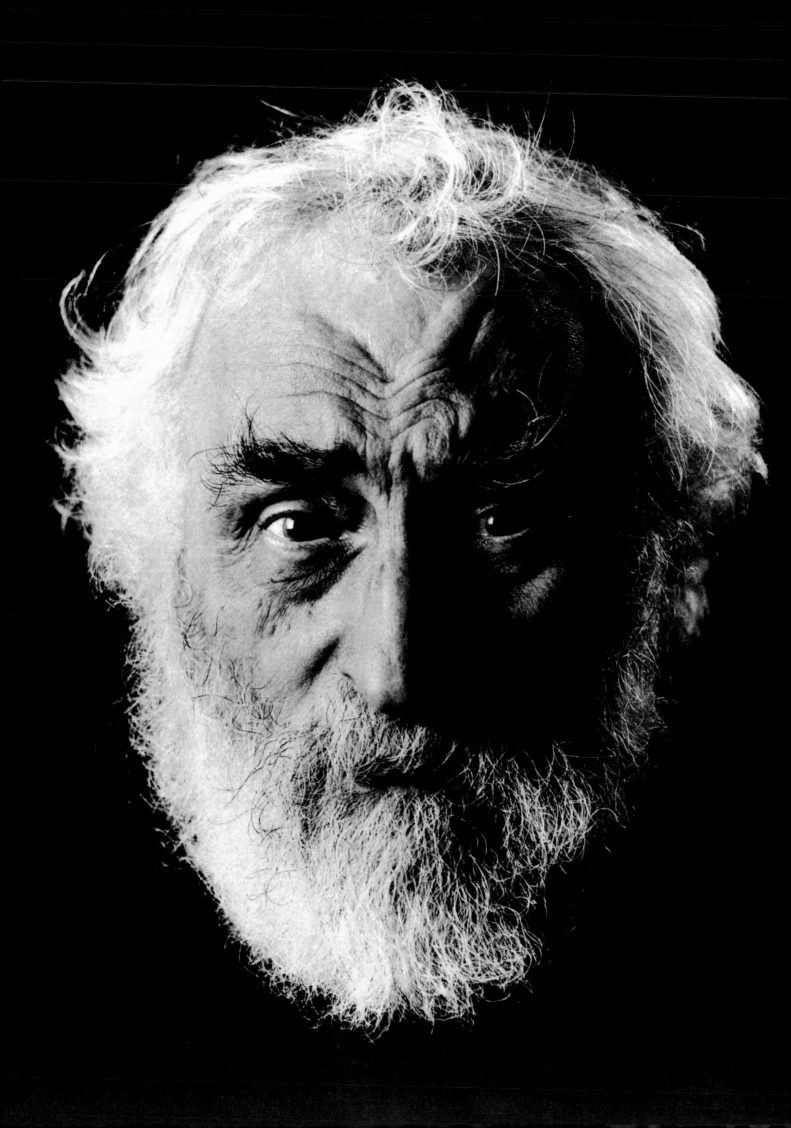

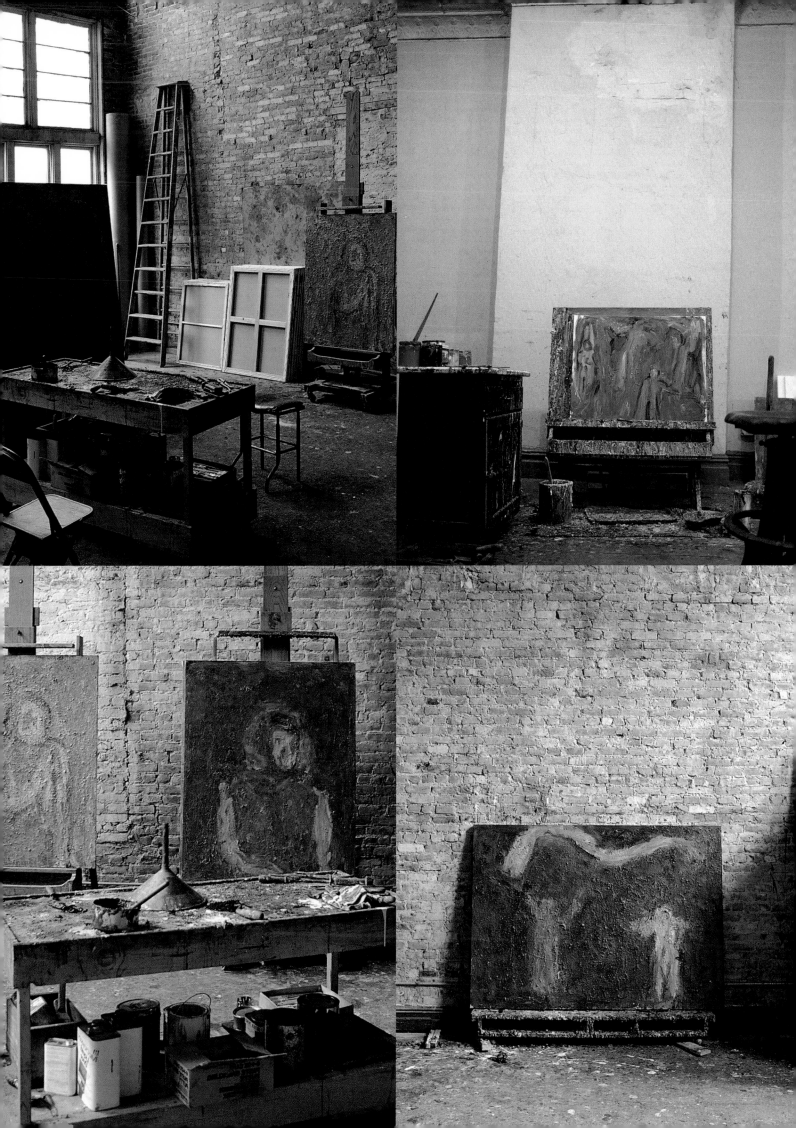

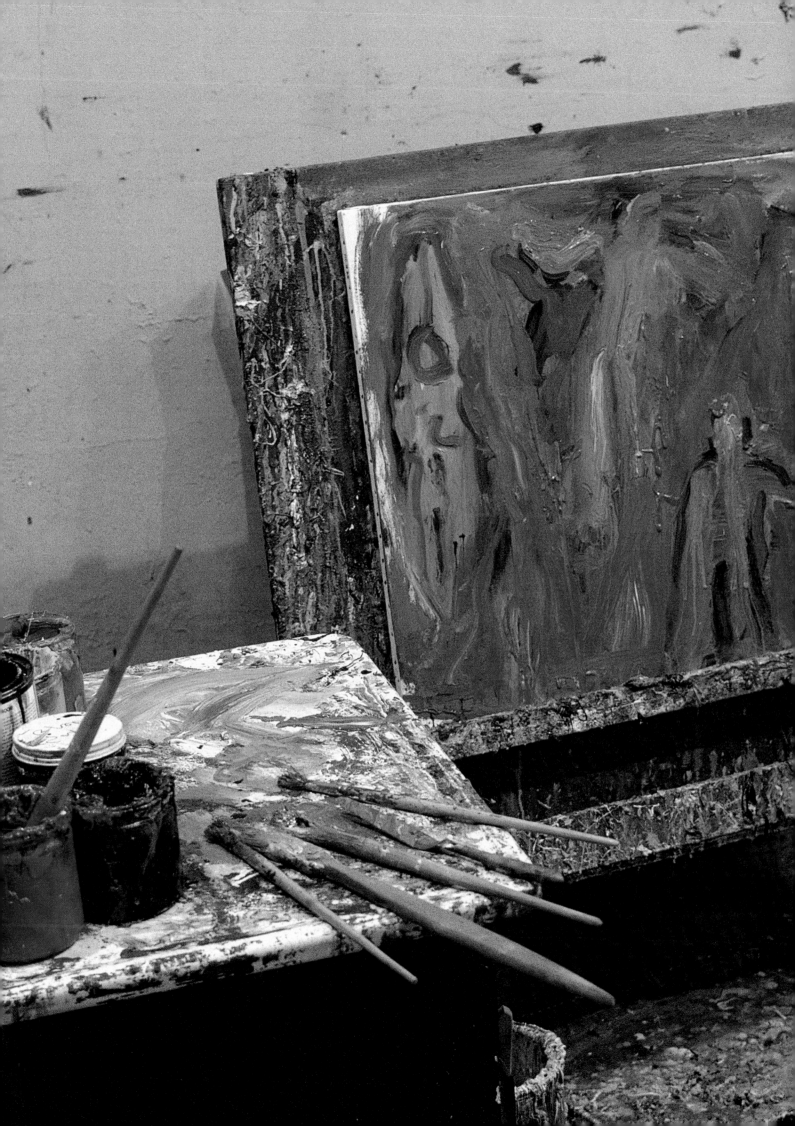

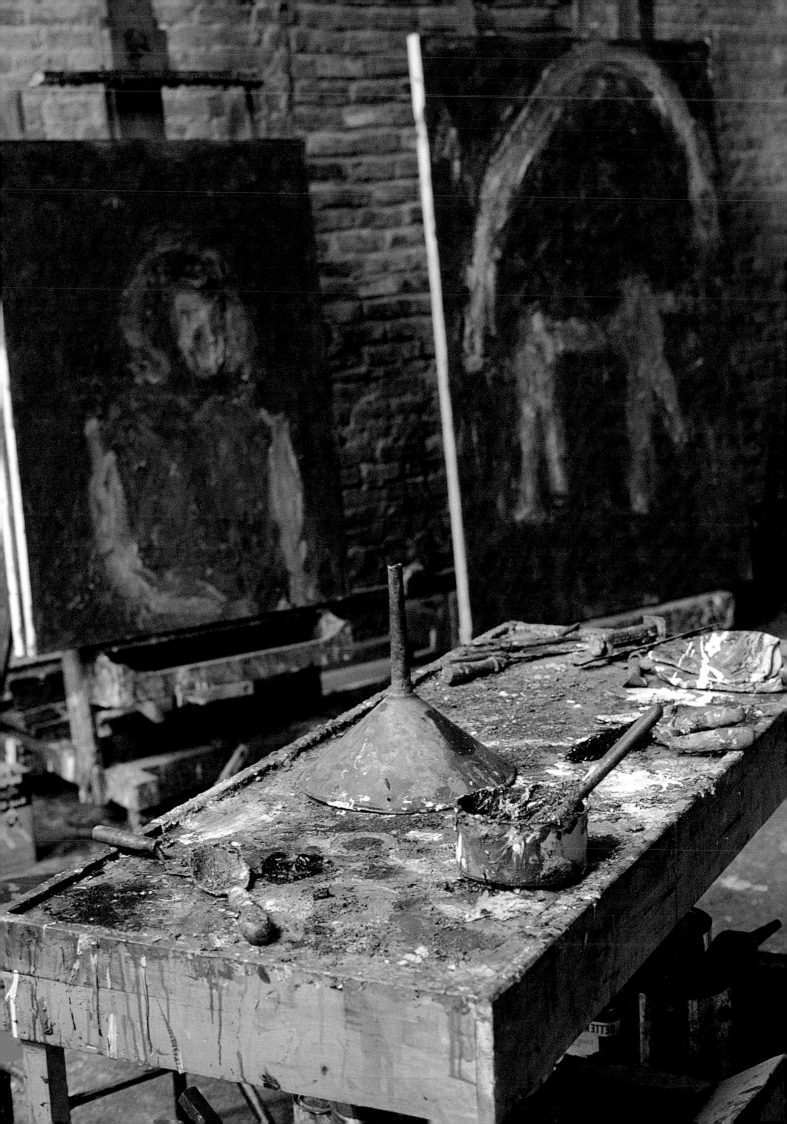

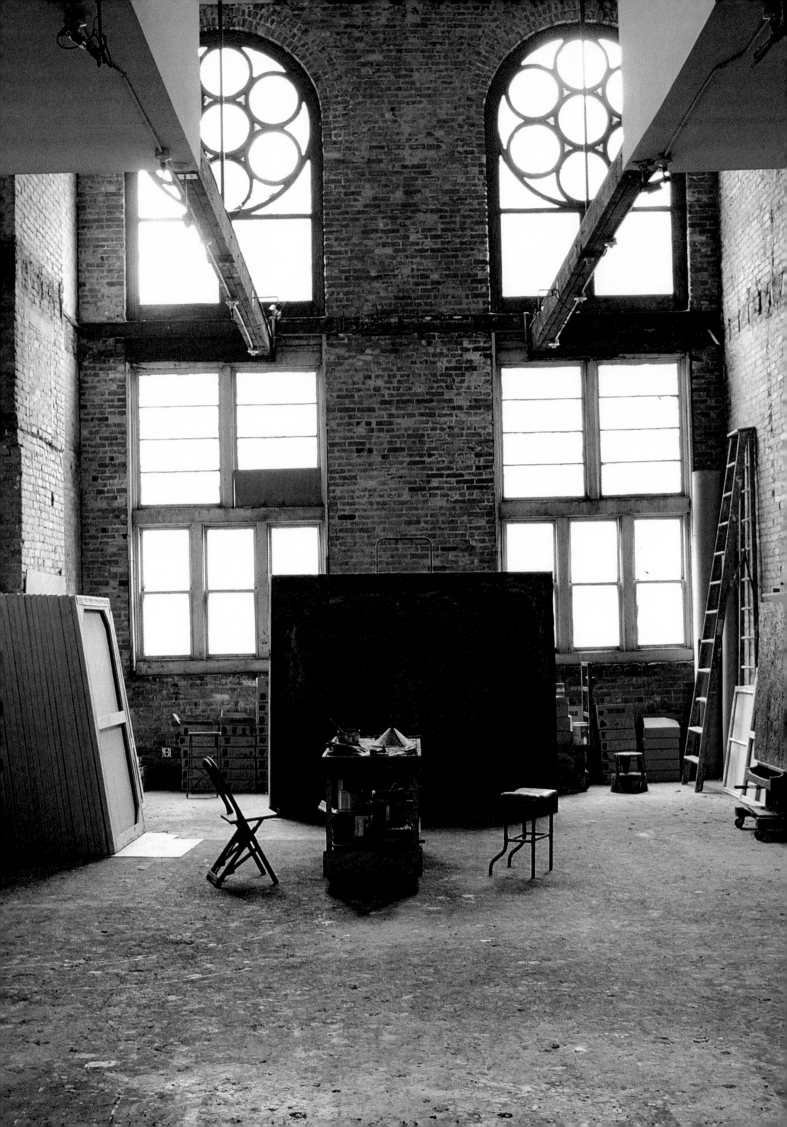

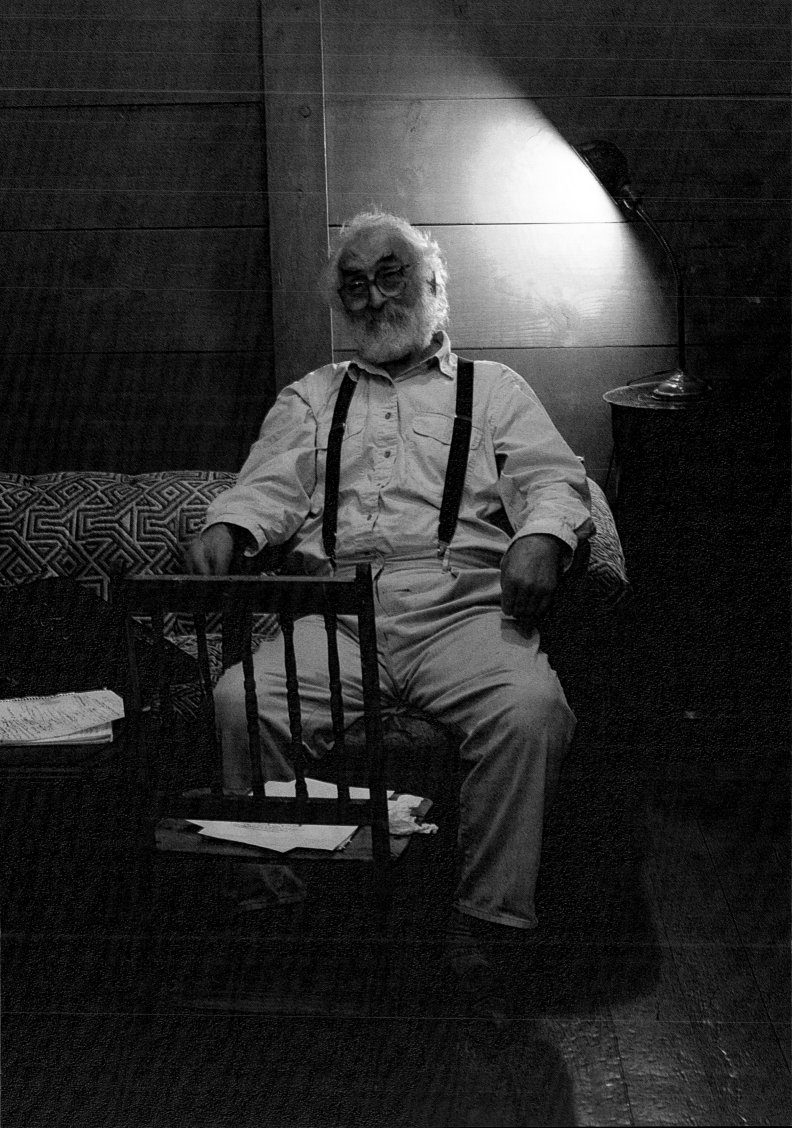

Julian Lethbridge

Julian Lethbridge's studio in the West Village has since been renovated. It was a floor in an old factory building that originally made fittings for ships. Whatever it had been in the interim was still present as the studio was set up with obviously left-over industrially carpeted floorways and remnants of wallboard partitions. It is in that wonderful part of the Village that feels much more open because the buildings are lower, the streets a little wider, and you can often see the sky and the water. Julian looks a lot like Anthony Hopkins. He is a complex and very intelligent man who knows a lot about both art and the philosophy and history of aesthetics. He also spends an extraordinary amount of time and energy seeing as much as he can in New York. If you want to know what's going on in town, ask Julian—he sees everything. He is very quiet, English, old school, and extremely discreet. The work is painstaking and ordered— mark over mark over mark over mark. I loved the works on glass that I photographed in one of the rooms off the main studio. My encounters with Julian always involve an exchange of passionate appreciation for art and ceramics. We can talk nonstop about an artist's work or an exhibition or a text. He is remarkably cultivated and refined and a joy to spend time with. This sitting was done for our friend Marianne McEvoy at *Elle Decor* to coincide with an exhibition that he was about to have at his New York gallery, Paula Cooper. Julian often has a kind of mischievous expression on his face, like the cat that just ate the canary. One never forgets Julian's eyes: the heavy-lidded, inward-looking eyes of a dreamer.

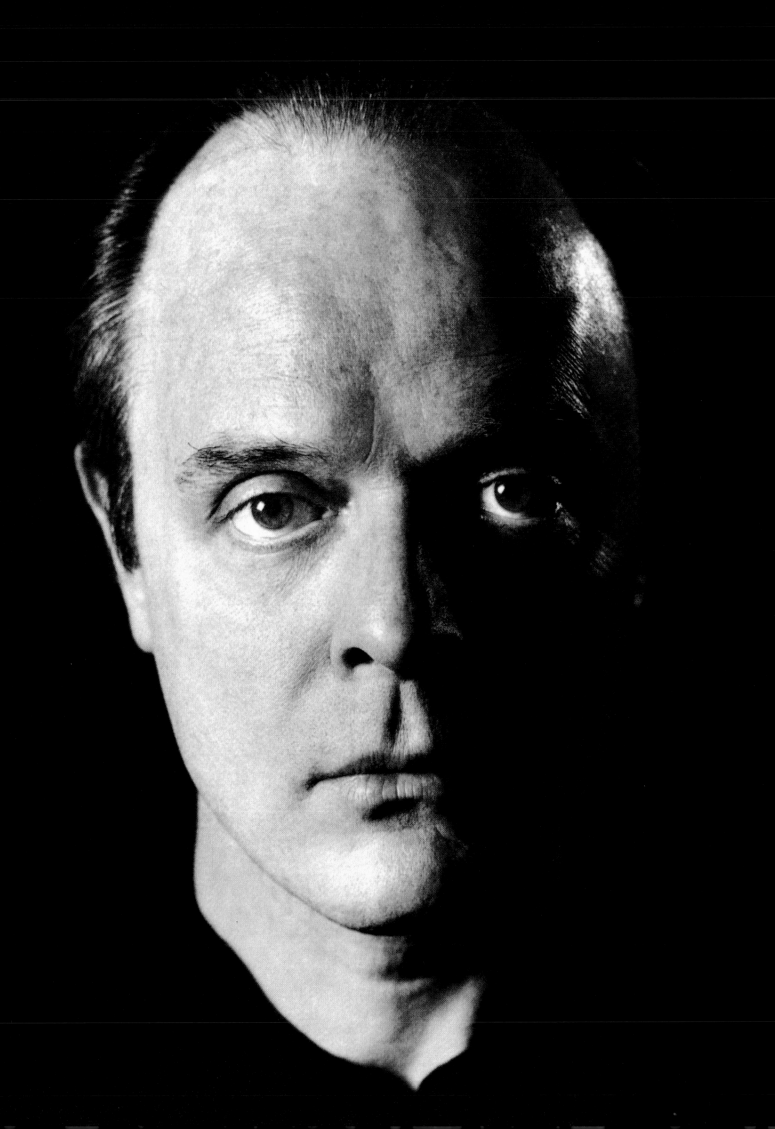

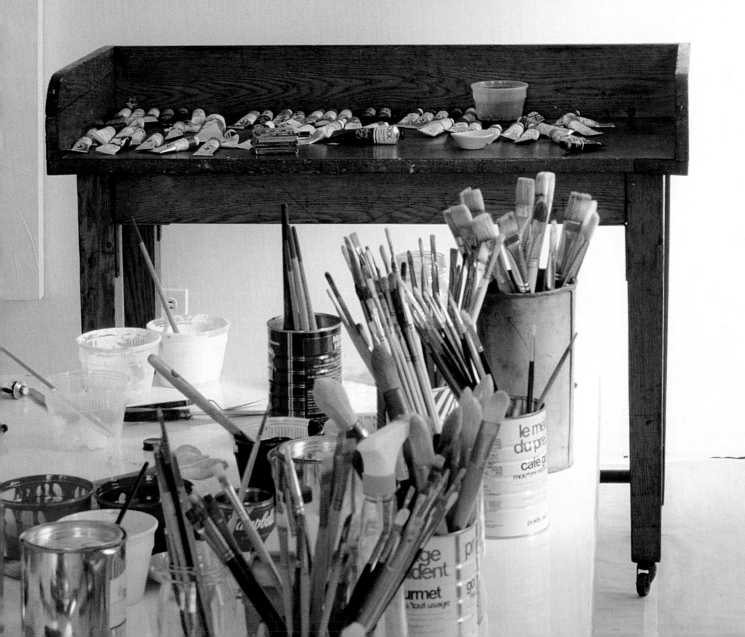

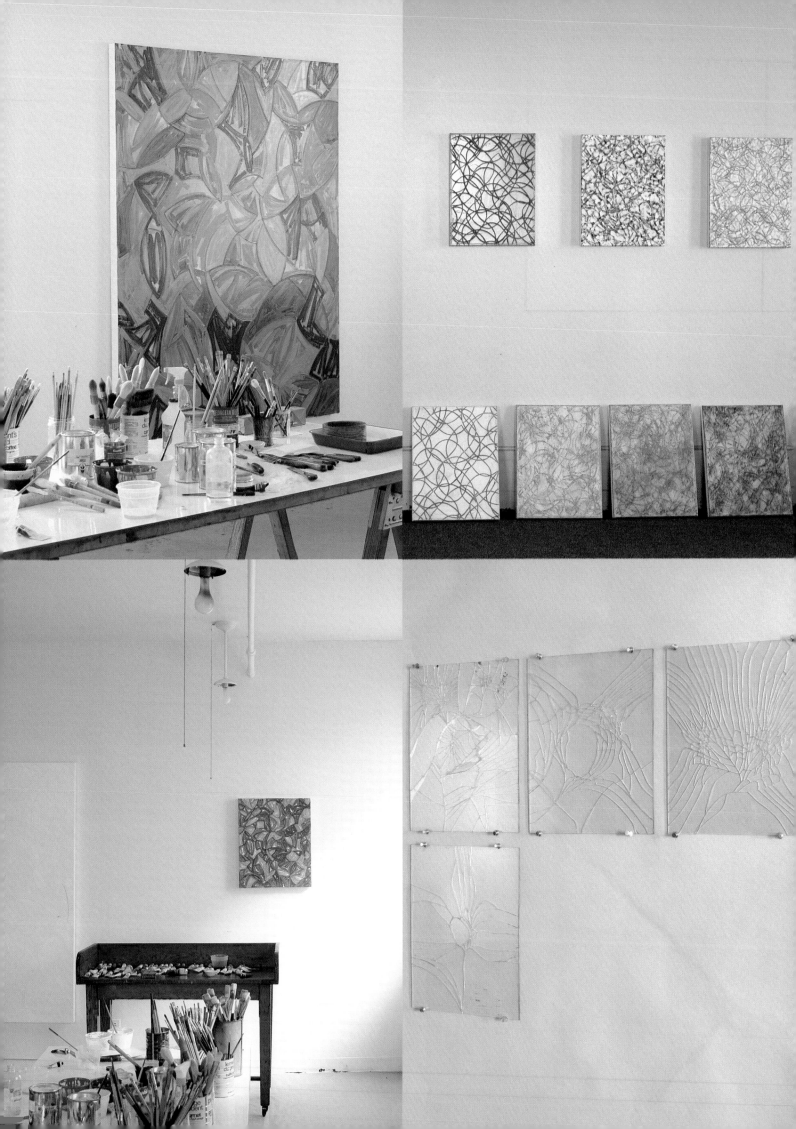

Felix Gonzales-Torres

Felix Gonzalez-Torres lived in a one-bedroom apartment in Chelsea and the entire world was his studio. He loved the cat in this picture. I feel so lucky to have known Felix and to be one of the many people whose lives he deeply touched. To know Felix was to love him. He understood better than any other artist working with AIDS in the 1990s how to translate traumatic sorrow and loss into something that would make people happy. Felix was one of the most joyous people I ever met. He filled rooms with warmth and goodwill and his happiness bounced off the walls. He was like a wonderful songbird. So the ephemeral nature of the work that one could walk away with, like the posters and the candy, conveyed a positive message, full of light and life. Like the man. Felix was obsessed with the loss of his lover. But instead of holding onto anger or resentment, he forged ahead, making all of his work a paen to love. He wanted to give everything away to beautify the world and spread joy. We had long conversations about art and a continuing dialogue about the vocabulary of hand gestures in the history of painting. He was cultivated, funny, generous, and self-effacing. He spoke with a Latin American accent and laughed a lot. He ambled through the space like a big kid. Everything was spotlessly ordered, with nothing out of place. Everywhere was brightness and color, like some enormous overgrown playroom. The apartment was chock full of colorful plastic toys of cartoon characters popular during his childhood. He took great pride in showing you the figures one by one and explaining what they were and where they came from. At the time, I thought it didn't have much to do with his work, and technically, it didn't. But, of course, in spirit, it had everything to do with the work and the generosity of his soul.

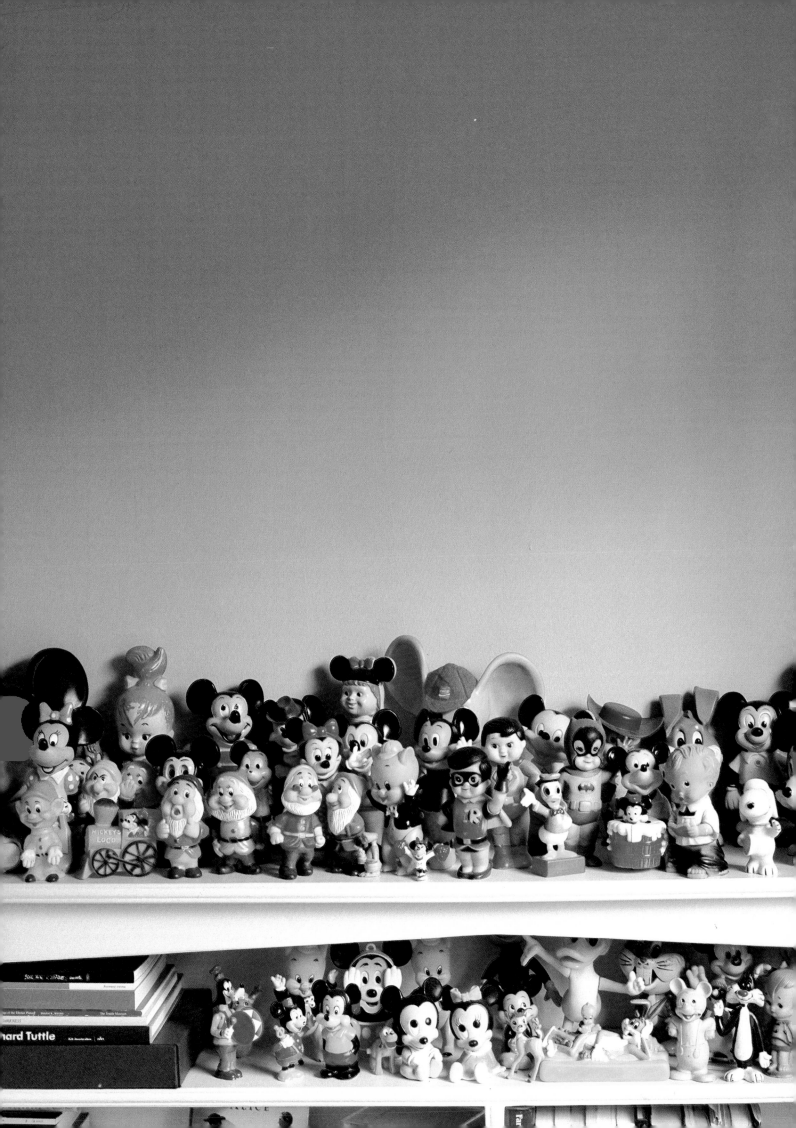

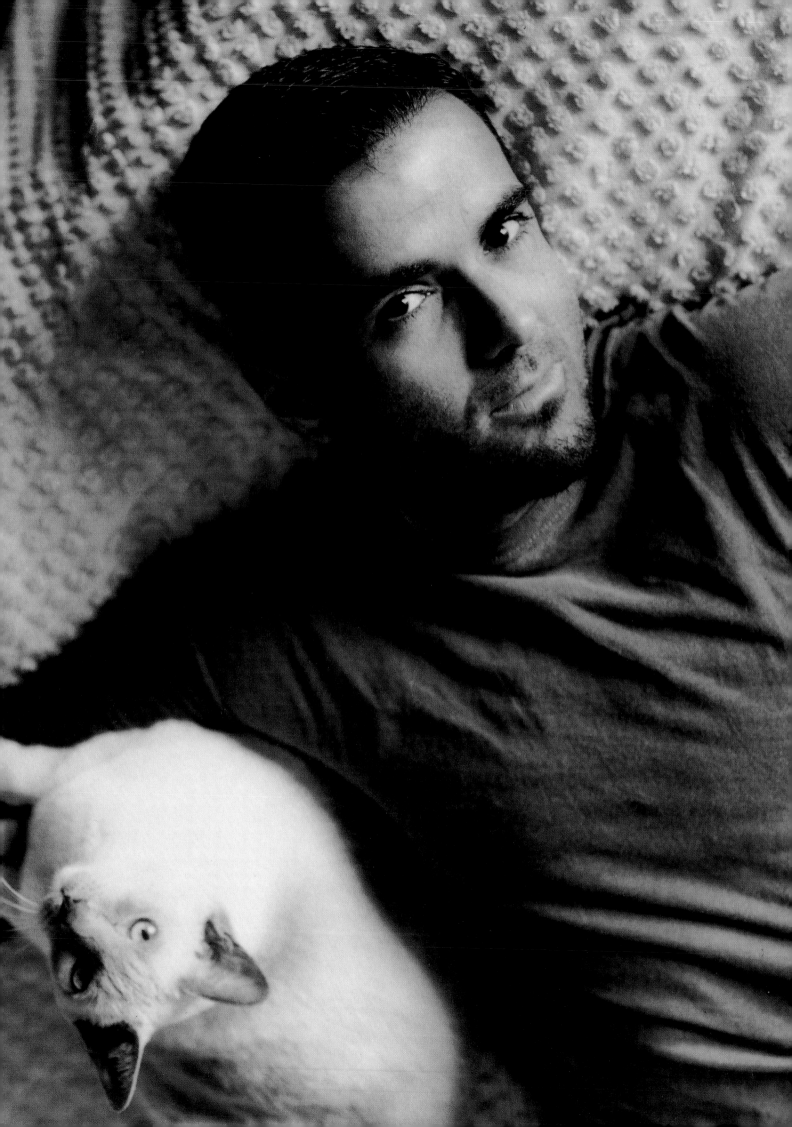

Cindy Sherman

Cindy Sherman's studio is just off her living room. Her SoHo loft is traditionally finished and could be a home anywhere, but the studio is another story. At the time I was there, it was littered with body parts, eyeballs, fake accident victims, magic-store props, and all sorts of gruesome paraphernalia. She was in the midst of directing a horror film, and tacked up at one end of the studio was her reading list, which included books on mass murders, Valerie Solanis (the woman who shot Warhol), and other various and sundry macabre topics. There was a framed photograph of Ursula Andress, and several drawers and cabinets opened to reveal work in progress dealing with bloody subjects. I've known Cindy for many years and she has always been shy and retiring. The acting-out in her work was a way of communicating another person to the world. After the initial film stills, the work became consistently bigger, more colorful, and eventually more gruesome. Cindy, in turn, became more and more private and self-effacing. The duality evolved naturally and organically over many years. Cindy herself could not be more grounded, sweet, and gentle. She is completely unassuming, with all of that enormous creative power going into the work. She is quiet, serious, happily married, and productive. On the street, where she goes virtually unnoticed, one would never imagine that she is Cindy Sherman. Her life is almost a disguise from her work. We did sittings in 1984 and '90. She used the material for press for years afterward, because she had very few documentary-style portraits of herself. I considered it a great compliment that she always agreed to sit for me, because she was notoriously reclusive.

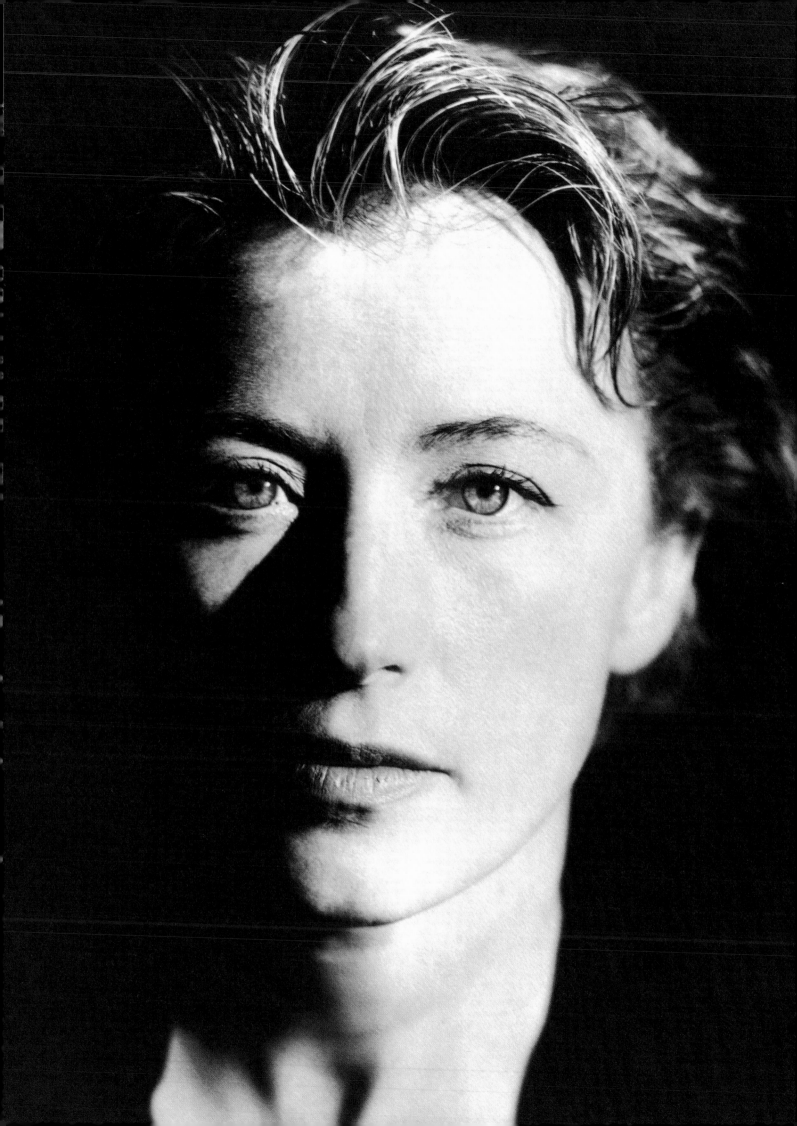

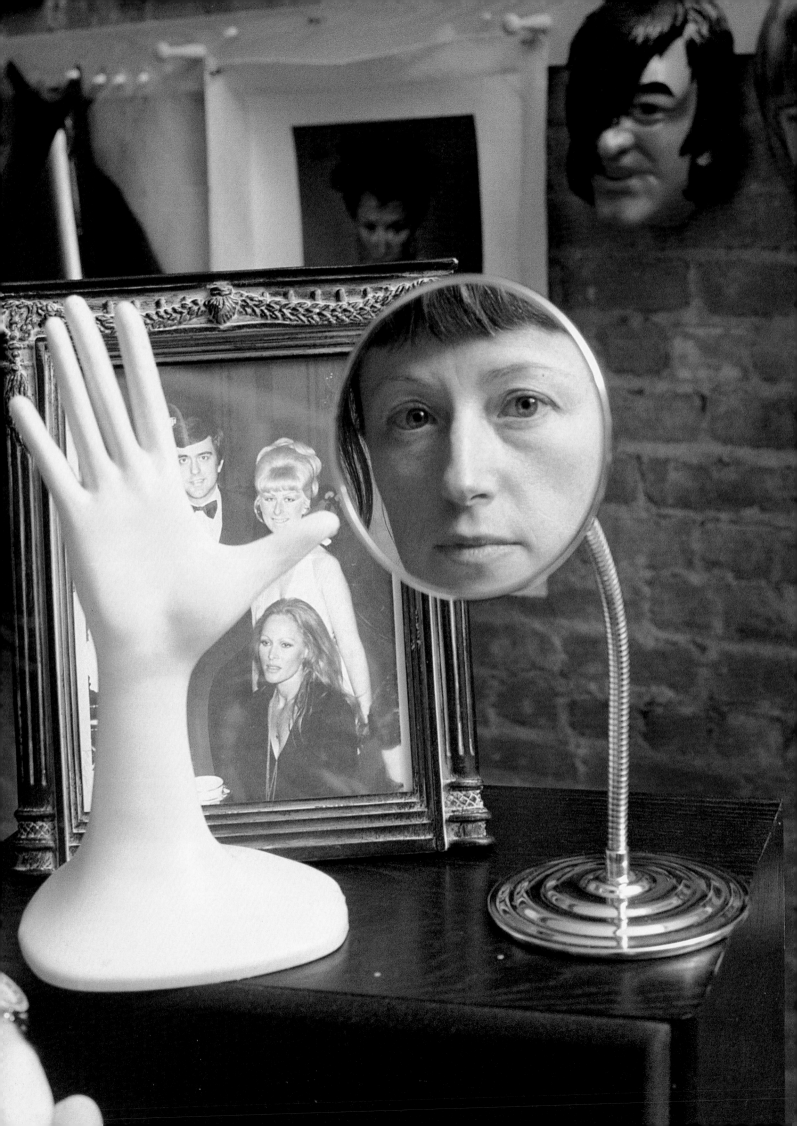

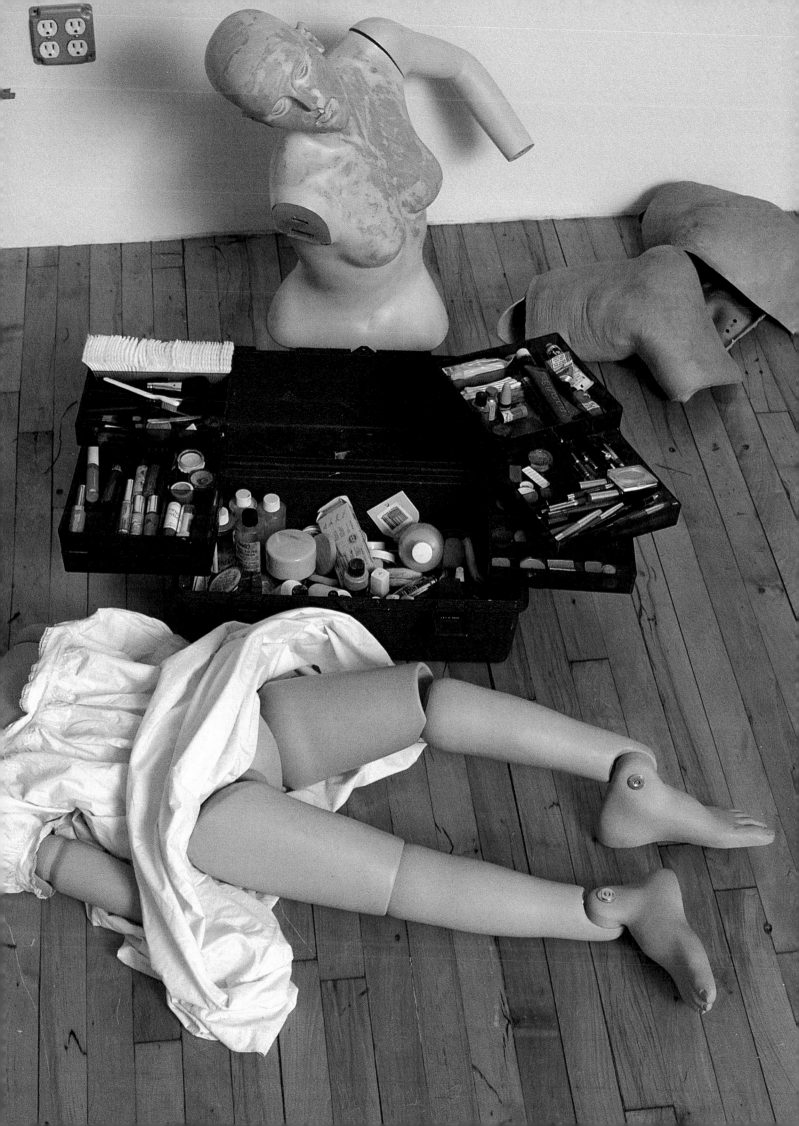

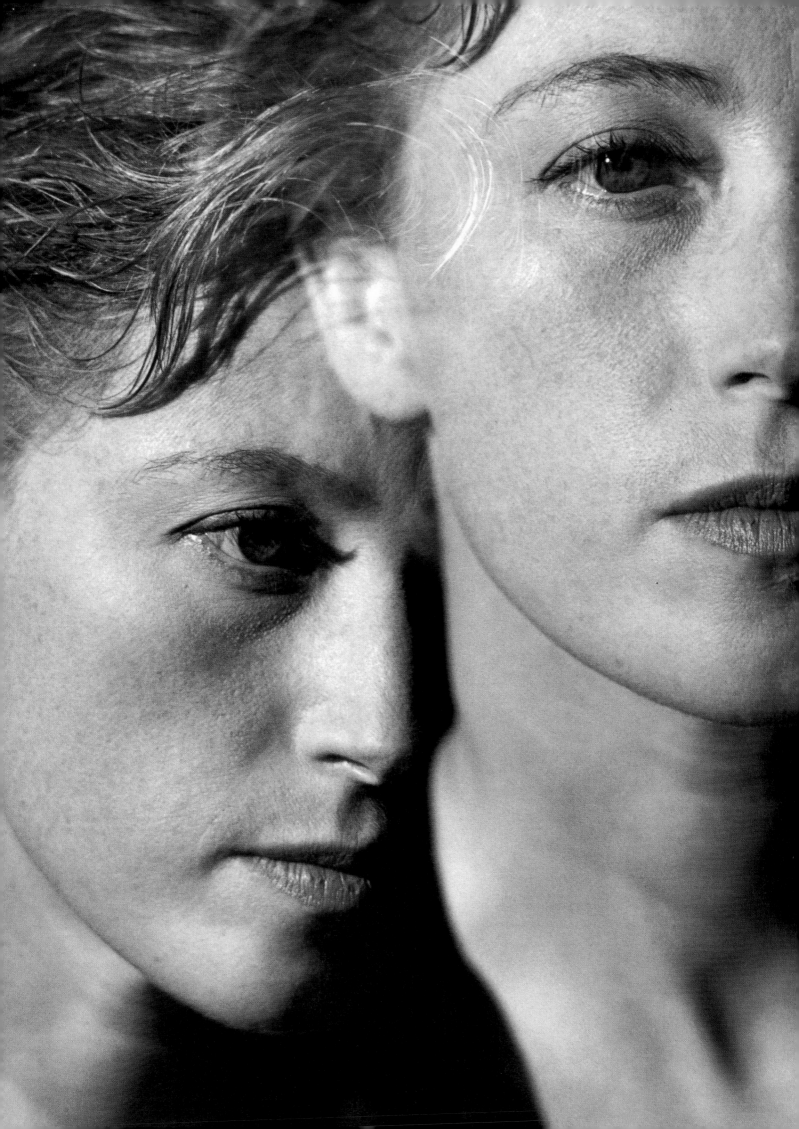

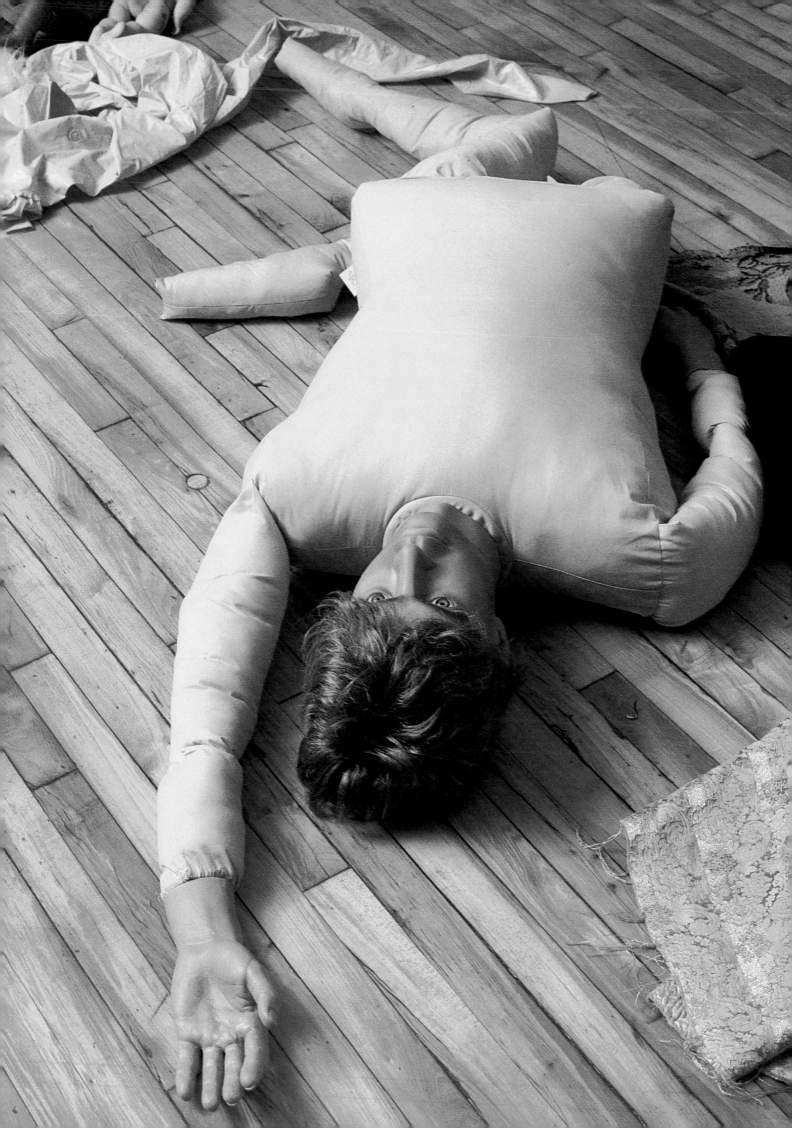

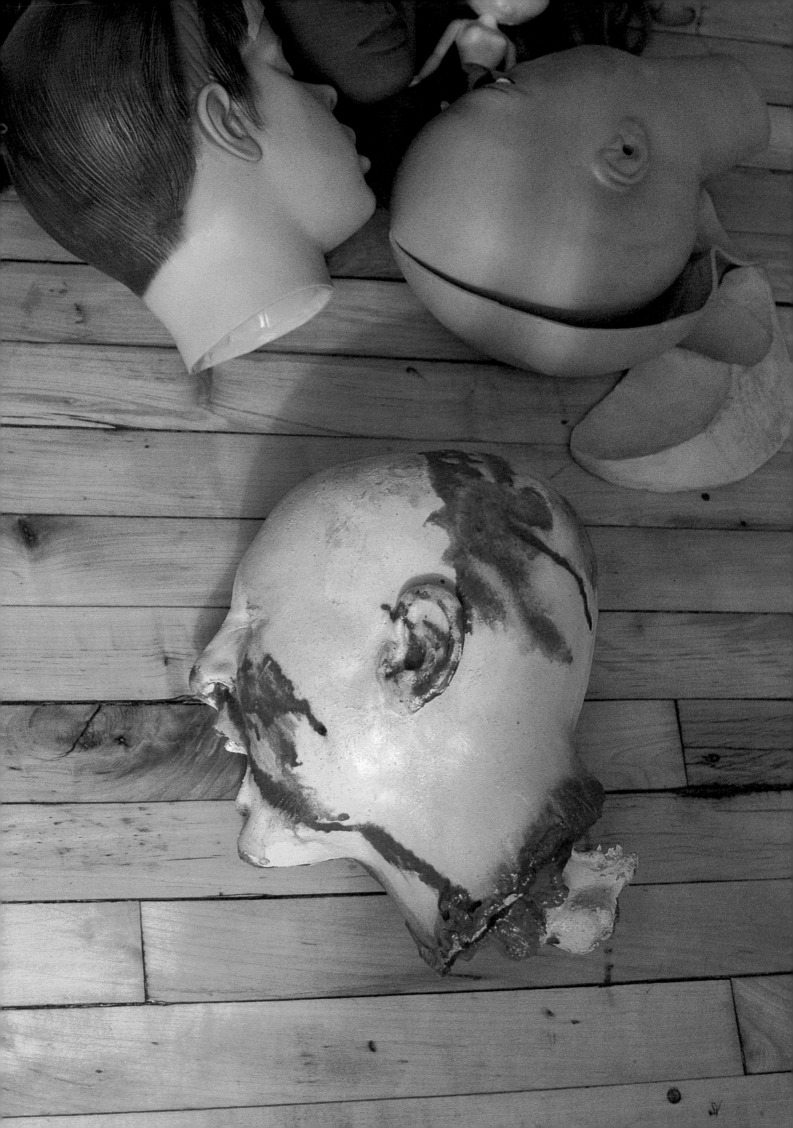

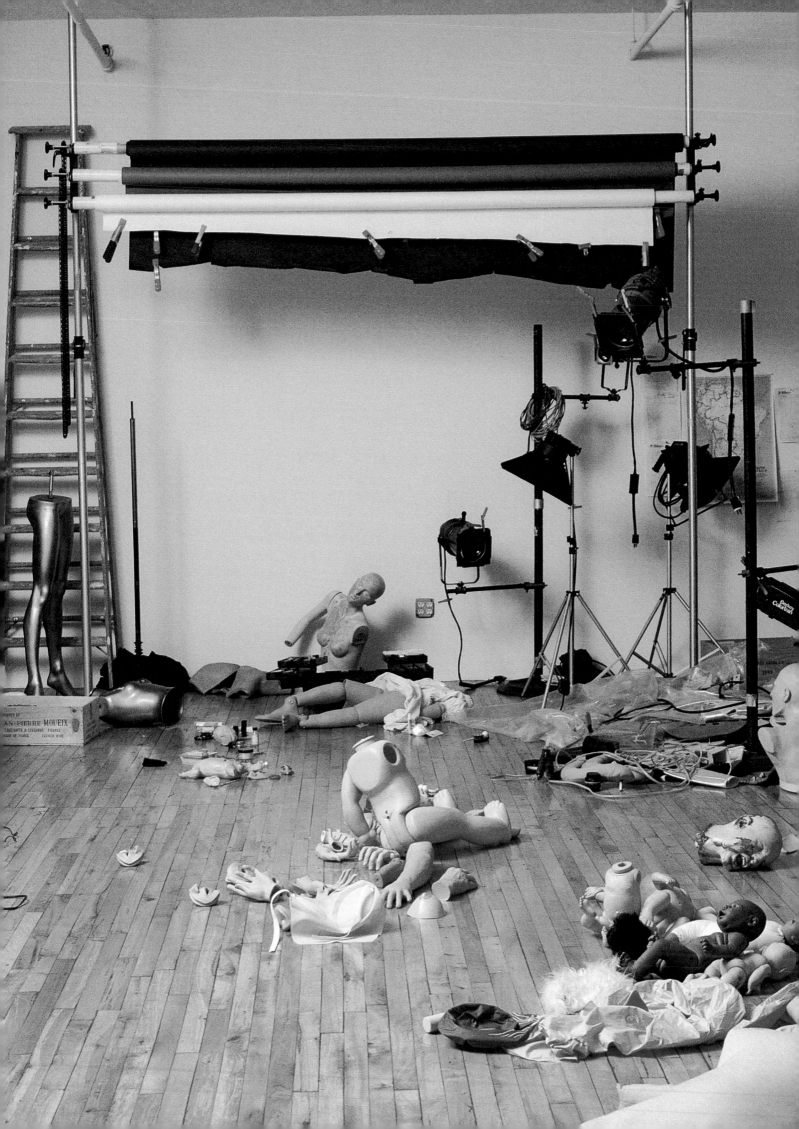

Jasper Johns

Jasper Johns was using two studios at the time of this sitting—one in the city and one in the country, about an hour from New York. The city studio was a large room at the back of an east-side townhouse. It was plain, white, and sober. The painting materials were stored in a corridorlike space behind the back wall, with passages at either end. On one wall was a large new painting that referred to a floorplan from the artist's past, on another wall, was a drawing of the Mona Lisa. The country studio was beautifully designed by Bill Katz, who helped to arrange this shoot. One of the walls opened onto a limitless view of green and sky with majestic old trees in the distance. The abundance of wood used in the construction made it feel more like a mountain retreat than an artist's studio. The vast space was filled with papers and books. There was one small new painting, and Johns was tending to an edition of bronzes of the *Number Three* that he had done in the 1960s. During the sitting, he began to make marks on his latest painting with a pencil and a ruler. It was fantastic to see the master at work. One can only speak in superlatives when describing Johns, his work, and his environments. He is gracious, humble, and private to the point of being hermetic. What initially seems severe is intimidating until he speaks or laughs. Then it is clear that he is gentle and easygoing and thoroughly delightful. He is calm and peaceful by nature, very quiet, like John Cage, with whom he was very close. I would imagine that Duchamp was like that, too. From the beginning, his paintings—the flags, the targets, the white paintings—were all discreet and quiet and meditative. He takes everything in and in his work he wastes nothing.

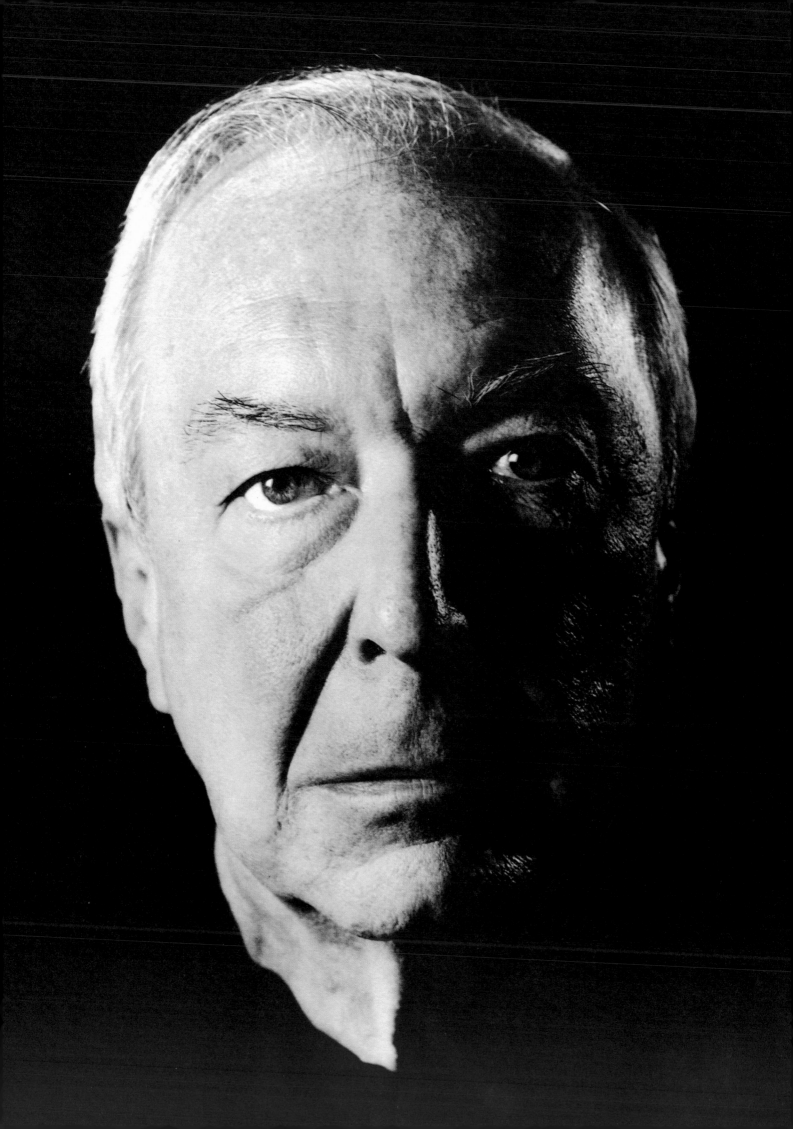

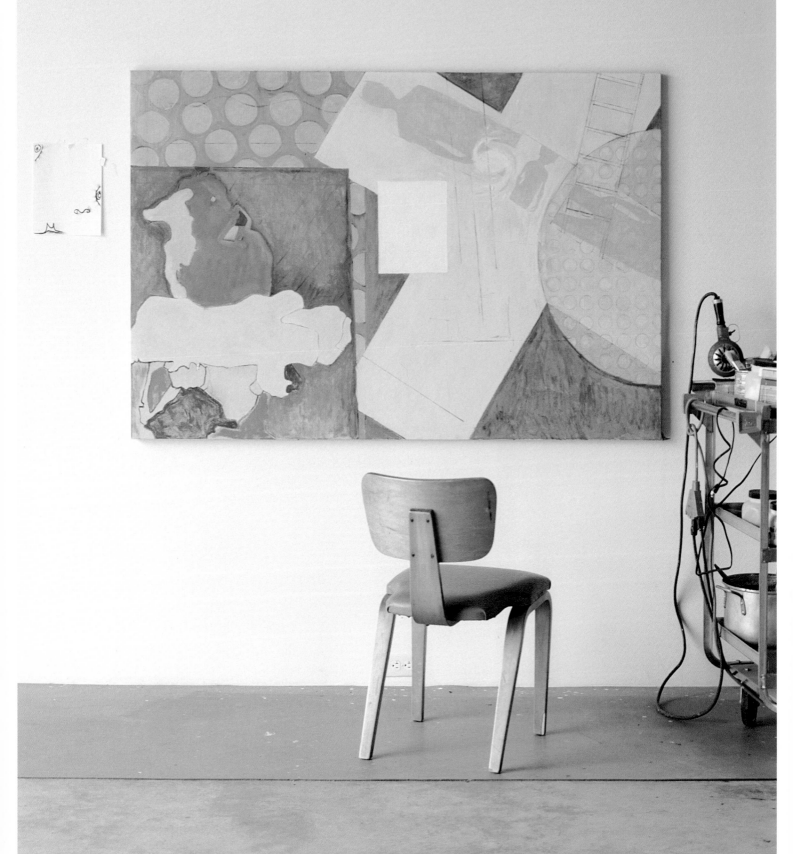

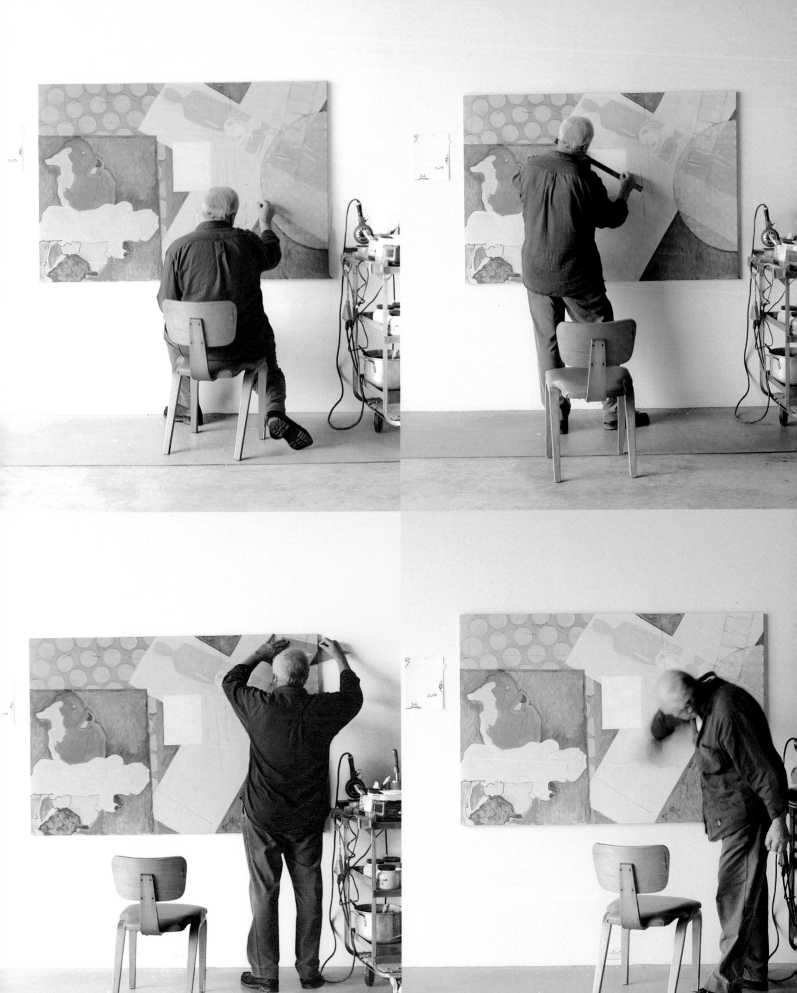

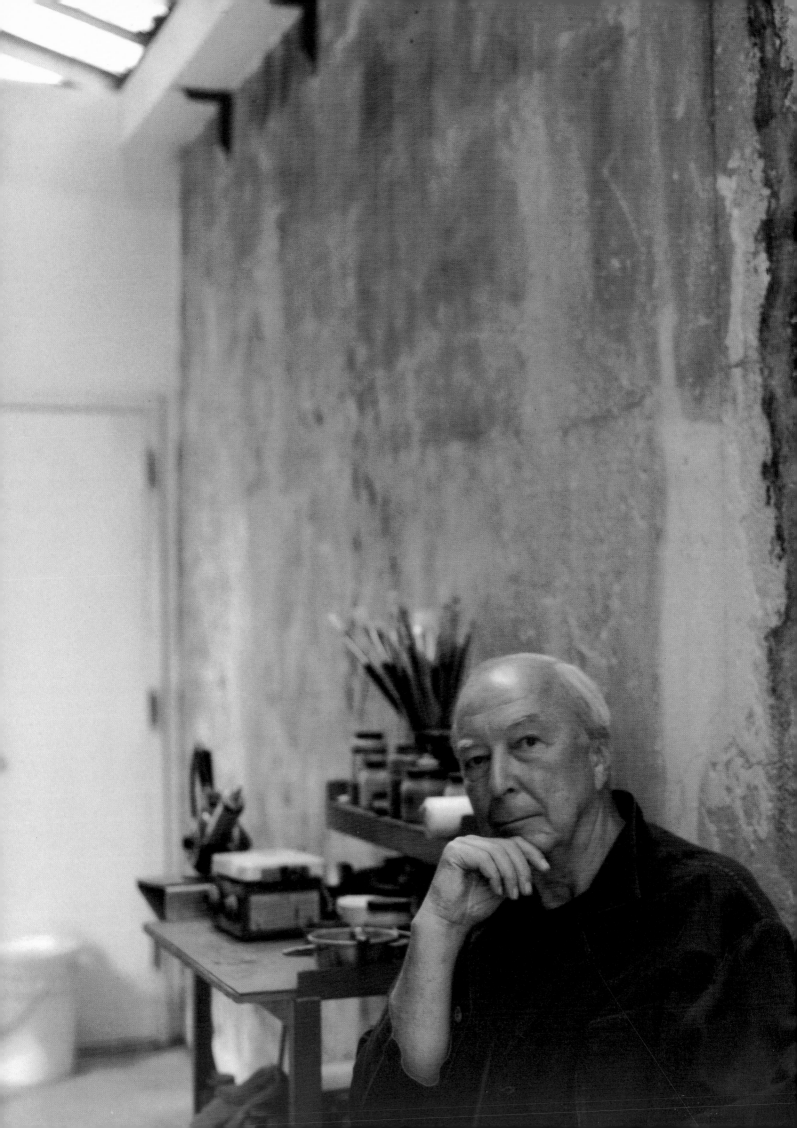

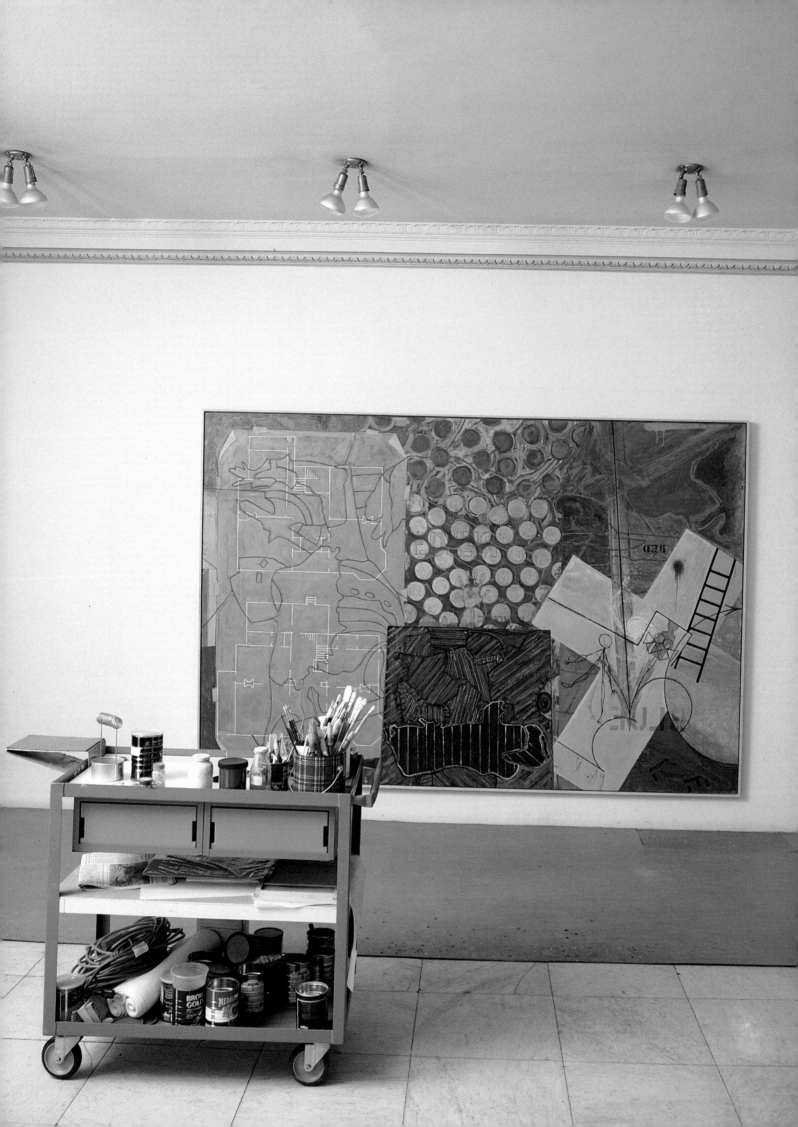

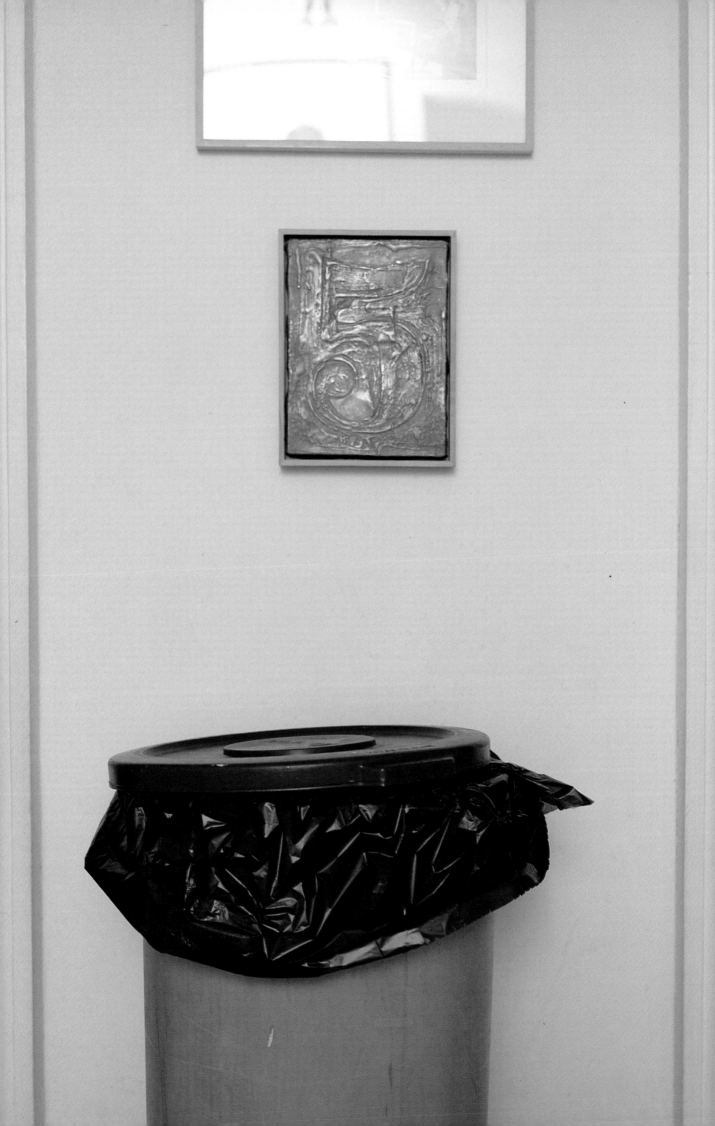

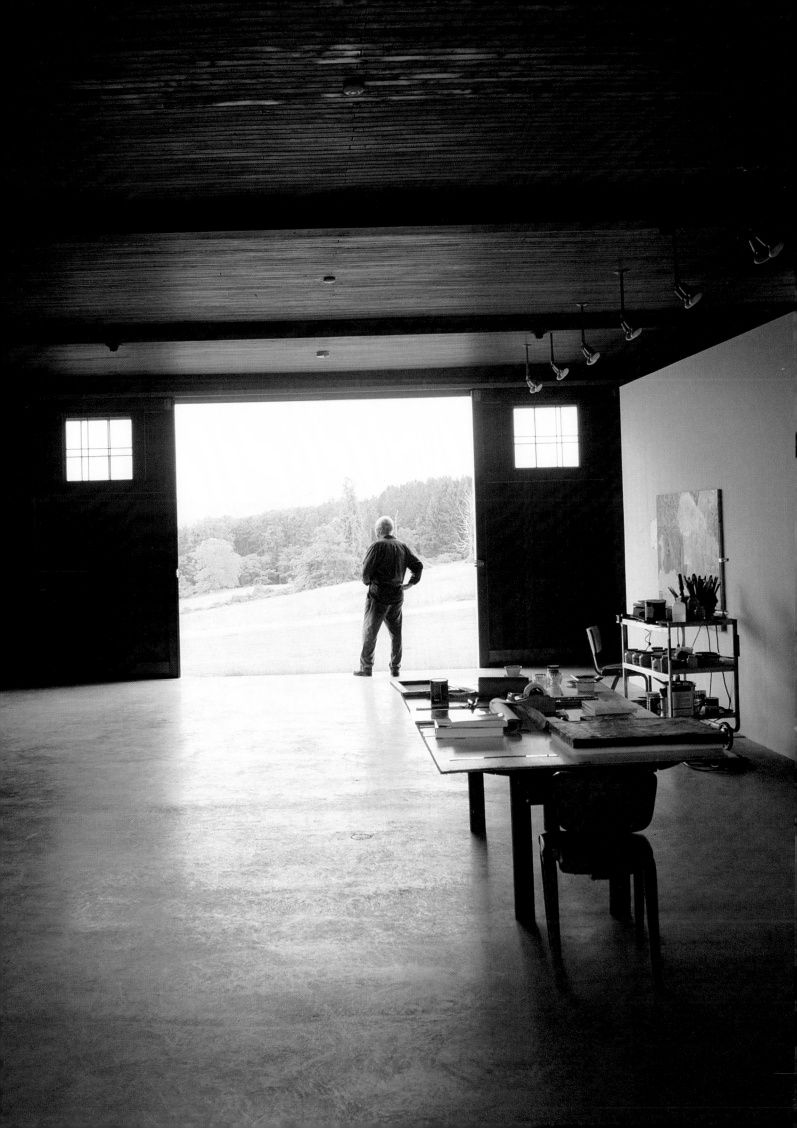

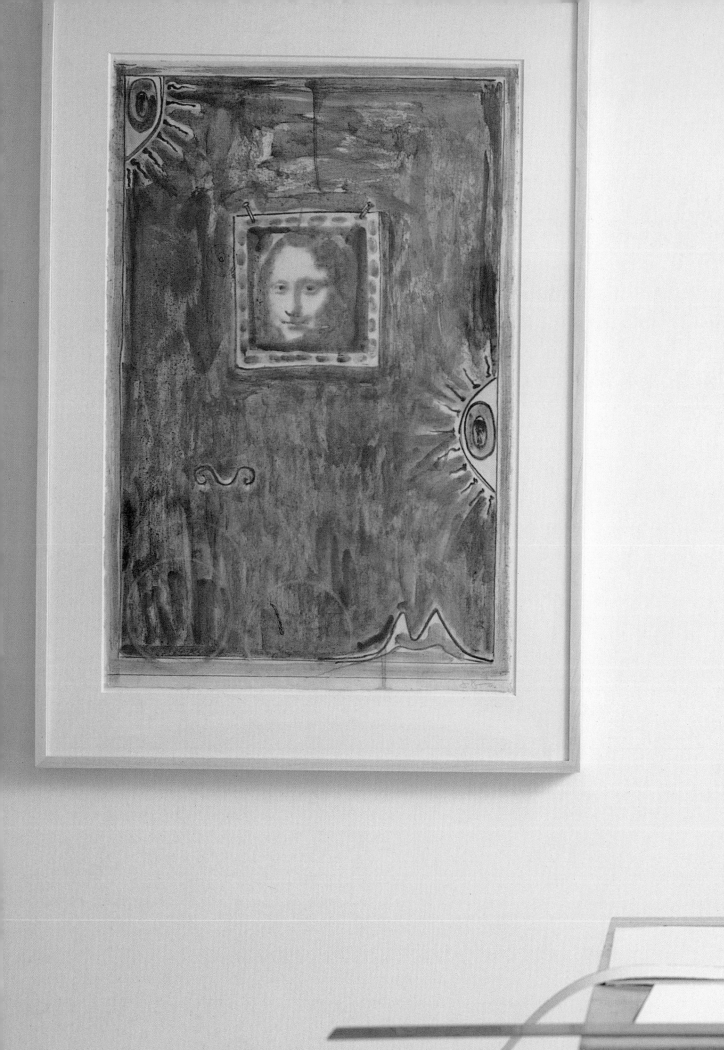

To Samia, with love

Special thanks go to all the artists and my assistants and the following: Martine and Prosper Assouline, Fabien Baron, CYMK Labs, Rowan Douglas, Diana Edkins, *Elle Decor*, Bobby Fisher, Dennis Golonka, Wendy Goodman, John Giunta, *Harper's Bazaar*, John Heil, Mark Kriendler Nelson, LTI Labs, Seth McCormick, Marianne McEvoy, Eve McSweeny, Herb Nass, Brigitte Polino-Neto, Nucleus Labs, Colombe Pringle, Lenny Steinberg, Yale Wagner and Daniel Wenger.